A type primer

A type primer

Second Edition

John Kane

Prentice Hall

Boston Columbus Indianapolis New York San Francisco Upper Saddle River Amsterdam Cape Town Dubai London
Madrid Milan Munich Paris Montréal Toronto Delhi Mexico City São Paulo Sydney Hong Kong Seoul Singapore
Taipei Tokyo

iv Editor-in-Chief: Sarah Touborg
Acquisitions Editor: Billy Grieco
Editorial Assistant: Jessica Parrotta
Assistant Managing Editor: Melissa Feimer
Senior Operations Supervisor: Brian K. Mackey
Director of Marketing: Brandy Dawson
Executive Marketing Manager: Kate Mitchell

Cover design: John Kane

Credits and acknowledgments borrowed from other
sources and reproduced, with permission, in this textbook
appear on the appropriate page within the text or in the
Picture credits opposite.

ISBN-13: 978-0-205-06644-5
ISBN-10: 0-205-06644-5

Commissioning Editor: Kara Hattersley-Smith
Senior Editor: Melissa Danny
Production Manager: Simon Walsh
Designer: John Kane
Photo Researcher: Evi Peroulaki
Copy Editor: Fiona Biggs
Proofreader: Emily Asquith
Indexer: Vicki Robinson

Printed in China

Library of Congress Cataloging-in-Publication Data
Kane, John, 1949-
 A type primer / John Kane. -- 2nd ed.
 p. cm.
 Includes bibliographical references and index.
 ISBN-13: 978-0-205-06644-5 (pbk. : alk. paper)
 ISBN-10: 0-205-06644-5 (pbk. : alk. paper)
1. Graphic design (Typography) 2. Layout (Printing) I. Title.
 Z246.K36 2011
 686.2'2--dc22
 2010040655

10 9 8 7 6 5 4 3 2 1

Acknowledgments

Author Grace Paley once pushed Hippocrates a bit to say that she wrote short stories because 'Art is *too* long, life is *too* short.' That sentiment nicely sums up what has kept this second edition off the shelves until now. The petty illnesses of middle age, combined with expanded professional responsibilities, didn't always allow me to stick as closely to this project as perhaps I should have. Apologies for the delay.

This edition grew out of the support and suggestions of valued colleagues. I am grateful to Nancy Skolos for inviting me to teach type at Rhode Island School of Design, and to Ernesto Aparacio, Jan Fairbairn, Lucinda Hitchcock, Matthew Monk, Bill Newkirk, Akefeh Nurosi, Douglass Scott, Hans van Dijk, Tom Wedell, Franz Werner, and — especially — Cyrus Highsmith and Krzysztof Lenk for their lessons in collegiality and professionalism. Students Mitchell Goldstein and Katherine Hughes at RISD offered invaluable teaching support.

At Northeastern, Ed Andrews, Isabel Meirelles, and Russell Pensyl kept me employed (no small thing); Cynthia Baron generously shared her expertise and advice; and Elizabeth Cromley actually read the first edition, which she proved by finding its one typo (*minuscule!*). I owe much to my students Dwight Roell, Kate Terrado, and Mitch Weiss for their assistance in wrestling various parts of this project to the ground. Fellow lecturers Sophia Ainslie, Julia Hechtman, and Karen Kurczynski make every day plain old fun, while colleague Mary Hughes gently punctures every pretension I throw her way. Department administrator Judy Ulman remains the heart and soul of all we do. But most of all, thanks with deep admiration and affection to Andrea Raynor and Matthew Rich, who school me daily in the ways of hard work, the Red Sox, handicapping throroughbreds, and All Important Things.

Thanks to the reviewers of the last edition: Andrea Marks (University of Oregon), Robert Newman (Savannah College of Art and Design), Liz Resnick (Massachusetts College of Art & Design), and David Smart (University of Plymouth, UK).

Generous students at RISD and Northeastern provided some of the examples that appear in this edition. I have credited them individually where their work appears, but I must thank them all, whether or not they're included in these pages, for giving me the best reason anyone could wish for to get out of bed each morning.

I have leaned too heavily on the goodwill and broad experience of my family and friends. In particular, I remain indebted to my mother, Carole Kane, for her unfailing encouragement and unflinching affection, even after all these years.

Finally…
Some things don't change. Just as with the first edition — in fact, just as with everything I do — the touchstones for this project remain Julie Curtis, David W. Dunlap, Nina Pattek, and my partner, Mark Laughlin. To them, once again, this book is dedicated.

JK

Contents

Introduction

Design is solving problems. Graphic design is solving problems by making marks. Type is a uniquely rich set of marks because it makes language visible. Working successfully with type is essential for effective graphic design.

That said, I can tell you that

this is a practical book.

Over the last 20-odd years teaching typography, I have been unable to find a text that spoke clearly to beginning students about the complex meeting of message, image, and history that is typography. Some of the best history texts are weak in examples; some of the best theoretical texts speak more to the professional than the novice. And no text provides background information to the student in a sequence that supports the basic exercises in any introductory type course. My intention here is to present the basic principles and applications of typography in a way that mirrors what goes on in the classroom and to back up that information with a series of exercises that reinforce the acquired knowledge.

My intent here is to get you, the beginning student of graphic design, to the point where you can understand and demonstrate basic principles of typography. If instinct is the sum of knowledge and experience, this book is an attempt to broaden both in order to strengthen your own typographic instincts.

I should also point out that this is an autodidact's book. What I know about typography I learned from reading, from practice, and from observation. I was lucky enough to read Emil Ruder first. And I was lucky to work in Boston at a time when dozens of gifted practitioners were trying to solve the same problems I was confronting daily, as we all moved from metal type through photoset type to digital type off our Macs. What I learned from them was constant application of theory to practice, unflagging respect for the letterform, and a ceaseless search for that moment when the personal met, or at least approached, the platonic.

Paul Rand once wrote: 'Typography is an art. Good typography is Art,' and therein lies the problem for both teacher and student. Craft can be taught. Art lies within the individual. Many beginning students are frustrated by the fact that there are no hard and fast rules in typography, no foolproof map to success. The pedagogic difficulty is that type has a system of principles, based on experience, and those principles keep evolving as language and media evolve. Countless times, students have asked, 'Is this right?' when in fact there is no such thing in typography as 'right.' The question they should be asking themselves is, 'Does this work? Is it useful?' Designers use type as a response— to a message, to an audience, to a medium. The only way to recognize successful typography is through informed, direct observation. It takes time, trial, and error to know what works and to lose anxiety over what may or may not seem 'right.'

If you work through the examples in this book for yourself, you should have enough experience to test your own ideas in typographic applications. After all, it is what each designer brings to a project—the sum of what he or she knows and feels, his or her unique experience— that guarantees that variety, excitement, and, occasionally, brilliance will continue to enliven typographic design. This book is not about style—a characteristic expression of attitude—so much as a clear-headed way of thinking and making. Style belongs to the individual; delight in thinking and making can be shared by everyone.

The guiding attitudes behind what follows are those that have vitalized most 20th-century art:

Content dictates form. Less is more. God is in the details.*

These three tenets neatly identify the typographer's job: appropriate, clear expression of the author's message, intelligent economy of means, and a deep understanding of craft.

* The first idea is a variation of architect Louis Sullivan's famous dictate, 'Form ever follows function.' The second, although popularized by architect Ludwig Mies van der Rohe, was first articulated by Robert Browning in 'Andrea del Sarto,' 1855 (and, in fact, the idea has existed in literature since Hesiod's 'Works and Days' (700 B.C.E.), in which he writes 'They do not even know how much more is the half than the whole.') The third, although attributed to architect Louis Kahn, has no source that I have been able to uncover.

The basic thinking behind this book comes out of two simple observations. First,

type is physical.

Until quite recently, any study of type would necessarily begin by hand-setting metal type. There is still no better way to understand the absolute physicality of the letterform—its 'thingness.' With each passing day, however, working with metal type becomes less and less possible. To approximate the experience of handling type, there are examples in this book that require careful hand-rendering of letterforms. (I've suggested these exercises primarily for readers who don't have, as I did not, the benefit of a classroom experience. They are not intended to supplant working with a capable instructor, although I certainly hope that they can enhance that process.) These exercises not only help you hone your hand/eye coordination, but also help you develop a typographic sensibility. You cannot achieve this sensibility merely by looking and thinking. The only way to appreciate the reality of type is first to make your own.

The second observation, particularly in terms of text type, is that

type evolved from handwriting.

While there are any number of things you can do with text type (particularly on a computer), your work will have the most integrity when what you do reflects the same impulse that leads us all to put pen to paper—effective, direct, useful communication.

Particularly in later examples, I have assumed that people using this book have a working familiarity with Adobe Illustrator and Quark Xpress or Adobe InDesign. You should also have at least one font from each of the classifications described on pages 48–50; in fact, you could do a lot worse than to choose the ten typefaces highlighted on page 12. They provide a rock-solid foundation for any typographic design problems you may encounter in the future.

I've used numerous examples to demonstrate the points I raise because one of the joys of working with type is that you can see immediately what is successful and what isn't (for that same reason I've tried to keep text to a minimum). I have designed almost every example in this book to reflect what was, and still is, possible on a simple type press. I've kept these examples as simple as possible for two reasons: 'simple' is deceptively difficult (and, in typography, often desirable); and, as I said earlier, this book is about intent and content, not effect or style.

This second edition incorporates many additions and amendments to the first; perhaps the most significant is the companion website (www.atypeprimer.com). There you will find examples of student work, discussions of best typographic practice for the web, recommendations for a strong typeface library, links to typographic resources, and other timely topics. I consider the website a logical extension of the material in this book, and I encourage you to refer to it often. Perhaps the most surprising discovery I've made since the first edition is the direct correspondence between good print typography and good web typography. I hope that this book's website clearly demonstrates how the principles in print translate to the screen.

x The sequence of examples in this book is built to demonstrate that the character and legibility of type only exist in the context of voids— what type designer Cyrus Highsmith describes as 'where type isn't.' A serious typographer constantly monitors and manipulates the relationship of form (where type is) to counterform (where it isn't). To understand this relationship, it is essential to see type as a progression of spaces (right). Changing any one space immediately alters its relationship with all the other spaces. Those of you familiar with Gestalt Principles will doubtless find similarity to the concepts of contiguity, continuity, and closure. I conclude the introduction with this observation because it is central to all good typography and because it offers us an ideal point from which to start. As you go through this book, keep in mind how the spaces operate, both in the examples shown and in the pages themselves.

The space inside the form

The space between forms

The space between words

The space between lines

The space between paragraphs

The space between columns of text

The space between text and the edge of the page

Basics

Describing letterforms

2 As with any craft that has evolved over 500 years, typography employs a number of technical terms. These mostly describe specific parts of letterforms. It is a good idea to familiarize yourself with this lexicon. Knowing a letterform's component parts makes it much easier to identify specific typefaces.

(In the entries that follow, **boldface** texts denote terms described elsewhere in the list.)

Stroke
Any line that defines the basic letterform.

Apex/Vertex
The point created by joining two diagonal **stems** (**apex** above, **vertex** below).

Arm
Short **strokes** off the **stem** of the letterform, either horizontal (E, F, T) or inclined upward (K, Y).

Baseline
The imaginary line defining the visual base of letterforms (see the diagram below).

Median
The imaginary line defining the **x-height** of letterforms (see the diagram below).

X-height
The height in any typeface of the lowercase 'x' (see the diagram below).

Ascender
The portion of the **stem** of a lowercase letterform that projects above the **median.**

Barb
The half-**serif** finish on some curved **strokes.**

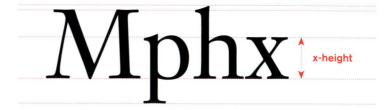

ascender height
cap height
median
baseline
descender height

x-height

Beak
The half-**serif** finish on some horizontal **arms.**

Cross Bar
The horizontal **stroke** in a letterform that joins two **stems** together.

Ear
The **stroke** extending out from the main **stem** or body of the letterform.

Bowl
The rounded form that describes a **counter.** The bowl may be either open or closed.

Cross Stroke
The horizontal **stroke** in a letterform that intersects the **stem.**

Em/en
Originally referring to the width of an uppercase M, an **em** is now the distance equal to the size of the typeface (an **em** in 48 pt. type is 48 points, for example). An **en** is half the size of an **em.** Most often used to describe em/en spaces and em/en dashes.

Bracket
The transition between the **serif** and the **stem.**

Crotch
The interior space where two **strokes** meet.

Finial
The rounded non-**serif terminal** to a **stroke.**

Counter
The negative space within a letterform, either fully or partially enclosed.

Descender
That portion of the **stem** of a lower-case letterform that projects below the **baseline.**

Leg
Short **strokes** off the **stem** of the letterform, either at the bottom of the stroke (L) or inclined downward (K, R).

fi fi fl fl hn

Ligature
The character formed by the combination of two or more letterforms.

Shoulder
The curved **stroke** that is not part of a **bowl.**

Stress
The orientation of the letterform, indicated by the thin **stroke** in round forms.

 g

Link
The **stroke** that connects the **bowl** and the **loop** of a lowercase G.

S

Spine
The curved **stem** of the S.

Swash
The flourish that extends the **stroke** of a letterform.

g

Loop
In some typefaces, the **bowl** created in the **descender** of the lowercase G.

Spur
The extension that articulates the junction of a curved and rectilinear **stroke.**

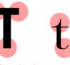

Tail
The curved or diagonal **stroke** at the finish of certain letterforms.

Serif
The right-angled or oblique foot at the end of the **stroke.**

Stem
The significant vertical or oblique **stroke.**

T t

Terminal
The self-contained finish of a **stroke** without a **serif.** This is something of a catch-all term. Terminals may be flat ('T', above), flared, acute, ('t', above), grave, concave, convex, or rounded as a ball or a teardrop (see **finial**).

The font

The full font of a typeface contains much more than 26 letters, 10 numerals, and a few punctuation marks. To work successfully with type, you should make sure that you are working with a full font and you should know how to use it.

Uppercase

Capital letters, including certain accented vowels, the c cedilla (ç) and n tilde (ñ), and the a/e and o/e ligatures (æ, œ).

AÅÂÄÀÁÃÆBCÇDEÉ
ÈÊËFGHIÌÍÎÏJKLMN
OÓÒÔÖØŒPQRS
TUÚÙÛÜVWXYZ

Lowercase

Lowercase letters include the same characters as uppercase plus f/i, f/l, f/f, f/f/i, and f/f/l ligatures, and the 'esset' (German double s).

a á à â ä å ã æ b c ç d e é è ê ë
f fi fl ff ffi ffl g h i ï î ì í j k l m n ñ
o ó ò ô ö ø œ p q r s ß
t u ü û ù ú v w x y z

Small capitals

Uppercase letterforms, drawn to the x-height of the typeface. Small caps are primarily found in serif fonts. Most type software includes a style command that generates a small cap based upon uppercase forms. Do not confuse real small caps with those generated artificially.

AÁÀÂÄÅÃÆBCÇDEÉÈÊË
FGHIÍÌÎÏJKLMNÑ
OØÓÒÔÖŒPQRSŠ
TUÚÙÛÜVWXYÝZŽ

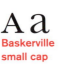

**Baskerville
small cap
artificially
generated**

**Baskerville
small cap
from the
font**

**Typeface shown:
Monotype Baskerville**

6

Uppercase numerals

Also called lining figures, these numerals are the same height as uppercase letters and are all set to the same kerning width. They are most successfully used with tabular material or in any situation that calls for uppercase letters.

1 2 3 4 5 6 7 8 9 0

Lowercase numerals

Also called oldstyle figures or text figures, these numerals are set to x-height with ascenders and descenders. They are best used wherever you would use upper- and lowercase letterforms. Lowercase numerals are far less common in sans serif than in serif typefaces.

1 2 3 4 5 6 7 8 9 0

Italic

Most fonts today are produced with a matching italic. Small caps, however, are almost always only roman. As with small caps, artificially generated italics are not the same as real italics.

Note the difference below between a 'true' italic and what is called an 'oblique.' The forms in a true italic refer back to 15th-century Italian cursive handwriting. Obliques are typically based on the roman form of the typeface. Contemporary typefaces often blur the distinction between italic and oblique, but you should be aware of the differences.

A Å Â Ä À Á Ã Æ B C Ç D
E Ë Ê È É F G H I Ï Î Ì Í J K L M
N Ñ O Ø Ö Ô Ò Ó Œ P Q R S T
U Ü Û Ù Ú V W X Y Z
1 2 3 4 5 6 7 8 9 0
a å â ä à á ã æ b c ç d e ë ê è é f fi fl ff
ffi ffl g h i ï î ì í j k l m n ñ o ø ö ô ò ó œ
p q r s ß t u ü û ù ú v w x y z
1 2 3 4 5 6 7 8 9 0

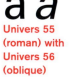

Baskerville roman with italic

Univers 55 (roman) with Univers 56 (oblique)

Punctuation, miscellaneous characters

Although all fonts contain standard punctuation marks, miscellaneous characters can change from typeface to typeface. It's important to be acquainted with all the characters available in a typeface before you choose the appropriate type for a particular job.

! * - – — _ () { } [] " " ' ' . : , ; …
/ ? ¿ † ‡ § ‹ › « » ¶ & # $ $ ¢ £ ¥
™ © ® @ ᵃ ᵒ ᵐ < > + ± =
÷ • ° Ð ð Þ þ ƒ · ° ¬ µ / ¯ ˘ ´ ″ 1
% ‰ ⅛ ¼ ⅓ ⅜ ½ ⅝ ⅔ ¾ ⅞

Dingbats

Various symbols and ornaments that are intended for use with type are called dingbats. The majority of dingbats are marketed as their own fonts and not in conjunction with any particular typeface.

Typefaces shown:
Monotype Baskerville (pages 6–7) and Universal News and
Commercial Pi (page 7, bottom)

Once you can recognize the parts of the letterform, you can apply what you know to identify different typefaces. Beyond the characteristic gestures of a typeface, however, there are also style applications that you should recognize. Keep in mind that some, all, or combinations of these styles may be found within one type family.

Roman

Roman
The basic letterform style, so called because the uppercase forms are derived from inscriptions on Roman monuments. When used to describe a type style, the term 'roman' is always lowercase. In some typefaces, a slightly lighter stroke than roman is called 'book.'

Italic

Italic
Named for 15th-century Italian handwriting on which the forms were based. (See page 6 for a description of 'oblique.')

Boldface

Boldface
Characterized by a thicker stroke than the roman form. Depending upon the relative stroke widths within the typeface, it can also be called 'semibold,' 'medium,' 'black,' 'extra bold,' or 'super.' In some typefaces (notably Bodoni), the boldest rendition of the typeface is referred to as 'poster.'

Light

Light
A lighter stroke than the roman form. Even lighter strokes are often called 'thin.'

Condensed

Condensed
As the name suggests, a condensed version of the roman form. Extremely condensed styles are often called 'compressed.'

Extended

Extended
Exactly what you would think. An extended variation on the roman forms.

The confusion of styles within families of typefaces may seem daunting to the novice; it certainly remains a small nuisance even to the experienced designer. The only way to deal with the profusion of names — like learning irregular verbs in French — is memorization. See page 44 for Adrian Frutiger's attempt to resolve the naming problem.

Adobe Caslon SemiBold

Akzidenz Grotesk Regular

Akzidenz Grotesk Medium

Bodoni Old Face Medium

Futura Book

Helvetica Compressed

Gill Sans Heavy

Gill Sans Extra Bold

Gill Sans Ultra Bold

Grotesque Black

Meta Normal

Univers Thin Ultra Condensed (Univers 39)

Measuring type

Along with its own lexicon, typo-
graphy also has its own units of
measurement. Originally, type size
was determined by the height of
actual pieces of lead type. Obviously,
we no longer commonly use lead
type in setting type; however, the
concept of letterforms cast on small
pieces of lead remains the most
useful way of thinking of type size.
Although type size originally referred
to the body of the type (the metal
slug on which the letterform was
cast), today we typically measure it
from the top of the ascender to the
bottom of the descender.

Similarly, the space between lines
of type is called 'leading' because it
was originally strips of lead placed
between lines of metal type.

We calculate the size of type with
units called 'points.' A point as we
use it now is 1/72 of an inch or
.35mm. The 'pica,' also used exten-
sively in printing, is made up of
twelve points. There are six picas
to an inch.

When writing out a dimension in
picas and points, the standard
abbreviation is **p.**

6 picas
is written
6p or **6p0**

6 picas, 7 points
is written
6p7

7 points
is written
7 pts., 0p7, or **p7**

When specifying type size and
leading, use a slash between the
two numbers.

10 pt. Univers with
2 pt. leading
is written
10/12 Univers

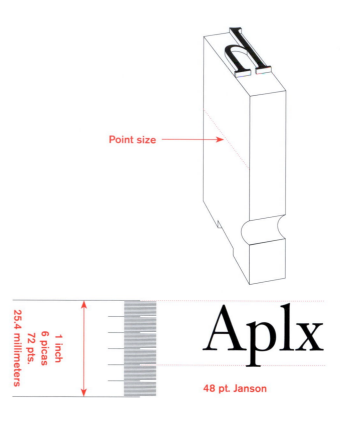

Point size

25.4 millimeters
72 pts.
6 picas
1 inch

Aplx

48 pt. Janson

48 pt. type →

3 pt. leading →

48 pt. Janson with
3 pt. leading—
48/51 Janson

Set width

All letterforms have set widths: the width of the form itself plus the space required on either side to prevent one letter from bumping into another. Set widths are described in **units**, an entirely arbitrary measure that changes from one system to another. In the example opposite, the uppercase M (typically the widest letterform) is 20 units wide and the lowercase a is 9 units wide; the measurements might just as easily be 40 units and 18 units.

When type was cast by hand, it was possible for every letter, upper- and lowercase, to have a unique set width. As mechanized typesetting evolved, type designers were forced to restrict the number of set widths in any typeface to accommodate the limitations of the system (metal or photo) that produced the type. An 'a' and an 'e', for instance, might be assigned the same set width in some systems because the technology wasn't able to express finer distinctions. Current digital technology has gone a long way toward restoring the variety of hand-cast type. Many softwares work at a scale of 200 units to the set width of an M.

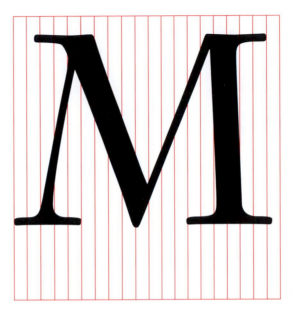

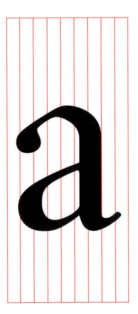

1,234,567.00
450,118.19

1,234,567.00
450,118.19

Traditionally, uppercase numerals had identical set widths so that they would align vertically (above). Lowercase numerals, designed with varying set widths, did not. For many typefaces, Open Type has removed these distinctions.

Comparing typefaces

Image, history, and meaning meet in every aspect of typography, even the simplest of letterforms.

The ten typefaces displayed opposite represent 500 years of type design. The men and women who rendered them all sought to achieve two goals: easy readability and an appropriate expression of contemporary esthetics. These type-faces (and there are others) have surpassed the latter goal. They have remained in use for decades—in some cases, centuries—after they were first designed, still considered successful expressions of how we think, how we read and write, and how we print.

As a beginning typographer, you should study these ten faces carefully. For any of the exercises in this book—and for almost any early projects—these are all you need to develop your skills. Once you under-stand how to use these faces appro-priately and effectively, you'll be well prepared to understand and appreciate other typefaces as you encounter them.

Most of the typefaces shown here are fully displayed in the chapter on Development, pages 15–50.

Bembo
Radiography

Garamond
Radiography

Janson
Radiography

Caslon
Radiography

Baskerville
Radiography

Bodoni
Radiography

Serifa
Radiography

Futura
Radiography

Gill Sans
Radiography

Univers
Radiography

As you study other designers' work, you'll notice that many people who work seriously with type employ a limited palette of typefaces. Some, in fact, go through their entire careers using only one or two.

For our purposes, what is worth noting is not the similarities among these typefaces, but their differences — the accumulation of choices that renders each unique. Compare, for example, different forms of the lowercase 'a':

a a a a a a **a** ɑ a **a**

Beyond the gross differences in x-height, these forms display a wealth of variety in line weight, relative stroke width and other internal relationships, and in feeling. For any good typographer, each of these feelings connotes specific applications determined by use and expression. In other words, the typefaces suggest applications for which they are appropriate.

As Eric Gill said, letters are things, they are not pictures of things. While the generic letter 'A' may indicate a variety of sounds, the lowercase 'a' as rendered in Bembo is a specific character, different in form and sensibility from the lowercase 'a' rendered in Bauer Bodoni, Serifa 55, Helvetica, or Futura. All five convey the idea of 'A'; each presents a unique esthetic.

R R R R R R R R R R

The uppercase R (above) displays the range of attitude typefaces are capable of conveying. If you examine these forms long enough, you are bound to decide that some of the tails seem more whimsical, some more stately; some will appear more mechanical, some more calligraphic, some harmonious, some awkward. As much as anything, what this examination tells you is how you feel about type and specific typefaces. It tells you what you bring to the discussion of appropriateness in type choices.

Display typefaces

For the bulk of this book, the typefaces that we're investigating have been designed as **text type**—that is, type intended primarily for presentation at between 6 pt. and 12 pt. Type presented at 18 pt. and above, for headlines or call-outs, is referred to as **display type**. Typefaces designed exclusively for use in display easily account for the majority of fonts produced today.

It's easy to understand the popularity of display typefaces. As these examples (right) demonstrate, they carry with them an endless variety of character, personality, history, and style. Experienced typographers use them to add spice to an already balanced composition. Neophytes, sadly, too often rely on them to give voice to what is otherwise irredeemably shapeless and bland.

The very characteristics that make display typefaces attractive at large scale—extreme compression or extension of form, unusually large or small counterforms, complex details, strong pictorial references—make them unsuitable at text sizes (bottom right). Keep in mind that display typefaces are meant to be 'seen' more than 'read.'

Top to bottom:
Bifur
Broadway
Brush Script
Cooper Black
Futura Black
Goudy Text
Haettenschweiler
Hobo
Kaufmann
Mistral
Onyx
Peignot
Playbill
Runic

HAMBURGS

Hamburgs

Hamburgs

Hamburgs

Hamburgs

Hamburgs

Hamburgs

Hamburgs

Hamburgs

Hamburgs

Hamburgs

HAMBURGS

Hamburgs

Hamburgs

HAMBURGS
Hamburgs
Hamburgs
Hamburgs
Hamburgs
Hamburgs
Hamburgs
Hamburgs
Hamburgs
Hamburgs
Hamburgs
HAMBURGS
Hamburgs
Hamburgs

Development

A timeline

An alphabet is a series of culturally agreed upon marks—letters—that represent specific sounds. Before the Phœnicians (a seafaring mercantile group living in current-day Lebanon) developed an alphabet around 1500 B.C.E., written language had depicted entire words at a time. The picture of a bull meant a bull, independent of its pronunciation. Being able to write—to document speech—meant knowing the thousands of marks that represented all the things in the known world. By developing a system dependent upon sound ('ah') and not object (bull) or concept (love), the Phœnicians were able to capture language with 20 marks instead of hundreds or thousands. Writing—cuneiforms, hieroglyphs—had been practiced for several millennia before the Phœnicians developed their set of marks, but, for our purpose—the study of letterforms—in the beginning was the alphabet.

The word 'alphabet' is a compression of the first two letters of the Greek alphabet: alpha and beta. By 800 B.C.E., the Greeks had adapted the 20 letters from the Phœnician alphabet, changing the shape and sound of some letters. (The Phœnician alphabet is also the forerunner of modern-day Hebrew and Arabic, but our focus is on its European evolution.)

On the Italian peninsula, first the Etruscans and then the Romans appropriated the Greek alphabet for their own use. The Romans changed the forms of several Greek letters and, on their own, added the letters G, Y, and Z. As Rome's influence spread throughout Europe, Asia Minor, and northern Africa, so too did the Roman alphabet—and Roman letterforms.

Early letterform development: Phœnician to Roman

4th century B.C.E.
Phœnician votive stele
Carthage, Tunisia
The stele bears a four-line inscription to Tanit and Baal Hammon.

Initially, writing meant scratching into wet clay with a sharpened stick or carving into stone with a chisel. The forms of uppercase letterforms (for nearly 2,000 years the only letterforms) can be seen to have evolved out of these tools and materials. At their core, uppercase forms are a simple combination of straight lines and pieces of circles, as the materials and tools of early writing required. Each form stands on its own. This epigraphic (inscriptional) or lapidary (engraved in stone) quality differentiates upper- from lowercase forms.

The evolution of the letterform 'A':

Phœnician
1000 B.C.E.

Greek
900 B.C.E.

Roman
100 B.C.E.

Date unknown
Greek fragment
Stone engraving

Late 1st century B.C.E.
Augustan inscription in the Roman Forum
Rome

The Greeks changed the direction of writing. Phœnicians, like other Semitic peoples, wrote from right to left. The Greeks developed a style of writing called *boustrophedon,* ('how the ox ploughs'), which meant that lines of text read alternately from right to left and left to right.

As they changed the direction of reading, the Greeks also changed the orientation of the letterforms, like this:

ASTHEYCHANGEDTHEDIRECTIO
NOFREADINGTHEYALSOCHANG
EDTHEORIENTATIONOFTHELETTE

(Note: the Greeks, like the Phœnicians, did not use letterspaces or punctuation.) Subsequently, the Greeks moved to a strictly left-to-right direction for writing.

Etruscan (and then Roman) carvers working in marble painted letter-forms before inscribing them. Certain qualities of their strokes — a change in weight from vertical to horizontal, a broadening of stroke at start and finish — carried over into the carved forms.

Not all early writing was scratched in clay or carved in stone. Business contracts, correspondence, even love songs required a medium that was less formal and less cumbersome than stone allowed for. From 2400 B.C.E., scribes throughout the eastern Mediterranean employed a wedge-shaped brush and papyrus for writing. Papyrus was made from a bamboo-like plant that grew in the Nile Valley. The plant's inner fibers were pulped, then flattened and dried under heavy weights.

Despite its relative ease of use, papyrus had several drawbacks. It could not be written on on both sides, and it was too brittle to be folded. Its main drawback, however, was its single source — Egypt. Availability was limited not only to the size of the papyrus crop from year to year, but also to the Pharaoh's willingness to trade.

Ephemeral communication — notes, calculations, simple transactions — were often scratched out on wax panels framed in wood. When the communication had served its purpose, the wax could be smoothed out for subsequent use. This practice continued into the Middle Ages.

By 400 C.E. the codex (individual parchment sheets stitched together) had replaced the papyrus scroll as the preferred format for books.

18

4th or 5th century
Square capitals

Late 3rd to mid-4th century
Rustic capitals

4th century
Roman cursive

Square capitals were the written version of the lapidary capitals that can be found on Roman monuments. Like their epigraphic models, these letterforms have serifs added to the finish of the main strokes. The variety of stroke width was achieved by the use of a reed pen held at an angle of approximately 60° off the perpendicular.

A compressed version of square capitals, rustic capitals allowed for twice as many words on a sheet of parchment and took far less time to write. The pen or brush was held at an angle of 30° off the perpendicular. Although rustic capitals were faster and easier to write than their square counterparts, they were slightly harder to read because of the compressed nature of the forms.

Both square and rustic capitals were typically reserved for documents of some intended permanence. Everyday transactions, however, were typically written with a cursive hand, in which forms were simplified for speed. We can see here the beginning of what we now refer to as lowercase letterforms.

By 150 B.C.E., parchment had replaced papyrus as the writing surface of choice. Most famously manufactured in Pergamum (from which the word is derived), parchment was made from the treated skins of sheeps and goats (vellum— a particularly fine version of parchment—was made from the skins of newborn calves). Unlike papyrus, parchment could be written on on both sides and folded without cracking. Its harder surface also stood up to a hard-nibbed reed pen, which in turn allowed for smaller writing.

Paper was invented in China in 105 C.E. by Ts'ai Lun, a court eunuch, who made a pulp of various available fibers, which he then spread over a piece of cloth and allowed to dry. His contemporaries (and those who followed) used a brush to 'paint' characters on the resulting, rather rough, sheet. Over time, the drying cloth was replaced by a dense screen of thin strips of bamboo. The technique did not reach Europe for 900 years.

Papermaking spread to Japan in the 7th century, to Samarkand (now Uzbekhistan) in the 8th, and then, via the Moors, to Spain, where papermaking was practiced around 1000 C.E. A paper mill (or factory), using water-powered machines to pulp linen fiber and fine screens to produce smooth, flexible sheets, was operating in Fabriano, Italy by 1300. The process spread quickly through Europe. By 1600, more than 16,000 paper mills were in operation.

4th–5th century	c. 500	925	19
Uncials	**Half-uncials**	**Caroline minuscule**	

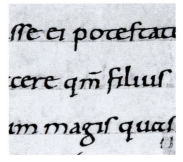

Uncials incorporated some aspects of the Roman cursive hand, especially in the shape of the A, D, E, H, M, U, and Q. 'Uncia' is Latin for a twelfth of anything; as a result, some scholars think that uncials refer to letters that are one inch (one twelfth of a foot) high. It might, however, be more accurate to think of uncials simply as small letters. The point for the scribe, after all, was to save expensive parchment, and the broad forms of uncials are more readable at small sizes than rustic capitals.

A further formalization of the cursive hand, half-uncials mark the formal beginning of lowercase letterforms, replete with ascenders and descenders, 2,000 years after the original Phœnician alphabet. Due to the political and social upheaval on the European continent at the time, the finest examples of half-uncials come from manuscripts produced in Ireland and England.

Charlemagne, the first unifier of Europe since the Romans, issued an edict in 789 to standardize all ecclesiastical texts. He entrusted this task to Alcuin of York, Abbot of St. Martin of Tours from 796 to 804, under whose supervision a large group of monks rewrote virtually all the ecclesiastical and, subsequently, secular texts then in existence. Their 'print'—including both majuscules (upper case) and minuscules (lower case)—set the standard for calligraphy for a century, including capitalization and punctuation.

Roman numerals, used in the 1st millennium throughout Europe, matched seven Roman letters.

I V X L C D M
1 5 10 50 100 500 1000

With the development of lowercase letterforms, the numerals came to be written in lowercase as well.

i v x l c d m
1 5 10 50 100 500 1000

What we call Arabic numerals originated in India between 1,500 and 2,000 years ago. Our first evidence of their use in Arabic is from an Indian astronomical table, translated in Baghdad around 800 C.E. Arab scribes referred to them as Hindu figures, and they looked like this (remember, Arabic reads from right to left):

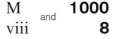

As with papermaking, use of Arabic numerals spread from Moorish Spain to Europe around 1000 C.E. The numerals were quickly adopted by merchants and scientists, not only because of their legibility but, significantly, because they brought with them the Hindu concept of zero, which allowed for decimals and place value. Compare:

M 1000
 and
viii 8

Blackletter to Gutenberg's type

West façade
Amiens Cathedral, France
1220–1269

c. 900
Blackletter (Textura)

1455
42-line bible
Johann Gutenberg
Mainz
(below [detail] and opposite)

With the dissolution of Charlemagne's empire came regional variations upon Alcuin's script. In northern Europe, a condensed, strongly vertical letterform known as blackletter or textura (for the woven effect it produced on a page of text) gained popularity. In the south, a rounder, more open hand, called 'rotunda,' prevailed. In northern France, England, and the Low Countries, a hybrid of the two, called *batarde,* was predominant. In the north, the blackletter style remained the standard for almost 500 years.

In the south, particularly in Italy, scholars were rediscovering, analyzing, and popularizing Roman and Greek texts. Their sources were written in Alcuin's Caroline minuscule, which they mistakenly believed to be that of the ancient authors. Scribes adapted the rotunda style to the Caroline as they copied the manuscripts, calling it 'scrittura humanistica' — humanist script.

We know that Johann Gutenberg did not singlehandedly invent type-casting or printing, but what little we know of him — mostly from court documents describing a lifetime of unpaid debts — is a good deal more than what we know of his few contemporaries. We do know that his achievement has endured, and so he is central to the development of type.

Born in Mainz in 1397, Gutenberg moved in 1428 to Strasbourg, where he worked as a goldsmith. Printing at that time — and it was a new idea in Europe — consisted of burnishing a piece of paper against a carved, inked block of wood. By 1436 he had begun experimenting with a new technology — an adjustable mold system for 'casting' movable, re-usable type from molten lead. In 1438 he designed his first press, based on the grape press used in winemaking. Along the way he developed an ink that had enough tack to stick to his metal type. By 1448 he had returned to Mainz and borrowed 150 gulden from a relative to set up shop.

By 1455, a subsequent mortgage from merchant Johann Fust had, with interest, reached 2,000 gulden. When Fust foreclosed, Gutenberg had to forfeit all his equipment — including his work in progress, the 42-line bible. Fust and his son-in-law Peter Schöffer finished production on the bible and sold it for a handsome profit. Fust and Shöffer continued printing and publishing with great success. Fust died in 1466. Gutenberg died penniless two years later. At Schöffer's death in 1502, his son Johann took over the business.

Gutenberg's skills included engineering, metalsmithing, and chemistry. He marshaled them all to build pages that accurately mimicked the work of the scribe's hand. For his letterforms, Gutenberg referred to what was known in his time and place — the blackletter of northern Europe. His type mold required a different brass matrix, or negative impression, for each letterform. Because he wanted his type to resemble handwriting as closely as possible, he eventually worked with 270 different matrices, including variants of individual letterforms and numerous ligatures.

verse sunt. Ibi constituit ei precepta atque iudicia: et ibi temptauit eum dicens. Si audieris vocem domini dei tui: et quod rectum est coram eo feceris: et obedieris mandatis eius: custodierisque omnia precepta illius: cunctum langorem quem posui in egipto non inducam super te. Ego enim sum dominus deus saluator. Veneruntque in helim filij israhel: ubi erant duodecim fontes aquarum et septuaginta palme: et castrametati sunt iuxta aquas. XVI. Profectique de helim venit omnis multitudo filiorum israel in desertum syn: quod est inter helim et sinai: quintadecima die mensis secundi postquam egressi sunt de terra egipti. Et murmurauit omnis congregatio filiorum israel contra moysen et aaron in solitudine. Dixeruntque filij israel ad eos. Utinam mortui essemus per manum domini in terra egipti: quando sedebamus super ollas carnium et comedebamus panem in saturitate. Cur induxistis nos in desertum istud: ut occideretis omnem multitudinem fame? Dixit autem dominus ad moysen. Ecce ego pluam vobis panes de celo. Egrediatur populus et colligat que sufficiunt per singulos dies: ut temptem eum utrum ambulet in lege mea an non. Die autem sexto parent quod inferant: et sit duplum quam colligere solebant per singulos dies. Dixeruntque moyses et aaron ad omnes filios israel. Vespere scietis quod dominus eduxerit vos de terra egipti: et mane videbitis gloriam domini. Audiui enim murmur vestrum contra dominum. Nos vero quid sumus: quia inmurmurastis contra nos? Et ait moyses. Dabit vobis dominus vespere carnes edere: et mane panes in saturitate: eo quod audierit murmurationes vestras quibus murmurati estis contra eum. Nos enim quid sumus? Nec contra nos est murmur vestrum:

sed contra dominum. Dixit quoque moyses ad aaron. Dic uniuerse congregationi filiorum israel. Accedite coram domino. Audiuit enim murmur vestrum. Cumque loqueretur aaron ad omnem cetum filiorum israel: respexerunt ad solitudinem. Et ecce gloria domini apparuit in nube. Locutus est autem dominus ad moysen dicens. Audiui murmurationes filiorum israel. Loquere ad eos. Vespere comedetis carnes: et mane saturabimini panibus: scietisque quod ego sum dominus deus vester. Factum est ergo vespere et ascendens coturnix cooperuit castra: mane quoque ros iacuit per circuitum castrorum. Cumque operuisset superficiem terre: apparuit in solitudine minutum: et quasi pilo tusum in similitudinem pruine super terram. Quod cum vidissent filij israhel: dixerunt ad inuicem. Manhu? Quod significat. Quid est hoc? Ignorabant enim quid esset. Quibus ait moyses. Iste est panis quem dominus dedit vobis ad vescendum. Hic est sermo quem precepit vobis dominus. Colligat unusquisque ex eo quantum sufficit ad vescendum: gomor per singula capita. Iuxta numerum animarum vestrarum que habitant in tabernaculo sic tolletis. Feceruntque ita filij israel: et collegerunt alius plus alius minus: et mensi sunt ad mensuram gomor: Nec qui plus collegerat habuit amplius: nec qui minus parauerat reperit minus: sed singuli iuxta id quod edere poterant congregauerunt. Dixitque moyses ad eos. Nullus relinquat ex eo in mane. Qui non audierunt eum: sed dimiserunt quidam ex eis usque mane: et scatere cepit uermibus atque computruit. Et iratus est contra eos moyses. Colligebant autem mane singuli: quantum sufficere poterat ad vescendum. Cumque incaluisset sol: liquefiebat. In die autem sexta collegerunt cibos

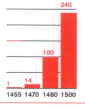

240

100

14

1

1455 1470 1480 1500

By 1500 there were 1,000 printing offices in 240 cities in Europe. 12,000,000 printed copies of 35,000 books were in distribution, more than all the books hand-copied in the previous one and a half millennia.

c. 1460
Lucius Lactantius
De Divinis Institutionibus
Venice

In 1462, the city of Mainz was ransacked by troops of the Archbishop of Nassau. Printers—many of whom had come from other countries to learn the new technology—spread back out across Europe in search of safer havens for the practice of their craft.

In 1465, two German printers—Conrad Sweynheym, who had clerked for Schöffer in Mainz, and Arnold Pannartz—established a press at the Benedictine monastery in Subiaco, some 31 miles (50 km) east of Rome. After printing just four books, they moved their press to the Palazzo de' Massimi in Rome, where they worked until 1473. Just as Gutenberg cast his type to mimic the prevailing writing style in the north, Sweynheym and Pannartz cast their type to match the Italian calligraphic hand—humanist script.

In 1469, German Johannes da Spira set up the first press in Venice. His type, too, reflected humanist script, but it displayed a regularity of tone that far exceeded the work of Sweynheym and Pannartz. Da Spira died in 1470, and his press was taken over by Nicholas Jenson, a Frenchman who had gone to Mainz in 1458 to learn type-casting and printing and who is believed to have cast da Spira's original type. Whether he did or not, in his own work until his death in 1480 Jenson effectively codified the esthetics of type for those who followed.

These three pages (above and opposite, with details below), produced within around ten years of each other, demonstrate the transition from humanist script to roman type in Italy. Nicholas Jenson's accomplishment—in terms of both craft and form—is all the more vivid when compared to the contemporary work of Sweynheym and Pannartz.

Some early printing offices, by date

1461 Bamberg	1470 Paris	1474 Valencia	
1462 Strasbourg	Toulouse	1475 Bruges	
1465 Subiaco	1473 Lyons	1476 London	
1466 Cologne	Utrecht	1477 Delft	
1468 Augsburg	Ulm		
1469 Venice			

1472
Cardinal Johannes Bessarion
Adversus Calumniatorem Platonis
Conrad Sweynheim and
Arnold Pannartz,
Subiaco Press, Rome

1471
Quintilian
Institutiones Oratoriae
Nicholas Jenson
Venice

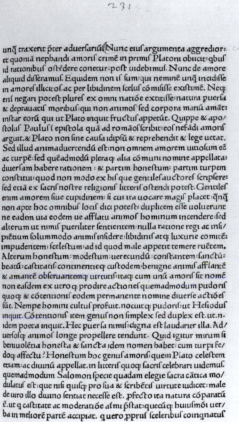

Venetian type from 1500

The spread of printing in the 16th century

1503	Turkey	1556	India
1508	Romania	1563	Palestine
1515	Greece	1584	Peru
1534	Mexico	1590	Japan
1550	Ireland		
1553	Russia		

24

1499
Colona
Hypnerotomachia Poliphili
type by Francesco Griffo

1515
Lucretius
De Rerum Natura
type by Francesco Griffo

tamente,quella alquáto temperai.Et reflexi gli rifonáti fofpiri, & cũ adu-
latrice fperácia(O cibo amorofo degli amanti, & fouente fiate cũ lachry-
mofo poto cõiunѐto)per altro morficante freno gyrai gli cõcitati péfieri
cũ tanto penficulato & fabricato piacere,mirando cũ extremo dileѐto in
quel corpo gratiffimo & geniale,in quelle rofee gene,in ѻlli mébri nitidi
&luculei folacianti.Per leѺle fingulare cofe,gli mei fremédi defii cõfor-
tantime benignaméte mitigai,dalle rabiofe ire da tropo ardore redempti,
& dal foco amorofo cufi ppinquo che difpofitaméte fe accendeuano.

LA NYMPHA PER ALTRI BELLI LOCHI,LO AMO-
ROSO POLIPHILO CONDVCE,OVE VIDE INNVME-
RE NYMPHE SOLENNIGIANTE ET CVM IL TRIVM-
PHO DI VERTVNO ET DI POMONA DINTORNO
VNA SACRA ARA ALACREMENTE FESTIGIANTI.
DA POSCIA PER VENERON AD VNO MIRAVEGLIO
SO TEMPLO. ILQVALE ELLO IN PARTE DESCRI-
VE,ET LARTE AEDIFICATORIA. ET COME NEL DI-
CTO TEMPLO,PER ADMONITO DELLA ANTISTITE,
LA NYMPHA CVM MOLTA CERIMONIA LA SVA
FACOLA EXTINSE, MANIFESTANTISE ESSERE LA
SVA POLIA A POLIPHILO. ET POSCIA CVM LA SA-
CRIFICABONDA ANTISTETE,NEL SANCTO SACEL
LO INTRATA,DINANTI LA DIVINA ARA INVOCO
LE TRE GRATIE.

ONTRASTARE GIA NON VALEVA IO
alle cælefte & uiolente armature,& dicio hauendo la ele-
gantiffima Nympha amorofaméte adepto,de me mifel
lo amante irreuocabile dominio,Seco piu oltra(imitan
te io gli moderati ueftigii)abaѐtrice pare allei uerfo ad
uno fpatiofo littore me cõduceua,Ilquale era cõtermine
della florigera & collinea cõualle,Oue terminauano a quefto littore le or
nate montagniole,& uitiferi colli,cum præclufi aditi,quefta aurea patria,
piena di incredibile obleѐtamento circumclauftrando.Leφnale erano di
filuofi nemori di cõfpicua denfitate,quanto fi fufferon ftati gli arbufculi
ordinatamétete locati amœne,Quale il Taxo cyrneo,& lo Arcado,Il pina
ftro infruѐtuofo & refinaceo,alti Pini,driti Abieti,negligenti al pandare,
&contumacial pondo,Arfibile Picee,il fungofo Larice,Tedeacree,&gli
colli amanti,Celebrati & cultiuati da feftigiante oreade,Quiui ambidui

m iii

LVCR·

O bruerent terras:nifi inædificatta fuperne
M ulta forent multis exempto nubila fole·
N ec tanto poffent terras opprimere imbri:
F lumina abundare ut facerent:cam pos'q; naturæ:
S i non extruѐtis foret alte nubibus æther·
H is igitur uentis,atq; ignibus omnia plena
S unt:ideo paffim fremitus, cr fulgura fiunt·
Q uippe etenim fupra docui permulta uaporis
E emina habere cauas nubes: cr multa neceffe eft
C onapere ex folis radijs,ardoreq; eorum.
H oc,ubi uentus eas idem qui cogit in unum
F orte locum quemuis,expreffit multa uaporis
S emina:feq; fimul cum eo commifcuit igni:
I nfinuatus ibi uortex uerfatur in alto:
E t cælidis acuit fulmen fornacibus intus·
N am duplici ratione accenditur:ipfe fua cum
M obilitate calefcit:cr e contagibus ignis.
I nde ubi percaluit uis uenti:uel grauis ignis
I mpetus inceffit:maturum tum quafi fulmen
P erfcindit fubito nubem:ferturq; corufcis
O mnia luminibus luftrans loca percitus ardor·
Q uem grauis infequitur fonitus:difplofa repente
O pprimere ut cæli uideantur templa fuperne·
I nde tremor terras grauiter pertentat:cr altum
M urmura percurrunt cœlum:nam tota fere tum
T empeftas concuffa tremit:fremitusq; mouentur·
Q uo de concuffu fequitur grauis imber,cr uber:
O mnis uti uideatur in imbrem uertier æther:
A tq; ita præcipitans ad diluuiem reuocare:
T antus diffidio nubis,uentiq; procella,

Venetian publisher Aldus Manutius (1450–1515) was the first of the great European printer-scholars, his books valued for their accuracy and scholarship. Their beauty owed much to Francesco Griffo da Bologna, a type-caster working for Manutius. By making the uppercase letters shorter than the ascenders in the lower case, Griffo was able to create a more even texture on the page than Jenson had achieved.

Manutius's achievements include the first pocket-sized books, whose low cost and easy portability helped foster the spread of knowledge among Renaissance scholars. In 1501, editions of Virgil and Juvenal featured Griffo's first *italic* type-face, based on the chancery script favored by Italian papal scribes. The immediate value of the italic was its narrower letterforms, which allowed for more words on a page, thereby reducing paper costs. Griffo's italics were produced only in lower case.

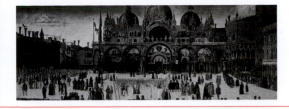

Gentile Bellini
Procession of the Reliquary of the Cross in Piazza San Marco (detail)
1496
Galleria dell'Accademia, Venice

ABCDEFGHIJKLMN
OPQRSTUVWXYZ
1234567890

ABCDEFGHIJKLMN
OPQRSTUVWXYZ

abcdefghijklmn
opqrstuvwxyz
1234567890

*ABCDEFGHIJKLM
NOPQRSTUVWXYZ*
1234567890
abcdefghijklmn
opqrstuvwxyz
1234567890

Bembo (shown here) is based on type cut by Francesco Griffo in 1495 for an edition of *De Aetna* by Pietro Bembo. This revival of Griffo's typeface was first produced by the Monotype Corporation in 1929, under the direction of Stanley Morison. The italic is based not on Griffo's type, but on the calligraphy of early 16th-century scribes Ludovico degli Arrighi and Giovantonio Tagliente.

The Golden Age of French printing

1531
Terentiani Mauri Niliacae Syenes Praesidis
Printed by Simon de Colines
Paris
Type-cast by Claude Garamond

The earliest printers in France brought with them the blackletter they had learned to cast in Mainz. By 1525, however, a group of French printers—among them Henri and Robert Estiennes, Simon de Colines, Geofroy Tory, and Jean de Tournes—had made the Venetian model their own, mirroring contemporary French interest in Italian Renaissance culture.

Of particular importance to the history of type is Parisian Claude Garamond (1480–1561), the first independent typefounder. Beyond establishing type-casting as a profession distinct from printing, Garamond created letterforms more expressive of the steel in which he worked than of the strokes made by a calligrapher's pen. A comparison of a Venetian 'a' (Monotype Dante, below left) with Garamond's (Adobe Garamond, below right) clearly demonstrates the difference:

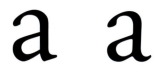

Around 1540, Garamond and his collaborator Robert Granjon developed the first italic forms that were intended for use with roman forms, including an italic upper case. Granjon's work in italic continued until 1577, when he designed a typeface called Civilité that reverted back to the elaborate French *batarde* handwriting of the day. Although it did not supplant italic, it did spur a line of script typefaces that continues to the present day.

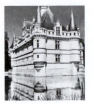

ABCDEFGHIJKLMN
OPQRSTUVWXYZ
1234567890

ABCDEFGHIJKLMN
OPQRSTUVWXYZ
abcdefghijklmn
opqrstuvwxyz
1234567890

ABCDEFGHIJKLMN
OPQRSTUVWXYZ
1234567890
abcdefghijklmn
opqrstuvwxyz
1234567890

For years, most typefaces called Garamond were derived from cuttings produced in 1615 by Jean Jannon, based on Garamond's work. Robert Slimbach produced Adobe Garamond (shown here) in 1989, working directly from specimens of Garamond's roman and Granjon's italic.

The spread of printing in the 17th century

1602	Philippines	1642	Finland
1610	Lebanon	1643	Norway
	Bolivia	1644	China
1639	America		
1640	Iran		

1572
Polyglot Bible (Preface)
Printed by Christophe Plantin
Antwerp

By the end of the 16th century, Dutch publishing houses, particularly the Plantin-Moretus and Elzevir family enterprises, were among the most successful in Europe. At first, these publishers and printers bought much of their type from French foundries. By the 17th century, however, they were buying from typefounders closer at hand.

Dutch type was widely recognized not so much for its intrinsic beauty as for its clarity and sturdiness. Compare, for example, (French) Adobe Garamond (left) and (Dutch) Linotype Janson (right):

a a

Virtually all English type of the period was purchased in Holland. The Oxford University Press, founded in 1667, purchased its first type from Christoffel van Dijck of Amsterdam. In 1672, Bishop John Fell brought over punches and matrices cut by Dirk and Bartholomew Voskens for the press.

REGNI NEAPOLITANI
PRIVILEGIVM.

PHILIPPVS DEI GRATIA REX
CASTELLÆ, ARAGONVM, VTRIVSQVE
SICILIÆ, HIERVSALEM, VNGARIÆ, DALMATIÆ, ET CROATIÆ, &c.

NTONIVS Perrenotus, S.R.C.tit. Sancti Petri ad Vincula Presbyter, Cardinalis de Granuela, præfatæ Regiæ & Catholicæ Maiestatis à consiliis status, & in hoc Regno locum tenens, & Capitaneus generalis, &c. Magco. viro Christophoro Plantino, ciui Antuerpiensi, & præfatæ Catholicæ Maiestatis Prototypographo fideli Regio, dilecto, gratiam Regiam & bonam voluntatem. Cùm ex præclarorum virorum literis certiores facti simus, opus Bibliorum quinque linguarum, cum tribus Apparatuum tomis, celeberrimum, reique publicæ Christianæ vtilissimū, eiusdem serenissimæ Maiestatis iussu, ope atque auspiciis, ad publicam totius Christiani orbis commoditatem & ornamentum, typis longè elegantissimis, & præstantissimi viri Benedicti Ariæ Montani præcipua cura & studio . quàm emendatissimè à te excusum esse, eiusdemq; exemplar sanctissimo Domino nostro P.P.Gregorio XIII. oblatum, ita placuisse, vt præfatæ Maiestatis sanctos conatus, & Regi Catholico in primis conuenientes, summopere laudarit, & amplissima tibi priuilegia ad hoc opus tuendum Motu proprio concesserit, Nos quoque cum naturali genio impellimur ad fouendum præclara quæque ingenia, quæ insigni quopiam conatu ad publica commoda promouenda atque augenda aspirant; primùm quidem longè præclarissimum hoc suæ Maiestatis studium, vt verè Heroicum & Ptolomei, Eumenis, aliorúmque olim conatibus in Bibliothecis instruendis eò præstantius, quòd non vanæ stimulo gloriæ, vt illi, sed rectæ Religionis conseruandæ & propagandæ zelo susceptum, meritò suspicientes; deinde eximiam operam doctissimi B. Ariæ Montani, ac immortali laude dignam admirantes, rebusque tuis, quemadmodú tuo nomine expetitur, prospicere cupientes, ne meritis frauderis fructibus tantæ operæ, & impensæ, quæ summa solicitudine & industria in opus ad finem feliciter perducendum à te etiam insumpta esse accepimus, cumque certò constet, opus hoc nunquam hactenus hoc in Regno excusum esse, dignúmque ipso S. sedis Apostolicæ suffragio sit iudicatum vt diuulgetur ac priuilegiis ornetur. Tuis igitur iustissimis votis, vt deliberato consilio, ita alacri & exporrecta fronte lubenter annuentes, tenore præsentium ex gratia speciali, præfatæ Maiestatis nomine, cum deliberatione & assistentia Regij collateralis consilij, statuimus & decreuimus, ne quis intra viginti annos proximos, a die dat. præsentium deinceps numerandos, in hoc Regno dictum Bibliorum opus, cum Apparatuum tomis coniunctis, vel Apparatus ipsos, aut eorū partem aliquam seorsum, citra ipsius Christophori, aut causam & ius ab ipso habentis, licentiam imprimere, aut ab aliis impressa vendere, aut in suis officinis vel aliàs tenere possit. Volentes & decernentes expressè,
quòd

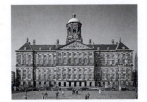

Jacob van Campen
Royal Palace
(formerly Amsterdam Town Hall)
Dam Square
1647–1655

ABCDEFGHIJKLM
NOPQRSTUVWXYZ
1234567890

ABCDEFGHIJKLMN
OPQRSTUVWXYZ

abcdefghijklmn
opqrstuvwxyz
1234567890

ABCDEFGHIJKLM
NOPQRSTUVWXYZ
1234567890

abcdefghijklmn
opqrstuvwxyz
1234567890

Although Janson was named for Dutch punch-cutter Anton Janson, we now know that it was cut by Hungarian Nicholas Kis in 1690. This version from Linotype is based on Stempel Foundry castings made in 1919 from Kis's original matrices.

In the 18th century, a formal distinction in English spelling was accepted between 'i' and 'j', 'u' and 'v'. At the same time, 'w', as opposed to 'vv', became a distinct character.

1734
William Caslon
Type specimen sheet
London

A SPECIMEN

By W. CASLON, Letter-Founder, in Ironmonger-Row, Old-Street, LONDON.

ABCD
ABCDE
ABCDEFG
ABCDEFGHI
ABCDEFGHIJK
ABCDEFGHIJKL
ABCDEFGHIKLMN

French Cannon.

Quousque tan-
dem abutere,
Catilina, pati-
Quousque tandem
abutere, Catilina,

DOUBLE PICA ROMAN.
Quousque tandem abutere, Catilina, patientia nostra? quamdiu nos etiam furor iste tuus eludet? quem ad finem sese effrenata jac-
ABCDEFGHJIKLMNOP

GREAT PRIMER ROMAN.
Quousque tandem abutere, Catilina, patientia nostra? quamdiu nos etiam furor iste tuus eludet? quem ad finem sese effrenata jactabit audacia? nihilne te nocturnum præsidium palatii, nihil urbis vigiliæ, nihil timor populi, nihil con-
ABCDEFGHIJKLMNOPQRS

ENGLISH ROMAN.
Quousque tandem abutere, Catilina, patientia nostra? quamdiu nos etiam furor iste tuus eludet? quem ad finem sese effrenata jactabit audacia? nihilne te nocturnum præsidium palatii, nihil urbis vigiliæ, nihil timor populi, nihil confus bonorum omnium, nihil hic munitissimus
ABCDEFGHIJKLMNOPQRSTVUW

PICA ROMAN.
Melium, novis rebus studentem, manu sua occldit. Fuit, fuit ista quondam in hac repub. virtus, ut viri fortes acrioribus suppliciis civem perniciosum, quam acerbissimum hostem coërcerent. Habemus enim senatusconfultum in te, Catilina, vehemens, & grave: non deest reip. consilium, neque autoritas hujus ordinis: nos, nos, dico aperte, consules desumus. De-
ABCDEFGHIJKLMNOPQRSTVUWX

SMALL PICA ROMAN. No 1.
At nos vigesimum jam diem patimur hebescere aciem horum autoritatis. habemus enim hujusmodi senatusconfultum, ve-

Double Pica Italick.
Quousque tandem abutere, Catilina, patientia nostra? quamdiu nos etiam furor iste tuus eludet? quem ad finem sese effrenata jac-
ABCDEFGHƷIKLMNO

Great Primer Italick.
Quousque tandem abutere, Catilina, patientia nostra? quamdiu nos etiam furor iste tuus eludet? quem ad finem sese effrenata jactabit audacia? nihilne te nocturnum præsidium palatii, nihil urbis vigiliæ, nihil timor populi, nihil con-
ABCDEFGHIƷKLMNOPQR

English Italick.
Quousque tandem abutere, Catilina, patientia nostra? quamdiu nos etiam furor iste tuus eludet? quem ad finem sese effrenata jactabit audacia? nihilne te nocturnum præsidium palatii, nihil urbis vigiliæ, nihil timor populi, nihil confenfus bonorum omnium, nihil hic munitissimus habendi fo-
ABCDEFGHIƷKLMNOPQRSTVU

Pica Italick.
Melium, novis rebus studentem, manu sua occldit. Fuit, fuit ista quondam in hac repub. virtus, ut viri fortes acrioribus suppliciis civem perniciosum, quam acerbissimum hostem coërcerent. Habemus enim senatus. consultum in te, Catilina, vehemens, & grave: non deest reip. consilium, neque autoritas hujus ordinis: nos, nos, dico aperte, consules desumus. Decrevit quondam senatus
ABCDEFGHIƷKLMNOPQRSTVUWXYZ

Small Pica Italick. No 1.
At nos vigesimum jam diem patimur hebescere aciem horum autoritatis, habemus enim hujusmodi senatusconfultum, serum-

Pica Black.
And be it further enacted by the Authority aforesaid, That all and every of the said Exchequer Bills to be made forth by virtue of this Act, or so many of them as shall from time to time remain undischarged and uncancelled, until the subscribing and cancelling the same pursuant to this Act,
ABCDEFGHIJKLMNOPQRST

Brevier Black.
And be it further enacted by the Authority aforesaid. That all and every of the said Exchequer Bills to be made forth by virtue of this Act, as so many of them as shall from time to time remain undischarged and uncancelled, until the subscribing and cancelling the same pursuant to this Act.

Pica Gothick.
ATTA ƱNSAR ÞU ÍN HIMINAM VEIHNAI NAMÔ ÞEIN QIMAI ÞIUDINASSUS ÞEINS VAIRÞAI VIAGA ÞEINS SVE ÍN HIMINA

Pica Coptick.
Ⲫⲉⲛ ⲟⲩⲁⲣⲭⲏ ⲁϥⲧ ⲉⲗⲗⲉⲟ ⲏⲧϥⲉ ⲛⲉⲙ ⲡⲕⲁϩⲓ⳼ ⲡⲕⲁϩⲓ ⲇⲉ ⲛⲉ ⲟⲩⲁⲧⲥⲁⲩ ⲉⲣⲟϥ ⲡⲉ ⲟⲩⲟϩ, ⲛⲧⲉⲟⲃⲧ ⲟⲩⲭⲁⲕⲓ ⲛⲁϧⲣⲉⲛ ⲉⲝⲉⲛ ⲫⲓⲧⲟⲩⲓ ⲟⲩⲟϩ, ⲟⲩⲡⲛⲁ ⲛⲧⲉϥⲧ ⲛⲁϧⲓⲛⲟⲩⲧ ϩⲓϫⲉⲛ ⲛⲓⲙⲱⲟⲩ ⳼– ⲟ–

Pica Armenian.
 Սկզբանէ էր բանն եւ բանն, որոյ առ Աստուած եւ աստուած էր բանն. Սա էր ի սկզբանէ առ Աստուած. Ամենայն ինչ նովաւ եղեւ եւ առանց նորա եղեւ եւ ոչ ինչ որ ինչ եղեւն։

English Syriack.
ܐܨܠܐ ܝܢ ܐܣܛ ܐܠܟܘܢ ܐܚ ܚܟܚ ܚܟܐ ܐܚ ܚ ܠ، ܚ ܟܚ ܗ ܣܡܘ ܐ ܟܐܠ ܘܠܐ ܗܝ، ܚܠܘܣܪ، ܚ ܠ، ܠ ܐ ܒ ܐ ܚ، ܠ، ܐܘܘܘ، ܚ ܣ ܚ، ܣܡܠ، ܚ ܚ ܚ ܚ ܪ

Pica Samaritan.
ⲀⲘⲨⲀⳠ Ⲁ⳥ⲀⲤ ⲤⲨ⳥⳥ ⲘⲦⳠⲤ ⳧ⲦⲦ⳥⳥⳥Ⲩ ⲘⲨⳠ⳥Ⲥ⳥ ⳦⳥⳧ⲦⳠ ⳤⲘⲨⳠ ⳧ⳤⲤ ⲘⲨⳠⲨⳤⲘ ⳧ⲘⳠ ⲤⳠⳤⲤⲨ ⲤⲤ ⳧Ⳡ Ⲧ⳥⳦ⳤⳤ ⳥ⳤⳠⲤ ⳧ⳤ⳦

English Arabick.
الله يا أمة تكفي لا يرحب عليكم لا الله محبي ربي شم لأ تنكر الذي بي اصلها



William Caslon (1692–1766) was the first notable English type designer. He introduced his sturdy, albeit idiosyncratic, typeface in 1734. It gained widespread acceptance almost immediately and, except between 1800 and 1850, has been a standard ever since. The influence of Dutch models is clear if you compare Janson (left) with Caslon (right):

a a



Caslon's type was distributed throughout England's American colonies, and was the typeface used in the first printed copies of the U.S. Declaration of Independence and Constitution. Through his sons, the foundry was to continue well into the second half of the 19th century.

Thomas Chippendale
Chair back (detail)
from *The Gentleman and Cabinet-Maker's Director*
London
1754

31

ABCDEFGHIJKLM
NOPQRSTUVWXYZ
1234567890

ABCDEFGHIJKLMN
OPQRSTUVWXYZ

abcdefghijklmn
opqrstuvwxyz
1234567890

ABCDEFGHIJKLMN
OPQRSTUVWXYZ
1234567890
abcdefghijklmn
opqrstuvwxyz
1234567890

Adobe Caslon, introduced in 1990, was designed by Carol Twombly from Caslon specimen sheets of 1738 and 1786.

1761
William Congreve
The Works of William Congreve
typeset and printed by John Baskerville
Birmingham

At the turn of the 18th century, Philippe Grandjean was almost a decade into production of a *romain du roi* for Louis XIV's royal press — a project that would carry on 30 years past his death in 1714. Characterized by thin, unbracketed serifs, extreme contrast between thick and thin strokes, and a perpendicular stress, the typeface marked a clear departure from the types of Griffo and Garamond, and met with immediate acclaim. However, as the personal property of the king, it could not be used by commercial printers.

Enterprising typefounders in France began copying Grandjean's work almost immediately, but the most successful application of his ideas came from John Baskerville (1706–1775), a self-taught typefounder, papermaker, and printer in Birmingham. Baskerville's type featured pronounced contrast between thick and thin strokes and a clear vertical stress. Compare Bembo (left) and Baskerville (right):

To maintain the delicacy of his type on the page, Baskerville had to develop several ancillary technologies. To prevent his shiny ink from spreading beyond the actual imprint of the page, he crafted his own very smooth paper (now called a 'wove' finish; earlier, ribbed sheets are called 'laid'). He also pressed his sheets between heated copper plates after printing to hasten drying.

> *The* LIFE *of* CONGREVE. xix
>
> natural, that, if we were not apprifed of it, we fhould never have fufpected they were Tranflations. But there is one Piece of his which ought to be particularly diftinguifhed, as being fo truly an Original, that though it feems to be written with the utmoft Facility, yet we may defpair of ever feeing it copied: This is his *Doris,* fo highly and fo juftly commended by Sir *Richard Steele,* as the fharpeft and moft delicate Satire he had ever met with.
>
> His two Pieces of the Dramatic Kind, do him equal Honor as a Poet and as a Lover of Mufic, *viz. The Judgment of Paris,* a Mafque, and *The Opera of Semele.* Of thefe, the former was acted with great Applaufe, and the latter finely fet to Mufic by Mr. *Eccles.* In Refpect to both, it is but Juftice to fay, that they have the fame Stamp of Excellency with the Reft of his Writings, were confidered as Mafter-pieces when publifhed, and may ferve as Models to Pofterity.
>
> His *Effay upon Humor in* Englifh *Comedy,* is, without Doubt, as inftructive, as entertaining,

George Hepplewhite
Window stool
from *The Cabinet-Maker and Upholsterer's Guide*
London
1790

ABCDEFGHIJKLMN
OPQRSTUVWXYZ
1234567890

ABCDEFGHIJKLMN
OPQRSTUVWXYZ
abcdefghijklmn
opqrstuvwxyz
1234567890

ABCDEFGHIJKLMN
OPQRSTUVWXYZ
1234567890
abcdefghijklmn
opqrstuvwxyz
1234567890

Monotype Baskerville was
produced in 1929 under
Stanley Morison's direction.

1818
Giambattista Bodoni
Manuale Tipografico
Parma (published posthumously)

Baskerville's innovations exerted a notable influence on European typefounders, particularly the Didot and Fournier families in France and Giambattista Bodoni (1740–1813) in Italy.

Serving as the subsidized private printer to the Duke of Parma, Bodoni produced over 100 typefaces. His early typefaces retain some elements we associate with Baskerville, primarily in the gentle slope of the upper serifs of the 'i', 'j', and 'l'. Firmin Didot, by contrast, produced type with unbracketed, purely horizontal serifs. Compare Bauer Bodoni (left) and Linotype Didot (right):

i i

Bodoni carried forward the technological advances begun by Baskerville, improving both ink and paper surface to show off his delicate type to best advantage.

I

GIAMBATTISTA BODONI

A CHI LEGGE.

Eccovi i saggi dell'industria e delle fatiche mie di molti anni consecrati con veramente geniale impegno ad un'arte, che è compimento della più bella, ingegnosa, e giovevole invenzione degli uomini, voglio dire dello scrivere, di cui è la stampa la miglior maniera, ogni qual volta sia pregio dell'opera far a molti copia delle stesse parole, e maggiormente quando importi aver certezza che

Alexandre-Pierre Vignon
Church of Mary Magdalene
('La Madeleine')
Paris
1807–1842

ABCDEFGHIJKLMN
OPQRSTUVWXYZ
1234567890

ABCDEFGHIJKLMN
OPQRSTUVWXYZ

abcdefghijklmn
opqrstuvwxyz
1234567890

ABCDEFGHIJKLMN
OPQRSTUVWXYZ
1234567890

abcdefghijklmn
opqrstuvwxyz
1234567890

Bauer Bodoni, produced by Louis Höll of the Bauer type foundry in 1926, is based on Bodoni's cuts of 1789. It shows clearly the differences between what Bodoni actually produced and what people often think of as 'Bodoni'.

 W CASLON JUNR

Boldface

The Industrial Revolution of the early 19th century, triggered by the invention of the steam engine, changed printing, typesetting, and type-casting from the product of the human hand to the product of power-driven machinery. The sheer speed of mechanized presses meant that thousands of copies could be printed in the time it formerly took to print dozens. The sudden, wide dissemination of printed matter contributed to the rise of literacy as dramatically as the invention of printing itself had three and a half centuries earlier. It also created a new market of consumers for manufacturers. Products (and services, for that matter) could be advertised to broad masses at relatively low cost. Printers began to distinguish between book printing and jobbing, or commercial printing. This new printing required a new esthetic.

Typefaces from the previous centuries, designed for text settings, seemed inadequate for the new medium of advertising. Bigger, bolder, louder type was required to make messages stand out in the otherwise gray printed environment. One of the first typefounders to experiment with a 'fat face' was Robert Thorne who, in 1803, cast the face that would bear his name (above left). Hundreds of boldfaces followed.

For several decades, boldfaces existed in a class distinct from text type. However, by the time typefaces from the 16th, 17th, and 18th centuries were revived in the early 20th century, typefounders (notably Morris Benton of American Type Founders) were so accustomed to working with boldface that they chose to retrofit bold forms into each typeface 'family,' along with existing italics, small caps, etc.

Sans serif

One variation of the boldface idea involved losing serifs altogether. First introduced by William Caslon IV in 1816 (above right), sans serif type, featuring no change in stroke weight, was reserved almost exclusively for headlines, although there are occasional examples of sans serif captions.

Caslon named his type 'Egyptian,' probably because the art and architecture of ancient Egypt had colored European imagination since Napoleon's campaign and the discovery of the Rosetta stone in 1799. But the label didn't stick. Opponents of the form quickly called it 'grotesque;' others termed it 'gothic' (a style that was also enjoying a revival in the early 19th century). English typefounder Vincent Figgins was the first to call it 'sans syrruph,' in 1832.

Charles Barry and A.W.N. Pugin
Houses of Parliament
London
1840–1860

1831
Poster

37

Display faces

Since medieval copyists had illuminated initial letters in manuscripts, typographers had often produced oversized, intricately detailed letterforms to provide color and contrast on the text page. In the 19th century, at the same time as the development of boldface and for much the same reason, typefounders began casting entire typefaces—upper- and lowercase—decorated (illuminated) to suggest various architectural and natural motifs. Typically, these typefaces were intended for use as headlines or display material; hence, the term 'display face.' In most cases the vogue for any particular display face lasted only as long as the trend in fashion it mimicked.

The subsequent evolution of type technology (first phototypesetting, then digital rendering), combined with the desire of some designers to introduce novelty for its own sake, has given rise to the use of these display faces (and their 20th-century offspring) in all kinds of settings, from 100-pt. display material in advertising to 7-pt. phone numbers on business cards. As it happens, we all know our alphabet well enough that we can usually read the letters and numbers in display faces despite the tortuous machinations they have endured.

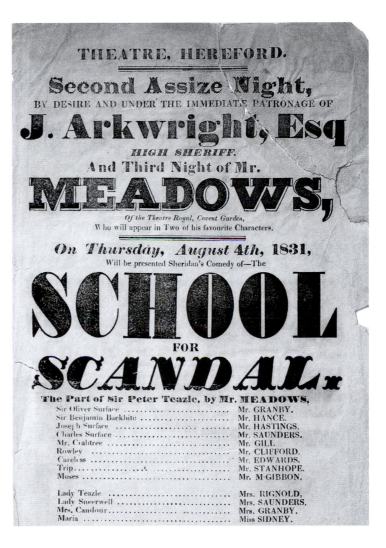

1817
Vincent Figgins
Specimens of Printing Types
London

A fourth 19th-century development in typography—the square serif—first appeared in England in 1817. Just as William Caslon IV was eliminating serifs altogether, other typefounders were fattening them up to have the same weight as the strokes of the letterform itself. First called 'Antique' by Vincent Figgins (above), the type eventually became known as 'Egyptian,' perhaps because its strong serifs mirrored the base and capital of an Egyptian column.

Although some 19th-century square serifs (such as Clarendon) drew upon traditional letterforms (and, like Clarendon, had bracketed serifs), many 20th-century typefaces referred to geometric models.

The mechanization of printing, and the allied rise of advertising, contributed to a general degradation of both the printer's and the typographer's craft. By the end of the 19th century, however, movements were afoot in both the U.S. and the UK to revive the handicraft and the care of previous centuries' printing. Central to this revival was William Morris's Kelmscott Press, founded in 1891.

Front of Crystal Palace
Hyde Park, London
from *The Illustrated London News*
May, 1851

ABCDEFGHIJKLM NOPQRSTUVWXYZ 1234567890

abcdefghijklmn opqrstuvwxyz

ABCDEFGHIJKLMN
OPQRSTUVWXYZ
1234567890

abcdefghijklmn
opqrstuvwxyz

Adrian Frutiger designed Glypha
for Linotype in 1977. Compare
Frutiger's forms with earlier,
more geometric slab serifs like
Memphis (below), designed
by Rudolf Wolf for the Stempel
foundry in 1929.

ABCDEFGHIJ
KLMNOPQRST
UVWXYZ
1234567890
abcdefghijkl
mnopqrstuvw
xyz

The movement to revive older type models, led by T. J. Cobden-Sanderson, Stanley Morison, and Beatrice Warde in the UK and Daniel Berkeley Updike, Frederick W. Goudy, W. A. Dwiggins, and Bruce Rogers in the U.S., flourished in the early 20th century. Their scholarly work showed typography, for the first time, to be a subject worthy of study even as they demonstrated the value of earlier forms.

At the same time, the astonishing and often bewildering technological developments of the new century, combined with widespread social upheaval in Europe and America, caused many to seek new forms of graphic expression. Sans serif type— until then reserved for headlines and captions—was seen by many as most appropriate for asymmetric page composition that broke with traditional models. It is worth noting that the idea of graphic design as a profession distinct from printing, type-casting, or 'fine' art, began at the same time.

Lyubov Popova
set design of Fernand
Crommelynk, *Le Cocu magnifique*
State Institute of Theatrical Art
Moscow
1922

ABCDEFGHIJKLMN OPQRSTUVWXYZ 1234567890

abcdefghijklmn
opqrstuvwxyz
1234567890

*ABCDEFGHIJKLM
NOPQRSTUVWXYZ
1234567890
abcdefghijklmn
opqrstuvwxyz*

The first widely used sans serif typeface, Akzidenz Grotesk was developed by the Berthold type foundry in 1896. ('Akzidenz' is German for the 'schrift' or type used by commercial — as opposed to book — printers, and 'grotesk' is the German word for sans serif. In the U.S., the typeface was known simply as Standard.) The light weight includes a set of lowercase numerals (shown in red) designed by Erik Spiekermann in 1990.

Edward Johnston
London Underground logo
London
1916

42

ABCDEFGHIJKLMN OPQRSTUVWXYZ 1234567890

abcdefghijklmn opqrstuvwxyz

ABCDEFGHIJKLMN
OPQRSTUVWXYZ
1234567890

abcdefghijklmn
opqrstuvwxyz

Designed by Eric Gill in 1928, Gill Sans is based on the typeface his teacher, Edward Johnston, created in 1916 for the signage of the London Underground. Gill also designed several serif type-faces (Perpetua, Joanna, Aries) which share many of the propor-tions and characteristic counters of Gill Sans. Although strictly contemporary in effect, Gill's type, like Johnston's before him, owes much to the proportions and forms of the Renaissance letter.

43

ABCDEFGHIJKLMN OPQRSTUVWXYZ 1234567890

abcdefghijklmn opqrstuvwxyz

ɑʌɑɑɘℯℊℊⅢⅡⲅ 1234567890

ABCDEFGHIJKLMN
OPQRSTUVWXYZ
1234567890
abcdefghijklmn
opqrstuvwxyz

Designed by Paul Renner in 1927, Futura is the first geometric sans serif typeface designed for text applications. Although Futura seems to use basic geometric proportions, it is in fact a complex combination of stressed strokes and complex curves, with stronger connections to preceding serif forms than its spare effect would at first suggest.

Renner designed a number of lowercase forms and numerals for Futura (shown in red), which the Bauer foundry abandoned, but which were revived by The Foundry (London) as Architype Renner in 1994.

	Univers 53	Univers 63	Univers 73	Univers 83
	Univers 54	*Univers 64*	*Univers 74*	*Univers 84*
Univers 45	Univers 55	Univers 65	Univers 75	Univers 85
Univers 46	*Univers 56*	*Univers 66*	*Univers 76*	*Univers 86*
Univers 47	Univers 57	Univers 67		
Univers 48	*Univers 58*	*Univers 68*		
Univers 39	Univers 49	Univers 59		

By mid-century, phototype-setting had replaced metal type for most commercial work, further freeing both typesetting and layouts from the technical restrictions of older traditions. Phototypesetting had its own drawbacks, however, which were finally resolved with the introduction of desktop publishing in the 1980s.

Although Adrian Frutiger is well respected for a number of widely used typefaces, his masterwork is Univers, released in 1957 by the Deberny & Peignot foundry in Paris for both metal and photo-type. In an effort to eliminate the growing confusion in typeface terminology (thin/light, regular/medium, bold/black) Frutiger used numbers rather than names to describe the palette of weights and widths in Univers. (Opposite: Univers 55)

In any two-digit descriptor, the first number designates line weight (3- is the thinnest, 8- the heaviest) and the second designates character width (-3 is the most extended, -9 most condensed). Even numbers indi-cate italic, odd numbers roman. Frutiger has subsequently used this system on other typefaces he has designed (Serifa, Glypha, Frutiger, Avenir, etc.), and other type manufacturers have adapted his system for some of their type-faces (Helvetica Neue, etc.).

ABCDEFGHIJKLMN
OPQRSTUVWXYZ
1234567890

abcdefghijklmn
opqrstuvwxyz

ABCDEFGHIJKLMN
OPQRSTUVWXYZ
1234567890

abcdefghijklmn
opqrstuvwxyz

Digital type

**Apple Computer
Macintosh SE
1987**

46 As the personal computing industry blossomed in the 1980s, so too did the concept of desktop publishing, whereby a designer had at his or her fingertips all the tools necessary to design, typeset, and illustrate a project, without having to resort to outside vendors. In many ways, the work method was a return to medieval scriptoriums. Bitstream, Inc. began offering digital typefaces in 1981; Adobe Systems, Inc. followed shortly thereafter. By 1990, virtually every type foundry in the world offered digital versions of their typefaces, and numerous type shops had opened up offering exclusively digital fonts. By 2000, 500-year-old methods of producing type had been relegated to the province of purists and hobbyists. An entire professional class—the typesetter—was extinct.

However, thanks to the early contributions and high standards of type designers Matthew Carter, Sumner Stone, and many others, this change in production did not necessarily mean a lessening of quality. The field of type design has continued to thrive, coupled with welcome advances in digital technology. Designers have never before had so much type—and so much good type—at their disposal.

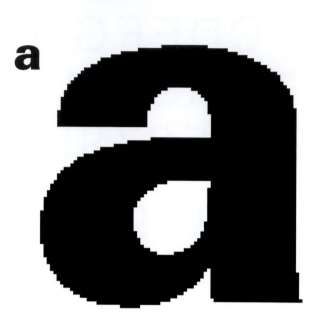

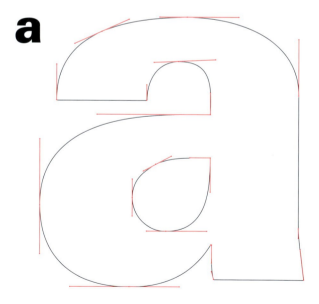

**Top:
36 pt. Univers 75 bitmapped
for screen presentation**

**Bottom:
36 pt. Univers 75 vectored
for printing**

An expanded type 'family'

In the last two decades, some typographers—notably Otl Aicher, Martin Majoor, Erik Spiekermann, and Sumner Stone—have developed families of typefaces that not only include a range of color (light/regular/bold/black), but also incorporate serif and sans serif versions. Shown here are samples from Aicher's Rotis family, drawn in 1989.

Rotis
Serif

Regular

Rotis
SemiSerif

Regular

Rotis
SemiSans

Regular

Rotis
Sans Serif

Regular

		Rotis Serif Regular	*Rotis Serif Italic*	Rotis Serif **Bold**	
		Rotis SemiSerif Regular		Rotis SemiSerif **Bold**	
Rotis SemiSans Light	*Rotis SemiSans Light Italic*	Rotis SemiSans Regular	*Rotis SemiSans Italic*	**Rotis SemiSans Bold**	**Rotis SemiSans Extra Bold**
Rotis Sans Serif Light	*Rotis Sans Serif Light Italic*	Rotis Sans Serif Regular	*Rotis Sans Serif Italic*	**Rotis Sans Serif Bold**	**Rotis Sans Serif Extra Bold**

Text typeface classification

Dates of origin approximated to
the nearest quarter century

As you have seen, type forms have developed in response to prevailing technology, commercial needs, and esthetic trends. Certain models have endured well past the cultures that spawned them. Recognizing the need to identify the stages of type-form development, typographers have come up with a number of systems to classify typefaces, some of them dizzying in their specificity.

The classification here, based on one devised by Alexander Lawson, covers only the main forms of text type. Decorative styles have been omitted, and sans serif forms have been grouped together without differentiation between humanist and geometric forms.

This system offers a useful, if simplified, description of the kinds of type you will most often encounter working with text. As your experience with type develops, you should definitely familiarize yourself with other, more specific, systems. Keep in mind that the best system is the one that most helps you recognize kinds of typefaces and their historical origins.

1450 — Blackletter

Blackletter
The earliest printing types, these forms were based upon the hand-copying styles then used for books in northern Europe.

Examples:
Cloister Black
Goudy Text

1475 — Oldstyle

Oldstyle
Based upon the lowercase forms used by Italian humanist scholars for book copying (themselves based upon the 9th-century Caroline minuscule) and the uppercase letter-forms found inscribed on Roman ruins. The forms evolved away from their calligraphic origins over 200 years as they migrated across Europe, from Italy to England.

Examples:
Bembo
Caslon
Dante
Garamond
Janson
Jenson
Palatino

1500 — Italic

Italic
Echoing contemporary Italian handwriting, the first italics were condensed and close-set, allowing more words per page. Although originally considered their own class of type, italics were soon cast to complement roman forms. Since the 16th century, virtually all text typefaces have been designed with accompanying italic (or oblique) forms.

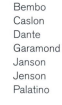

1550

Script

Originally an attempt to replicate engraved calligraphic forms, this class of type is not entirely appropriate in lengthy text settings. In shorter applications, however, it has always enjoyed wide acceptance. Forms now range from the formal and traditional to the casual and contemporary.

Examples:
Kuenstler Script
Mistral
Snell Roundhand

1750

Transitional

A refinement of Oldstyle forms, this style was achieved in part because of advances in casting and printing. Thick-to-thin relationships were exaggerated and brackets were lightened.

Examples:
Baskerville
Bulmer
Century
Times Roman

1775

Modern

This style represents a further rationalization of Oldstyle letterforms. Serifs were unbracketed, and the contrast between thick and thin strokes was extreme. English versions (like Bell) are also known as Scotch Roman and more closely resemble transitional forms.

Examples:
Bell
Bodoni
Caledonia
Didot
Walbaum

1825

Square serif

Originally heavily bracketed serifs, with little variation between thick and thin strokes, these faces responded to the newly developed needs of advertising for heavy type in commercial printing. As they evolved, the brackets were dropped. This class is also known as slab serif.

Examples:
Clarendon
Memphis
Rockwell
Serifa

1900

Sans serif

As its name implies, these type-faces eliminated serifs altogether. Although the form was first introduced by William Caslon IV in 1816, its use did not become widespread until the beginning of the 20th century. Variations tended toward either humanist forms (Gill Sans) or the rigidly geometric (Futura). Occasionally, strokes were flared to suggest the epigraphic origins of the form (Optima). Sans serif is also referred to as grotesque (from the German 'grotesk') and gothic.

Examples:
Akzidenz Grotesk
Grotesque
Gill Sans
Franklin Gothic
Frutiger
Futura
Helvetica
Meta
News Gothic
Optima
Syntax
Trade Gothic
Univers

1990

Serif/sans serif

A recent development, this style enlarges the notion of a family of typefaces to include both serif and sans serif alphabets (and, often, stages between the two).

Examples:
Rotis
Scala
Stone

Letters, words, sentences

Understanding letterforms

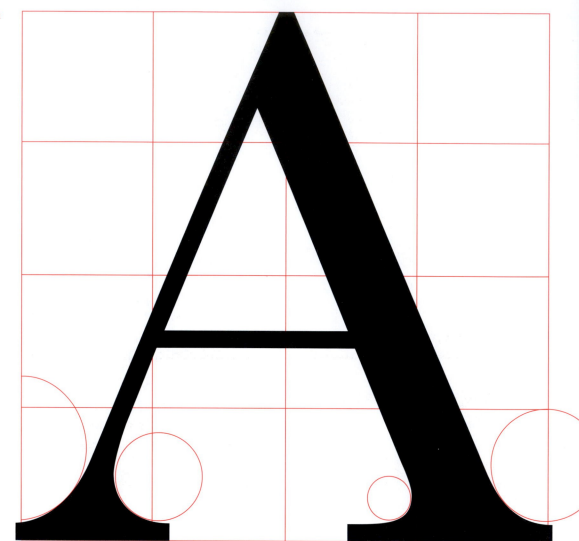

Here are two forms of a relatively simple letter—the uppercase 'a.' Both suggest the symmetry of the form as someone might print it, but neither is in fact symmetrical at all. It's easy to see the two different stroke weights of the Baskerville form (above); more noteworthy is the fact that each of the brackets connecting serif to stem expresses a unique arc.

The Univers form (opposite) may appear symmetrical, but a close examination shows that the width of the left stroke is thinner than that of the right stroke. Both demonstrate the meticulous care a type designer takes to create letterforms that are both internally harmonious and individually expressive.

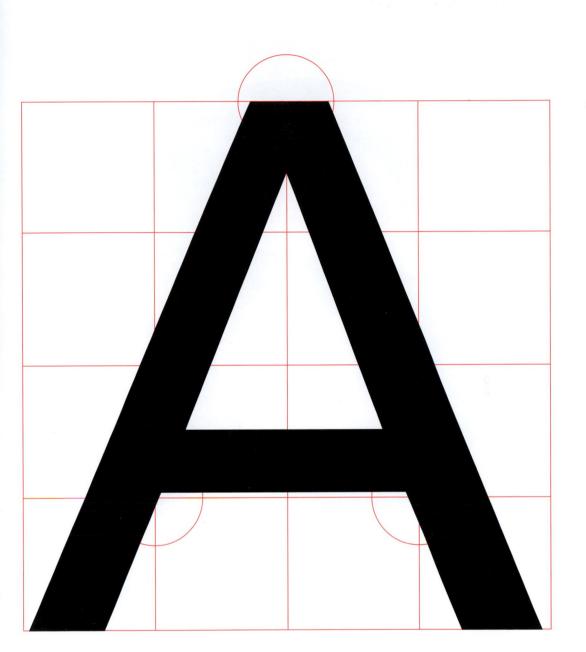

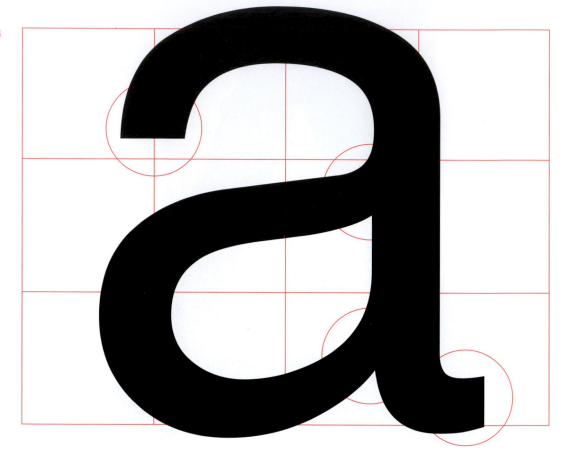

The complexity of each individual
letterform is neatly demonstrated
by examining the lowercase 'a' of
two seemingly similar sans serif
typefaces—Helvetica and Univers.
A comparison of how the stems
of the letterforms finish and how
the bowls meet the stems quickly
reveals the palpable difference in
character between the two.

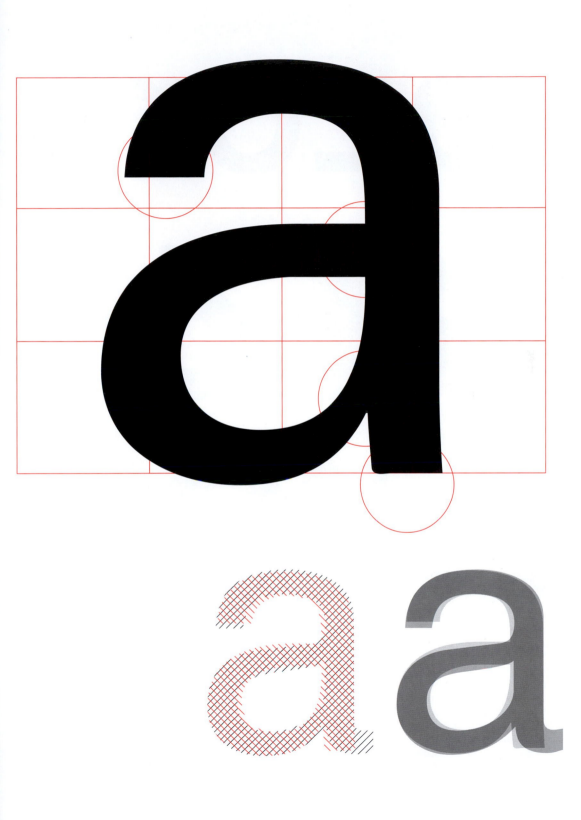

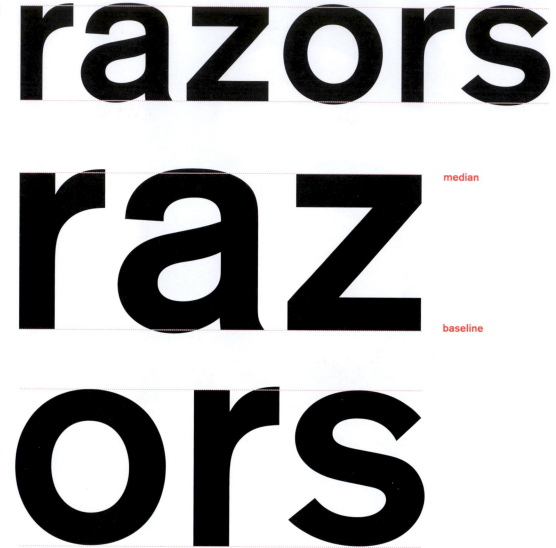

median

baseline

As you already know, the x-height generally describes the size of lowercase letterforms. However, you should keep in mind that curved strokes, such as in 's', must rise above the median (or sink below the baseline) in order to appear to be the same size as the vertical and horizontal strokes they adjoin.

Compare the 'a' in the large examples above with the 'o' and 's.' The latter two characters clearly seem too small, and bounce around within the perceived x-height of the typeface, because they do not extend beyond the median or baseline.

Form/counterform

Just as important as recognizing specific letterforms is developing a sensitivity to the counterform (or counter)—the space described, and often contained, by the strokes of the form. When letters are joined to form words, the counterform includes the spaces between them. The latter is a particularly important concept when working with letterforms like the lowercase 'r' that have no counters *per se.* How well you handle the counters when you set type determines how well words hang together—in other words, how easily we can read what's been set.

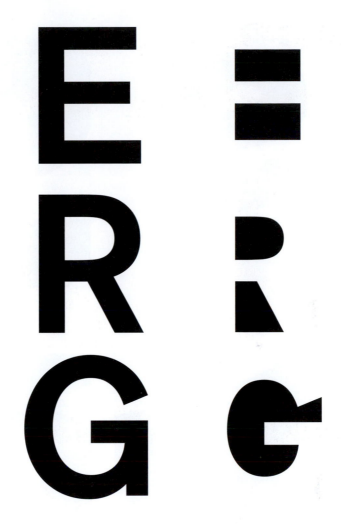

dreams

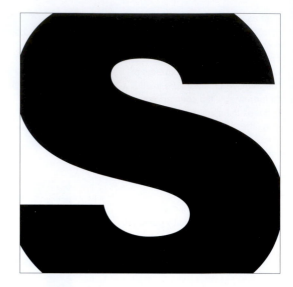

Helvetica Black

One of the most rewarding ways to understand the form and counter of letters is to examine them in close detail. Beyond giving you an appreciation of the meticulous care that goes into each compound curve, these examinations also provide a good feel for how the balance between form and counter is achieved and a palpable sense of a letterform's unique characteristics. It also gives you a glimpse into the process of letter-making.

It's worth noting here that the sense of the 'S' holds at each stage of enlargement, while the 'g' tends to lose its identity as individual elements are examined without the context of the entire letterform.

Baskerville

Norman Ives (1923–1978), an
eminent graphic designer, collagist,
and muralist, worked extensively
with pieces of letterforms in his
complex constructions.

Linotype Didot

Contrast

Light/bold

Condensed/extended

Organic/machined

Roman/italic

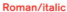

The basic principles of graphic design apply directly to typography. Above, some examples of contrast— the most powerful dynamic in design—as applied to type, based on a format devised by Rudi Ruegg.

Combining these simple contrasts produces numerous variations: small+organic/large+machined; few+bold/many+light; etc. Adding color increases the possibilities even more (i.e. black/red).

Small/large

Positive/negative

Serif/sans serif

Ornate/simple

Reinforcing meaning

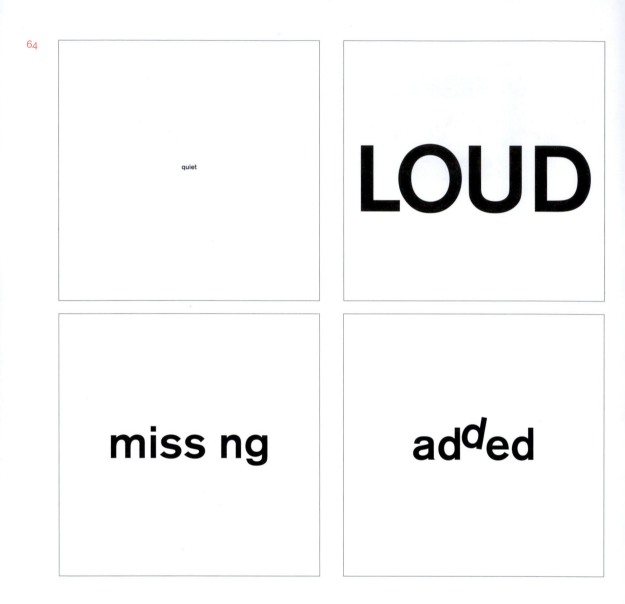

It's possible to find typographic equivalents for words. Simple choices in typeface, size, weight, and position on the page can strengthen representation of the concepts, objects, and actions that words describe. Here, we've stuck to one weight of one typeface, Akzidenz Grotesk Medium, but played with size and placement.

The examples above express some quality of the adjectives on display. 'Quiet' is small and lowercase, 'loud' large and uppercase. The second 'i' in 'missing' is, in fact, missing, and the second 'd' in 'added' is in the process of being added.

TR^{AIN}

bird

NONCON*f*ORMIST

shadow

The examples above all carry some quality of the nouns expressed. In 'train,' for example, a Fibonacci sequence of type sizes (see page 109), aligned at the cap height, creates the illusion of perspective— we can easily imagine a long train receding into the distance—or, for that matter, pulling into a station.

The dot on the 'i' in 'bird' flies above the rest of the letters; the 'f' in 'nonconformist' does not conform with the other letters; 'shadow' casts a shadow. The examples of contrast in type on pages 62–63 offer a number of possibilities for building on these simple changes.

66

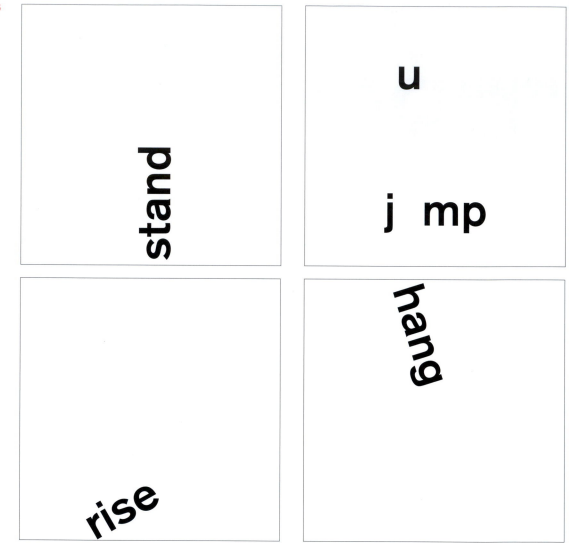

The meaning of the verbs on this page is reinforced through placement within the frame. Direction is implied by how we read (left-to-right = forward; top-to-bottom = down, and so forth).

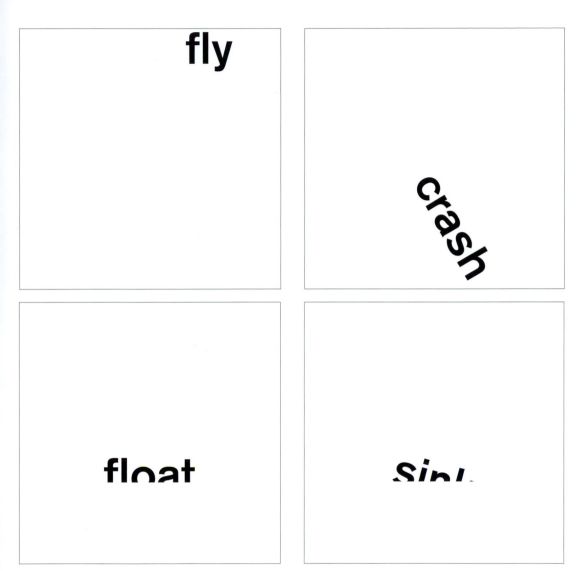

In the second row on this page, meaning is further enhanced by covering up some portion of the word (and, in the case of 'sink,' by tilting the type slightly downward). Imagine taking a bite out of 'eat.'

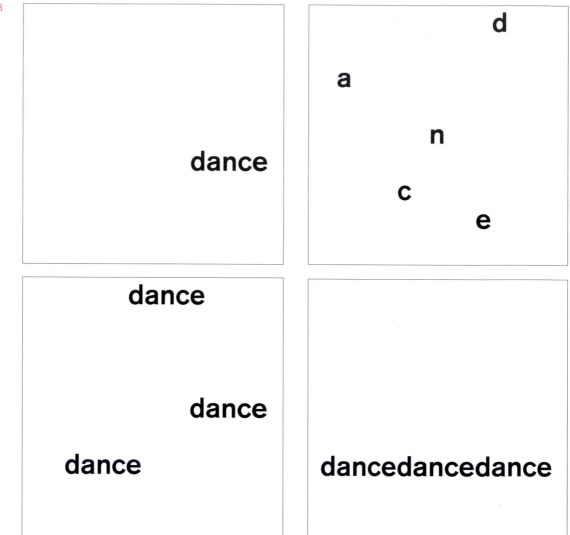

Here, simple placement of the word 'dance' in the square suggests the activity in a place, possibly a stage. Breaking the letters apart suggests a dancer moving.

Repetition of the word (this page and opposite) suggests different kinds of rhythm and, in fact, different kinds of dancing.

```
dancedancedance
dancedancedance
dancedancedance
dancedancedance
dancedancedance
dancedancedance
dancedancedance
dancedancedance
dancedancedance
```

```
                    dance
                    dance
                    dance
        dance       dance
                    dance
                    dance
                    dance
                    dance
                    dance
```

```
dancedancedance
ancedancedanced
ncedancedanceda
cedancedancedan
edancedancedanc
dancedancedance
ancedancedanced
ncedancedanceda
cedancedancedan
```

```
dance
            dance
        dancedance
            dance
      dance
dancedance
            dance
ncedancedanceda
        dance
```

Making sentences, finding sense

One way to make sentences (or, for that matter, sentence fragments) more expressive is to reinforce the sense of the words through type play. The examples shown here provide various methods of support- ing (or subverting) the author's intent, by manipulating the size, weight, and placement of words.

The text in this sequence is taken from the *Déclaration des droits de l'homme et du citoyen* (Declaration of the Rights of Man and of the Citizen, 1789): 'Article 11. The free communication of ideas and opin- ions is one of the most precious of the rights of man. Every citizen may, accordingly, speak, write, and print with freedom, but shall be respons- ible for such abuses of this freedom as shall be defined by law.'

Flush left

Article 11
The free communication of ideas and opinions is one of the most precious of the rights of man. Every citizen may, accordingly, speak, write, and print with freedom, but shall be responsible for such abuses of this freedom as shall be defined by law.

Flush right

Article 11
The free communication of ideas and opinions is one of the most precious of the rights of man. Every citizen may, accordingly, speak, write, and print with freedom, but shall be responsible for such abuses of this freedom as shall be defined by law.

Simply, set the text.
Or, perhaps, not so simply. When setting type in a field, it's useful to keep in mind the expression 'lines of type.' Compositionally, they operate on a page in much the same way that simple lines do in a basic design study, with two important exceptions:

1
The Latin alphabet always reads left to right.

2
The quality of the line is determined by the size and weight of the type- face, by the inherent gray value of the typeface itself, and by the leading (space) between the lines of type.

For more on text setting,
see pages 94–105.

Justified

Article 11
The free communication of ideas and opinions is one
of the most precious of the rights of man. Every citizen
may, accordingly, speak, write, and print with freedom,
but shall be responsible for such abuses of this freedom
as shall be defined by law.

Centered

Article 11
The free communication of ideas and opinions is one
of the most precious of the rights of man. Every citizen
may, accordingly, speak, write, and print with freedom,
but shall be responsible for such abuses of this freedom
as shall be defined by law.

Narrow setting **Vertical**

**Diagonal
setting** **Larger type**

Placement of the type (see examples above) is as much about where type isn't as where it is. Designers working with type must always balance the importance of dynamic counterform with the need for type to remain readable; the most interesting composition may not be the most accessible.

Studies in perception have shown that readers' comprehension increases relative to the ease of scanning the text. In other words, fewer visual distractions lead to greater retention of content. This simple observation is most useful to keep in mind when setting extended text. Shorter settings such as we see here, however, reasonably allow for more 'play' in the presentation.

In short, while it may be possible to heighten meaning through distinctive and directed arrangement of type, direct consideration of the content and the reader should always be one's uppermost goals.

Article 11
The free communication of ideas and opinions is one of
the most precious of the rights of man. Every citizen may,
accordingly, speak, write, and print with freedom, but shall
be responsible for such abuses of this freedom as shall be
defined by law.

Article 11
The free communication of ideas and opinions is one of
the most precious of the rights of man. Every citizen may,
accordingly, speak, write, and print with freedom, but shall
be responsible for such abuses of this freedom as shall be
defined by law.

Article 11
The free communication of ideas and opinions is one
of the most precious of the rights of man. Every citizen
may, accordingly, speak, write, and print with freedom,
but shall be responsible for such abuses of this freedom
as shall be defined by law.

Article 11
The free communication of ideas and opinions is one
of the most precious of the rights of man. Every citizen
may, accordingly, speak, write, and print with freedom,
but shall be responsible for such abuses of this freedom
as shall be defined by law.

Choosing an appropriate typeface depends on a number of factors, some of them seemingly contradictory: the content of the text, the tone of the author's voice, the period in which the text was written, and the intended audience. Each of the examples above speaks to some quality of the text.

Top left: the script setting (Kuenstler Script) reflects the original, calligraphed presentation of the text to Louis XVI. Top right: this 16th-century typeface (Adobe Garamond) is closely identified with classic French printing.

Bottom left: the design of this French typeface (Linotype Didot), was contemporaneous with the first publication of the text. Bottom right: a sans serif font (Univers 55) speaks directly to the modern audience.

Article 11
The free communication of ideas and opinions is one of
the most precious of the rights of man. Every citizen may,
accordingly, speak, write, and print with freedom,
but shall be responsible for such abuses of this freedom
as shall be defined by law.

Here we see two approaches that work against any serious communication. Top: a typeface so distinctive (Mistral) that it interrupts direct access to the content. Bottom: a 'formal' typeface (Trajan), set in all caps, that needlessly dresses up the text (what the French might describe as *péter plus haut que son cul*).

In both cases, before the reader can get to the matter, he or she must see through the effect of the typefaces themselves (in all likelihood, this also occurred when coming upon the script example on page 72). These examples highlight the problems inherent in using display typefaces for setting text (see page 14).

ARTICLE 11
THE FREE COMMUNICATION OF IDEAS AND
OPINIONS IS ONE OF THE MOST PRECIOUS
OF THE RIGHTS OF MAN. EVERY CITIZEN MAY,
ACCORDINGLY, SPEAK, WRITE, AND PRINT
WITH FREEDOM, BUT SHALL BE RESPONSIBLE
FOR SUCH ABUSES OF THIS FREEDOM AS SHALL
BE DEFINED BY LAW.

Article 11
The free communication
of ideas and opinions
is one of the most precious of the rights of man.
Every citizen may, accordingly,
speak, write, and print with freedom,
but shall be responsible
for such abuses of this freedom
as shall be defined by law.

Examine the syntax.
One way to make short text more
expressive is to break it up for
sense. In the example above, the two
sentences in Article 11 have been
set so that each line contains one
discrete component of the thought.

The irregularity of the rag, some-
thing to be avoided assiduously in
longer text settings, in this instance
provides both cues for how to read
the text and a lively interraction of
form and counterform.

Article 11
The free communication
of ideas and opinions
is one of the most precious
of the rights
of man.
Every citizen may, accordingly,
speak,
write, and
print with freedom,
but shall be responsible
for such abuses of this freedom
as shall be defined
by law.

Above, the idea is taken one step further by organizing the sense of the text both horizontally and vertically. Visualizing the syntax in this way generates rich, complex counterform on the page.

Text set in this manner is called asymmetric because it does not conform to the typical methods of typesetting displayed on pages 72 and 73. In practice, lines in asymmetric type are broken as much for appearance on the page as for the sense of the text.

Article **11**
The free **communication**
of ideas and opinions
is one of the **most precious of the rights** of man.
Every citizen may, accordingly,
speak, write, and print with freedom,
but shall be **responsible**
for such abuses of this freedom
as shall be defined by law.

Find the core message.
Highlighting the key words in the
text, by changing either their weight
or their size, keys the reader in to
the heart of the text, separated from
its natural grammatical setting.

Notice that there is no shift from
roman to italic. Despite its long use
in text to call out certain words,
phrases, and titles, italic does not
provide enough visual difference
from roman to serve the purpose of
this exercise.

Above: A bold sans serif (Univers
75) has been paired with the
roman (Linotype Didot). For a
discussion of this approach, see
pages 128–129.

Article 11
The free communication
of ideas and opinions
is one of the most precious
of the rights of man.
Every citizen may, accordingly,
speak, write, and print with freedom,
but shall be responsible
for such abuses of this freedom
as shall be defined by law.

Above: Change in scale highlights
key phrases in the text.

Article 11

The free communication
of ideas and opinions
is one of the most precious
of the rights of man.

Every citizen may, accordingly,
speak,
write, and
print
with freedom,

but shall be responsible
for such abuses of this freedom
as shall be defined by law.

Combine scale and structure.
In the example above, the two
previous strategies are combined.
Both the organization of the text
and the use of scale support the
meaning.

Article **11**

The **free communication of ideas and opinions**

is one of the most precious of the rights of man.
Every citizen may, accordingly,
speak, write, and print with freedom,
but shall be responsible
for such abuses of this freedom as

shall be defined by law.

As you can see above, and as we have all seen in countless real world examples, scale, weight, and organization conspire to subvert the intended meaning of the text.

Type and color

As the previous examples demon-strate, typography continually offers the designer opportunities to exploit color on a page, even in a 'one-color' situation. Each typeface—assembled in regularly occurring lines, grouped into paragraphs and columns, or set in single words or simple phrases—creates a unique tone on the page. As the samples of Akzidenz Grotesk (right) demonstrate, changes in weight and compression or expan-sion of the letterforms all contribute to a palette of typographic tones.

Condensed

Akzidenz Grotesk Light

The guiding attitudes behind what follows are those that have vitalized most twentieth-century art: content dictates form; less is more; god is in the details. These three tenets neatly identify the typographer's job: appropriate, clear expression of the author's message, intelligent economy of means, and a deep understanding of craft.

Akzidenz Grotesk Regular

The guiding attitudes behind what follows are those that have vitalized most twentieth-century art: content dictates form; less is more; god is in the details. These three tenets neatly identify the typographer's job: appropriate, clear expression of the author's message, intelligent economy of means, and a deep understand-ing of craft.

Akzidenz Grotesk Medium

The guiding attitudes behind what follows are those that have vitalized most twentieth-century art: content dictates form; less is more; god is in the details. These three tenets neatly identify the typographer's job: appropriate, clear expression of the author's message, intelligent economy of means, and a deep understanding of craft.

Akzidenz Grotesk Bold

The guiding attitudes behind what follows are those that have vitalized most twentieth-century art: content dictates form; less is more; god is in the details. These three tenets neatly identify the typographer's job: appropriate, clear expression of the author's message, intelligent economy of means, and a deep understanding of craft.

Akzidenz Grotesk Extra Bold

The guiding attitudes behind what follows are those that have vitalized most twentieth-century art: content dictates form; less is more; god is in the details. These three tenets neatly identify the typographer's job: appropriate, clear expression of the author's message, intelligent economy of means, and a deep understanding of craft.

Akzidenz Grotesk Super

Roman

The guiding attitudes behind what follows are those that have vitalized most twentieth-century art: content dictates form; less is more; god is in the details. These three tenets neatly identify the typographer's job: appropriate, clear expression of the author's message, intelligent economy of means, and a deep understanding of craft.

The guiding attitudes behind what follows are those that have vitalized most twentieth-century art: content dictates form; less is more; god is in the details. These three tenets neatly identify the typographer's job: appropriate, clear expression of the author's message, intelligent economy of means, and a deep understanding of craft.

The guiding attitudes behind what follows are those that have vitalized most twentieth-century art: content dictates form; less is more; god is in the details. These three tenets neatly identify the typographer's job: appropriate, clear expression of the author's message, intelligent economy of means, and a deep understanding of craft.

The guiding attitudes behind what follows are those that have vitalized most twentieth-century art: content dictates form; less is more; god is in the details. These three tenets neatly identify the typographer's job: appropriate, clear expression of the author's message, intelligent economy of means, and a deep understanding of craft.

The guiding attitudes behind what follows are those that have vitalized most twentieth-century art: content dictates form; less is more; god is in the details. These three tenets neatly identify the typographer's job: appropriate, clear expression of the author's message, intelligent economy of means, and a deep understanding of craft.

The guiding attitudes behind what follows are those that have vitalized most twentieth-century art: content dictates form; less is more; god is in the details. These three tenets neatly identify the typographer's job: appropriate, clear expression of the author's message, intelligent economy of

Italic

The guiding attitudes behind what follows are those that have vitalized most twentieth-century art: content dictates form; less is more; god is in the details. These three tenets neatly identify the typographer's job: appropriate, clear expression of the author's message, intelligent economy of means, and a deep understanding of craft.

The guiding attitudes behind what follows are those that have vitalized most twentieth-century art: content dictates form; less is more; god is in the details. These three tenets neatly identify the typographer's job: appropriate, clear expression of the author's message, intelligent economy of means, and a deep understanding of craft.

The guiding attitudes behind what follows are those that have vitalized most twentieth-century art: content dictates form; less is more; god is in the details. These three tenets neatly identify the typographer's job: appropriate, clear expression of the author's message, intelligent economy of means, and a deep understanding of craft.

Extended

The guiding attitudes behind what follows are those that have vitalized most twentieth-century art: content dictates form; less is more; god is in the details. These three tenets neatly identify the typographer's job: appropriate, clear expression of the author's message, intelligent economy of means, and a deep under-

The guiding attitudes behind what follows are those that have vitalized most twentieth-century art: content dictates form; less is more; god is in the details. These three tenets neatly identify the typographer's job: appropriate, clear expression of the author's message, intelligent economy of means, and a deep

The guiding attitudes behind what follows are those that have vitalized most twentieth-century art: content dictates form; less is more; god is in the details. These three tenets neatly identify the typographer's job: appropriate, clear expression of the author's message,

The guiding attitudes behind what follows are those that have vitalized most twentieth-century art: content dictates form; less is more; god is in the details. These three tenets neatly identify the typographer's job: appropriate, clear expression of the author's message,

In addition to properties best discussed elsewhere—hue, saturation, temperature—each color has a specific value, a tone that describes the color's weight on the page as a percentage of black.

Consider the color shown opposite, Pantone 032. Compare how the color meets black, white, and tints of black. We can see that it provides more or less the same contrast to white as to black, and neither advances nor recedes when seen next to a 50% screen of black. We can therefore describe it as having a gray value of approximately 50%.

Understanding—being able to see—gray value contributes significantly to readability in simple 'two-color' printing situations.

100% color

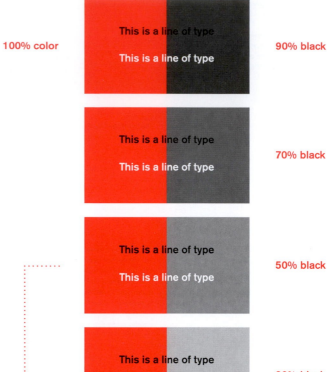

90% black

70% black

50% black

30% black

10% black

50% black

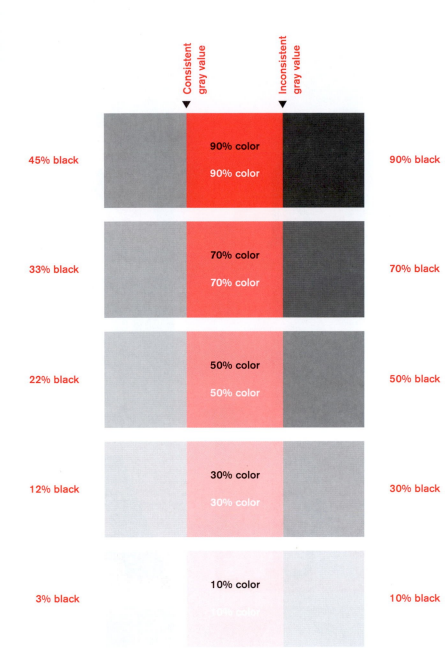

45% black **90% color** **90% color** 90% black

33% black **70% color** **70% color** 70% black

22% black **50% color** **50% color** 50% black

12% black **30% color** **30% color** 30% black

3% black **10% color** 10% color 10% black

Because, as we already know, full saturation of our color has a gray value of 50%, it will always be lighter than a similar percentage of black. For example, 90% of this color has a gray value of more or less 50% x 90%, or 45%. Note that straight math is only an approximate indicator. Trust your eye.

84 Although ink on paper remains a strictly two-dimensional phenomenon, we can imply a sense of depth on any page by manipulating contrast between colors. As these examples show, greater contrast between colors suggests a greater distance from front to back, figure to ground if you will. Less contrast suggests proximity.

One obvious use of color is to reinforce typographic hierarchy. In the examples on this page the black 'a's, because they provide more contrast with the white background, are clearly more important than the red or gray 'a's.

In these examples above, the 'a' seems to advance because it contrasts most strongly with the tones in both the background and the 'A.'

Although we tend to think of color as a way to highlight text elements within the black-and-white environment, the fact is that color—because it reduces contrast to the white background—often weakens readability, making text recede into, rather than advancing from, the page. See pages 127–129 for examples of how the convention of color contrast competes with the goal of emphasis.

Here (above), the maximum contrast exists between the 'A' and the background. As a result, the 'a' tends to recede, confusing what appears to be the intention of the composition.

Article 11

speak,

The free communication of ideas and opinions

write, and

is one of the most precious of the rights of man.

print

Every citizen may, accordingly, speak, write, and print with

with

freedom, but shall be responsible for such abuses of this

freedom

freedom as shall be defined by law.

Here, color and scale work together to reinforce the main thrust of the black text.

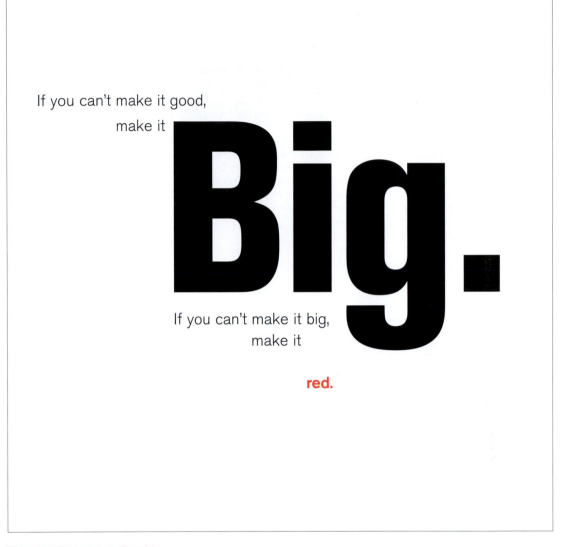

If you can't make it good,

make it **Big.**

If you can't make it big,
make it

red.

Here, simple contrast of scale,
weight, and color is used to
dramatic effect to demonstrate
the idea of the statement.

English is not Chinese

A characteristic of type design is that the letterforms themselves have evolved as a response to handwriting—the marks we make as we scrawl across a page. One of the identifiable features of those marks is that we make them as part of a horizontal flow, from left to right. This is something we all take for granted, as natural a part of written language as the use of upper- and lowercase.

Not all languages are written this way. Hebrew and Arabic, for instance, read right to left, and books in those languages begin at what we would consider the back. Look how illegible English would be if we encountered it set from right to left:

eb dluow hsilgnE elbigelli woh kooL
thgir morf tes ti deretnuocne ew fi
:tfel ot

Letterforms in typefaces have any number of attributes intended to reinforce the left-to-right flow of the written language: ascenders, descenders, consistent x-height, counters in lowercase forms typically appearing to the right. All these contribute to the sense of a line of text. And from the moment when we first learn to read, our brain assimilates these characteristics as essential for readable type.

Now to the point: written Chinese, unlike English, is not based on an alphabet; rather it is written in a series of characters called pictographs—forms that express an entire word or idea without necessarily indicating how to pronounce it.

Until recently, Chinese characters were typically read top to bottom, right to left, like this:

環滌皆山也其西
太守也太守謂誰

歸而賓客從也樹
太守醉也已而夕

非絲非竹射者中
看野蔌雜然而前

漁溪深而魚肥釀
傴提攜往來而不

歸四時之景不同

The simple fact that all Chinese characters are drawn to the same width makes this reading very simple. You can see in the example above that the characters descending the page make natural and obvious columns.

Occasionally, you will come across English type that has been set like Chinese:

W
O
R
S
E
N
I
N
G

w
o
r
s
e
n
i
n
g

Improving

As you can see, English letterforms are not all drawn to the same width. In left-to-right reading, the difference in widths presents no problem to readability; in fact, it adds to variety and color on the page. In vertical reading, all the type can do is create a shape. (Look at the profiles created by the difference between the wide W and the less-wide O, or between the N and the I.) When you consider that the primary purpose of type is to convey information with as little intrusion as possible, and that letterforms exist as a response to the lateral gestures of hand writing, then it should be clear that setting type vertically is inherently anti-typographic.

When the composition calls for vertical type, be mindful of the properties of the letterforms themselves, and set the type accordingly.

While you're at it, keep in mind how the baseline of the vertical type can, or cannot, relate to the vertical axes suggested by the rest of your type (in this instance, the left margin of the text).

Text

Tracking: kerning and letterspacing

Originally, the term 'kern' described the portion of a letterform that extended beyond the body of the type slug. As the example on the right shows, this adaptation was required in letterforms with angled strokes, so that spacing between letters within a word would remain optically consistent. Today the term 'kerning' describes the automatic adjustment of space between letters as prescribed by a table embedded within the digital font.

Because kerning removes space between letters, it is often mistakenly referred to as 'letterspacing.' In fact, letterspacing means adding space between letters, not removing it. For our purposes, the term 'tracking,' used in most computer programs that incorporate typesetting, best describes the addition or removal of space between letters. Keep in mind that even the best tracking table sometimes requires minor adjustments, especially at larger point sizes.

Without kerning

With kerning

Without kerning

With kerning

Yellow rifts

Normal tracking

Yellow rifts

Loose tracking (letterspacing)

Yellow rifts

Tight tracking (kerning)

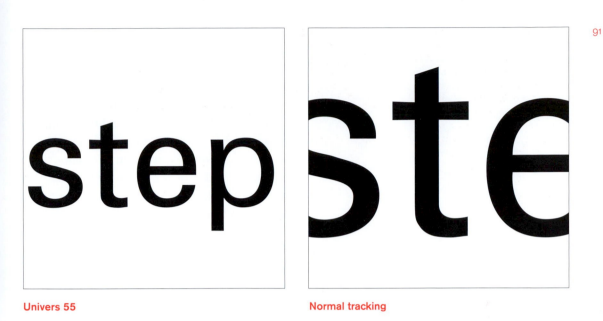

Univers 55

Normal tracking

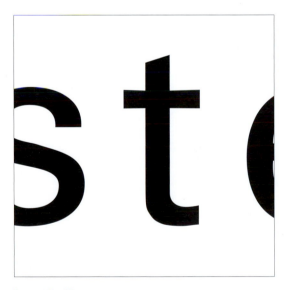

Tight tracking

Loose tracking

When setting text, tracking is critical to maintain easy reading. Note how loosely tracked text practically disintegrates right on the page, whereas tightly tracked text sacrifices readability as it comes to resemble no more than a series of stripes.

Normal tracking

Miss Brooke had that kind of beauty which seems to be thrown into relief by poor dress. Her hand and wrist were so finely formed that she could wear sleeves not less bare of style than those in which the Blessed Virgin appeared to Italian painters; and her profile as well as her stature and bearing seemed to gain the more dignity from her plain garments, which by the side of provincial fashion gave her the impressiveness of a fine quotation from the Bible—or from one of

Loose tracking

Miss Brooke had that kind of beauty which seems to be thrown into relief by poor dress. Her hand and wrist were so finely formed that she could wear sleeves not less bare of style than those in which the Blessed Virgin appeared to Italian painters; and her profile as well as her stature and bearing seemed to gain the more dignity from her plain garments, which by the side of provincial fashion gave her the impressiveness of a fine

Tight tracking

Miss Brooke had that kind of beauty which seems to be thrown into relief by poor dress. Her hand and wrist were so finely formed that she could wear sleeves not less bare of style than those in which the Blessed Virgin appeared to Italian painters; and her profile as well as her stature and bearing seemed to gain the more dignity from her plain garments, which by the side of provincial fashion gave her the impressiveness of a fine quotation from the Bible—or from one of the elder poets—in a paragraph of today's newspaper.

Designers often letterspace upper-case letters, but there has long been strong resistance within the type community to letterspacing lower-case letters within text. The reason for this resistance is quite clear if you look at the examples here. Uppercase forms are drawn to be able to stand on their own (consider their epigraphic origins). Lowercase forms require the counterform created between letters to maintain the line of reading (consider their origins in calligraphy).

Even though, when displayed alone and not as text, lowercase forms allow for some play in tracking, a moment occurs when readability is sacrificed for effect and meaning is lost.

IN MEMORIAM

In Memoriam

AFFLUENCE

affluence

EPISTEMOLOGY

epistemology

Formatting text

Flush left

This format most closely mirrors the asymmetrical experience of handwriting. Each line starts at the same point but ends wherever the last word on the line ends. Spaces between words are consistent throughout the text, allowing the type to create an even, gray value.

Flush left, ragged right (fl, rr)

If you know Starkfield, Massachusetts, you know the post-office. If you know the post-office you must have seen Ethan Frome drive up to it, drop the reins on his hollow-backed bay and drag himself across the brick pavement to the white colonnade; and you must have asked who he was.

Centered

This format imposes symmetry upon the text, assigning equal value and weight to both ends of any line. It transforms fields of text into shapes, thereby adding a pictorial quality to material that is non-pictorial by nature. Because centered type creates such a strong shape on the page, it's important to amend line breaks so that the text does not appear too jagged.

Centered (cent.)

If you know Starkfield, Massachusetts, you know the post-office. If you know the post-office you must have seen Ethan Frome drive up to it, drop the reins on his hollow-backed bay and drag himself across the brick pavement to the white colonnade; and you must have asked who he was.

Flush right

This format places emphasis on the end of a line as opposed to its start. It can be useful in situations (like captions) where the relationship between text and image might be ambiguous without a strong orientation to the right.

Flush right, ragged left (fr, rl)

If you know Starkfield, Massachusetts, you know the post-office. If you know the post-office you must have seen Ethan Frome drive up to it, drop the reins on his hollow-backed bay and drag himself across the brick pavement to the white colonnade; and you must have asked who he was.

Justified

Like centering, this format imposes a symmetrical shape upon the text. It is achieved by expanding or reducing spaces between words and, sometimes, between letters. The resulting openness of lines can occasionally produce 'rivers' of white space running vertically through the text. Careful attention to line breaks and hyphenation is required to amend this problem whenever possible.

Justified (just.)

If you know Starkfield, Massachusetts, you know the post-office. If you know the post-office you must have seen Ethan Frome drive up to it, drop the reins on his hollow-backed bay and drag himself across the brick pavement to the white colonnade; and you must have asked who he was.

All text, 10/13.5 Janson

Designers tend to set type one way or another depending upon several factors, not the least of which are tradition and personal preference. Prevailing culture and the need to express oneself play important, inevitable roles in any piece of communication. However, when setting a field of type, keep in mind the typographer's first job—clear, appropriate presentation of the author's message. Type that calls attention to itself before the reader can get to the actual words is simply interference, and should be avoided. Quite simply, if you see the type before you see the words, change the type.

Anna Klein, Mitchell King
and their families
invite you to join them
in the celebration of
their wedding.

23 June 2001
Village Hall
Framingham Center
1:30 p.m.
Reception to follow.

R.S.V.P.

Preconceptions about how something should look often interfere with effective, appropriate design of the message at hand. The formality of a wedding invitation, for example, is not necessarily tied to centered type—nor to script, for that matter.

Anna Klein, Mitchell King
and their families
invite you to join them
in the celebration of
their wedding.

23 June 2001
Village Hall
Framingham Center
1:30 P.M.
Reception to follow.

R.S.V.P.

Texture

Beyond learning about the unique characteristics of each typeface—and understanding its place in history—it's very important to understand how different typefaces feel as text. Different typefaces suit different messages. A good typographer has to know which typeface best suits the message at hand.

On pages 12–13 we discussed how typefaces 'felt' different from each other. On the next three pages, you can see how those ten typefaces compare with each other in identical text settings. Here you can see that the difference between typefaces is expressed not only in individual letterforms but also—and most importantly—in lines of type massed together to form blocks of text.

Consider too the different textures of these typefaces. Type with a relatively generous x-height or relatively heavy stroke width produces a darker mass on the page than type with a relatively smaller x-height or lighter stroke. Sensitivity to these differences in color is fundamental for creating successful layouts.

Call me Ishmael. Some years ago—never mind how long precisely—having little or no money in my purse, and nothing particular to interest me on shore, I thought I would sail about a little and see the watery part of the world. It is a way I have of driving off the spleen, and regulating the circulation. Whenever I find myself growing grim about the mouth; whenever it is a damp, drizzly November in my soul; whenever I find myself pausing before coffin warehouses, and bringing up the rear of every funeral I meet; and especially whenever my hypos get such an upper hand of me, that it requires a strong moral principle to prevent me from deliberately step-

10/13.5 Bembo

Call me Ishmael. Some years ago—never mind how long precisely—having little or no money in my purse, and nothing particular to interest me on shore, I thought I would sail about a little and see the watery part of the world. It is a way I have of driving off the spleen, and regulating the circulation. Whenever I find myself growing grim about the mouth; whenever it is a damp, drizzly November in my soul; whenever I find myself pausing before coffin warehouses, and bringing up the rear of every funeral I meet; and especially whenever my hypos get such an upper hand of me, that it requires a strong moral principle to prevent me from deliber-

10/13.5 Adobe Caslon

Call me Ishmael. Some years ago—never mind how long precisely—having little or no money in my purse, and nothing particular to interest me on shore, I thought I would sail about a little and see the watery part of the world. It is a way I have of driving off the spleen, and regulating the circulation. Whenever I find myself growing grim about the mouth; whenever it is a damp, drizzly November in my soul; whenever I find myself pausing before coffin warehouses, and bringing up the rear of every funeral I meet; and especially whenever my hypos get such an upper hand of me, that it requires a strong moral principle to prevent me from deliberately stepping into the

10/13.5 Adobe Garamond

Call me Ishmael. Some years ago—never mind how long precisely—having little or no money in my purse, and nothing particular to interest me on shore, I thought I would sail about a little and see the watery part of the world. It is a way I have of driving off the spleen, and regulating the circulation. Whenever I find myself growing grim about the mouth; whenever it is a damp, drizzly November in my soul; whenever I find myself pausing before coffin warehouses, and bringing up the rear of every funeral I meet; and especially whenever my hypos get such an upper hand of me, that it requires a strong moral principle to prevent me from deliberately

10/13.5 Monotype Baskerville

Call me Ishmael. Some years ago—never mind how long precisely—having little or no money in my purse, and nothing particular to interest me on shore, I thought I would sail about a little and see the watery part of the world. It is a way I have of driving off the spleen, and regulating the circulation. Whenever I find myself growing grim about the mouth; whenever it is a damp, drizzly November in my soul; whenever I find myself pausing before coffin warehouses, and bring-ing up the rear of every funeral I meet; and especially whenever my hypos get such an upper hand of me, that it requires a strong

10/13.5 Janson

Call me Ishmael. Some years ago—never mind how long precisely—having little or no money in my purse, and nothing particular to interest me on shore, I thought I would sail about a little and see the watery part of the world. It is a way I have of driving off the spleen, and regulating the circulation. Whenever I find myself growing grim about the mouth; whenever it is a damp, drizzly November in my soul; whenever I find myself pausing before coffin warehouses, and bring-ing up the rear of every funeral I meet; and especially whenever my hypos get such an upper hand of me, that it requires a strong

10/13.5 Bauer Bodoni

Call me Ishmael. Some years ago—never mind how long precisely—having little or no money in my purse, and nothing particular to interest me on shore, I thought I would sail about a little and see the watery part of the world. It is a way I have of driving off the spleen, and regulating the circulation. Whenever I find myself growing grim about the mouth; whenever it is a damp, drizzly November in my soul; whenever I find myself pausing before coffin warehouses, and bringing up the rear of every funeral I meet; and especially

10/13.5 Serifa

Call me Ishmael. Some years ago—never mind how long precisely—having little or no money in my purse, and nothing particular to interest me on shore, I thought I would sail about a little and see the watery part of the world. It is a way I have of driving off the spleen, and regulating the circulation. Whenever I find myself growing grim about the mouth; whenever it is a damp, drizzly November in my soul; whenever I find myself pausing before coffin warehouses, and bringing up the rear of every funeral I meet; and especially whenever my hypos get such an upper hand of me, that it

10/13.5 Futura Book

Call me Ishmael. Some years ago—never mind how long precisely—having little or no money in my purse, and nothing particular to interest me on shore, I thought I would sail about a little and see the watery part of the world. It is a way I have of driving off the spleen, and regulating the circulation. Whenever I find myself growing grim about the mouth; whenever it is a damp, drizzly November in my soul; whenever I find myself pausing before coffin warehouses, and bringing up the rear of every funeral I meet; and especially

10/13.5 Univers 55

Call me Ishmael. Some years ago—never mind how long precisely—having little or no money in my purse, and nothing particular to interest me on shore, I thought I would sail about a little and see the watery part of the world. It is a way I have of driving off the spleen, and regulating the circulation. Whenever I find myself growing grim about the mouth; whenever it is a damp, drizzly November in my soul; whenever I find myself pausing before coffin warehouses, and bringing up the rear of every funeral I meet; and especially whenever my hypos get such an upper hand of me, that it requires a strong

10/13.5 Meta Plus Normal

Typing is not typesetting

For the better part of the 20th century, the distinctive forms of type-writer type (notably its single character width and unstressed stroke) characterized the immediacy of thought: getting the idea down without dressing it up. Now that computers have replaced typewriters, most word processing programs default to Helvetica or Times Roman (or their derivatives) as the typographic expression of simple typing (see below). E-mail—currently the most immediate form of typed communication—appears on our computer screens as an electroni-cally neutered serif or sans serif, any individuality scraped off in deference to the requirements of the pixel.

As a typographer, you should recognize the difference between typing and typesetting. Time and usage may ultimately make Inkjet Sans the expected typeface for letters. For now, however, on paper, typewriter type (like Courier, shown below) is still the best expression of the intimate, informal voice—direct address. Imitating the formalities of typesetting in a letter is always inap-propriate because it suggests an undeserved permanence—the end of a discussion, not its continuation.

I have great trouble, and
some comfort, to acquaint you
with. The trouble is, that my
good lady died of the illness
I mentioned to you, and left
us all much grieved for the
loss of her; for she was a dear
good lady, and kind to all us
her servants. Much I feared, as
I was taken by her ladyship to
wait upon her person, I should
be quite destitute again, and
forced to return to you and my
poor mother, who have enough to
do to maintain yourselves; and,
as my lady's goodness had put

10/12 Courier

I have great trouble, and
some comfort, to acquaint
you with. The trouble is,
that my good lady died of
the illness I mentioned to
you, and left us all much
grieved for the loss of her;
for she was a dear good
lady, and kind to all us her

10/12 Helvetica

I have great trouble, and some
comfort, to acquaint you
with. The trouble is, that my
good lady died of the illness
I mentioned to you, and left
us all much grieved for the
loss of her; for she was a dear
good lady, and kind to all us
her servants. Much I feared,

10/12 Times Roman

Leading and line length

I had taken Mrs. Prest into my confidence; in truth without her I should have made but little advance, for the fruitful idea in the whole business dropped from her friendly lips. It was she who invented the short cut, who severed the Gordian knot. It is not supposed to be the nature of women to rise as a general thing to the largest and most liberal view—I mean of a practical scheme; but it has struck me that they sometimes throw off a bold conception—such as a man would not

10/10 Janson
10 pt. type
10 pt. line

I had taken Mrs. Prest into my confidence; in truth without her I should have made but little advance, for the fruitful idea in the whole business dropped from her friendly lips. It was she who invented the short cut, who severed the Gordian knot. It is not supposed to be the nature of women to rise as a general thing to the largest and most liberal view—I mean of a practical scheme; but it has struck me that they sometimes throw off

10/11 Janson
10 pt. type
11 pt. line

I had taken Mrs. Prest into my confidence; in truth without her I should have made but little advance, for the fruitful idea in the whole business dropped from her friendly lips. It was she who invented the short cut, who severed the Gordian knot. It is not supposed to be the nature of women to rise as a general thing to the largest and most liberal view—I mean of a practical scheme; but it has struck me that they sometimes throw off

10/10.5 Janson
10 pt. type
10.5 pt. line

I had taken Mrs. Prest into my confidence; in truth without her I should have made but little advance, for the fruitful idea in the whole business dropped from her friendly lips. It was she who invented the short cut, who severed the Gordian knot. It is not supposed to be the nature of women to rise as a general thing to the largest and most liberal view—I mean of a practical scheme; but it has struck me that they sometimes throw off

10/11.5 Janson
10 pt. type
11.5 pt. line

The goal in setting text type is to allow for easy, prolonged reading. At the same time, a field of type should occupy the page much as a photograph does.

Type size
Text type should be large enough to be read easily at arm's length — imagine yourself holding a book in your lap.

Leading
Text that is set too tightly encourages vertical eye movement; a reader can easily lose his or her place. Type that is set too loosely creates striped patterns that distract the reader from the material at hand.

Virtually every computer program
assumes a default leading of 120%
of type size (10 pt. type is set to a 12
pt. line, 12 pt. type is set to a 14.4 pt.
line, etc.). If your program says your
type is leaded to 'default,' fix it.

I had taken Mrs. Prest into my confidence;
in truth without her I should have made but
little advance, for the fruitful idea in the
whole business dropped from her friendly
lips. It was she who invented the short cut,
who severed the Gordian knot. It is not
supposed to be the nature of women to rise as
a general thing to the largest and most liberal
view—I mean of a practical scheme; but it

10/12 Janson
10 pt. type
12 pt. line

I had taken Mrs. Prest into my confidence;
in truth without her I should have made but
little advance, for the fruitful idea in the
whole business dropped from her friendly
lips. It was she who invented the short cut,
who severed the Gordian knot. It is not
supposed to be the nature of women to rise as
a general thing to the largest and most liberal
view—I mean of a practical scheme; but it

10/13 Janson
10 pt. type
13 pt. line

I had taken Mrs. Prest into my confidence;
in truth without her I should have made but
little advance, for the fruitful idea in the
whole business dropped from her friendly
lips. It was she who invented the short cut,
who severed the Gordian knot. It is not
supposed to be the nature of women to rise as
a general thing to the largest and most liberal
view—I mean of a practical scheme; but it

10/12.5 Janson
10 pt. type
12.5 pt. line

I had taken Mrs. Prest into my confidence;
in truth without her I should have made but
little advance, for the fruitful idea in the
whole business dropped from her friendly
lips. It was she who invented the short cut,
who severed the Gordian knot. It is not
supposed to be the nature of women to rise as
a general thing to the largest and most liberal

10/13.5 Janson
10 pt. type
13.5 pt. line

Line length

Appropriate leading for text is as much a function of line length as it is a question of type size and leading. Shorter lines require less leading; longer lines, more.

In general text settings—specifically not including captions and headlines—a good rule of thumb is to keep line length somewhere between 35 and 65 characters. In practice, limitations of space or the dictates of special use may require longer or shorter lengths. In any event, be sensitive to that moment when extremely long or short line lengths impair easy reading.

I had taken Mrs. Prest into my confidence; in truth without her I should have made but little advance, for the fruitful idea in the whole business dropped from her friendly lips. It was she who invented the short cut, who severed the Gordian knot. It is not supposed to be the nature of women to rise as a general thing to the largest and most liberal view—I mean of a practical scheme; but it has struck me that they sometimes throw off a bold conception—such as a man would not have risen to—with singular serenity. "Simply ask them to take you in on the footing of a lodger"—I don't think that unaided I should have risen to that. I was beating about the bush, trying to be ingenious, wondering by what combination of arts I might have become an acquaintance, when she offered this happy suggestion that the way to become an acquaintance was first to become an inmate. Her actual knowledge of the Misses Bordereau was scarcely larger than mine, and indeed I had

10/12 Janson x 22p3

I had taken Mrs. Prest into my confidence; in truth without her I should have made but little advance, for the fruitful idea in the whole business dropped from her friendly lips. It was she who invented the short cut, who severed the Gordian knot. It is not supposed to be the nature of women to rise as a general thing to the largest and most liberal view—I mean of a practical scheme; but it has struck me that they sometimes throw off a bold conception—such as a man would not have risen to—with singular serenity. "Simply ask them to take you in on the footing of a lodger"—I don't think that unaided I should have risen to that. I was beating about the bush, trying to be ingenious, wondering by what combination of arts I might have become an acquaintance, when she offered this happy suggestion that the way to become an acquaintance was first to become an inmate. Her actual knowledge of the Misses

10/13 Janson x 22p3

I had taken Mrs. Prest into my confidence; in truth without her I should have made but little advance, for the fruitful idea in the whole business dropped from her friendly lips. It was she who invented the short cut, who severed the Gordian knot. It is not supposed to be the nature of women to rise as a general thing to the largest and most liberal view—I mean of a practical scheme; but it has struck me that they sometimes throw off a bold conception—such as a man would not have risen to—with singular serenity. "Simply ask them to take you in on the footing of a lodger"—I don't think that unaided I should have risen to that. I was beating about the bush, trying to be ingenious, wondering by

I had taken Mrs. Prest into my confidence; in truth without her I should have made but little advance, for the fruitful idea in the whole business dropped from her friendly lips. It was she who invented the short cut, who severed the Gordian knot. It is not supposed to be the nature of women to rise as a general thing to the largest and most liberal view— I mean of a practical scheme; but it has struck me that they sometimes throw off a

10/12 Janson x 16p3

10/12 Janson x 10p4

I had taken Mrs. Prest into my confidence; in truth without her I should have made but little advance, for the fruitful idea in the whole business dropped from her friendly lips. It was she who invented the short cut, who severed the Gordian knot. It is not supposed to be the nature of women to rise as a general thing to the largest and most liberal view—I mean of a practical scheme; but it has struck me that they sometimes throw off a bold conception—such as a man would not have risen to—with singular serenity. "Simply ask them to take you in on the footing of a lodger"—I don't think that unaided I should have risen to that. I was beating about the

I had taken Mrs. Prest into my confidence; in truth without her I should have made but little advance, for the fruitful idea in the whole business dropped from her friendly lips. It was she who invented the short cut, who severed the Gordian knot. It is not supposed to be the nature of women to rise as a general thing to the largest and most liberal view— I mean of a practical scheme; but it has struck me that

10/13 Janson x 16p3

10/13 Janson x 10p4

Lorem ipsum dolor sit amet, consectetuer adipiscing elit, sed diam non-ummy nibh euismod tincidunt ut laoreet dolore magna aliquam erat volutpat. Ut wisi enim ad minim veniam, quis nostrud exerci tation ullamcorper. Suscipit lobortis nisl ut aliquip ex ea commodo consequat. Duis autem vel eum iriure dolor in hendrerit in vulputate velit esse molestie consequat, vel illum dolore eu feugiat nulla facilisis at vero eros et accumsan. Iusto odio dignissim qui blandit praesent luptatum zzril delenit augue duis dolore te feugait nulla facilisi. Lorem ipsum dolor sit amet, consectetuer adipiscing elit, sed diam nonummy nibh euismod tincidunt ut laoreet dolore magna aliquam erat volutpat. Ut wisi enim ad minim veniam, quis nostrud exerci tation ullamcorper sus-cipit lobortis nisl ut aliquip ex ea commodo consequat. Duis autem vel eum iriure dolor in hendrerit in vulputate velit esse molestie consequat, vel illum dolore eu feugiat nulla facilisis at vero eros et accumsan et iusto odio dignissim qui blandit praesent luptatum zzril delenit augue duis dolore te feugait nulla facilisi. Nam liber tempor cum soluta nobis eleifend option congue nihil imperdiet doming id quod mazim placerat facer possim assum. Lorem ipsum dolor sit amet, consectetuer adipisc-ing elit, sed diam nonummy nibh euismod tincidunt ut laoreet dolore magna aliquam erat volutpat. Ut wisi enim ad minim veniam, quis nos-trud exerci tation ullamcorper suscipit lobortis nisl ut aliquip ex ea commodo consequat. Duis autem vel eum iriure dolor in hendrerit in vulputate velit esse molestie consequat, vel illum dolore eu feugiat nulla facilisis at vero eros et accumsan et iusto odio dignissim qui blandit praesent luptatum zzril delenit augue duis dolore te feugait nulla facil-isi. Lorem ipsum dolor sit amet, consectetuer adip Lorem ipsum dolor sit amet, consectetuer adipiscing elit, sed diam nonummy nibh euismod tincidunt ut laoreet dolore magna aliquam erat volutpat. Ut wisi enim ad minim veniam, quis nostrud exerci tation ullamcorper suscipit lobor-tis nisl ut aliquip ex ea commodo consequat. Duis autem vel eum iriure dolor in hendrerit in vulputate velit esse molestie consequat, vel illum dolore eu feugiat nulla facilisis at vero eros et accumsan et iusto odio dignissim qui blandit praesent luptatum zzril delenit augue duis dolore

Lorem ipsum dolor sit amet, consectetuer adipiscing elit, sed diam non-ummy nibh euismod tincidunt ut laoreet dolore magna aliquam erat volutpat. Ut wisi enim ad minim veniam, quis nostrud exerci tation ullamcorper. Suscipit lobortis nisl ut aliquip ex ea commodo consequat. Duis autem vel eum iriure dolor in vulputate velit esse molestie consequat, vel illum dolore eu feugiat nulla facilisis at vero eros et accumsan. Iusto odio dignissim qui blandit praesent luptatum zzril delenit augue duis dolore te feugait nulla facilisi. Lorem ipsum dolor sit amet, consectetuer adipiscing elit, sed diam nonummy nibh euismod tincidunt ut laoreet dolore magna aliquam erat volutpat. Ut wisi enim ad minim veniam, quis nostrud exerci tation ullamcorper sus-cipit lobortis nisl ut aliquip ex ea commodo consequat. Duis autem vel eum iriure dolor in hendrerit in vulputate velit esse molestie consequat, vel illum dolore eu feugiat nulla facilisis at vero eros et accumsan et iusto odio dignissim qui blandit praesent luptatum zzril delenit augue duis dolore te feugait nulla facilisi. Nam liber tempor cum soluta nobis eleifend option congue nihil imperdiet doming id quod mazim placerat facer possim assum. Lorem ipsum dolor sit amet, consectetuer adipisc-ing elit, sed diam nonummy nibh euismod tincidunt ut laoreet dolore magna aliquam erat volutpat. Ut wisi enim ad minim veniam, quis nos-trud exerci tation ullamcorper suscipit lobortis nisl ut aliquip ex ea commodo consequat. Duis autem vel eum iriure dolor in hendrerit in vulputate velit esse molestie consequat, vel illum dolore eu feugiat nulla facilisis at vero eros et accumsan et iusto odio dignissim qui blandit praesent luptatum zzril delenit augue duis dolore te feugait nulla facil-isi. Lorem ipsum dolor sit amet, consectetuer adip Lorem ipsum dolor

Compositional requirements
Text type should create a field that can occupy the page much as a photograph does. Think of your ideal text as having a middle gray value (above, left), not as a series of stripes (above, right).

It is often useful to enlarge type 400% on the screen to get a clear sense of the relationship between descenders on one line and ascenders on the line below. Here you can clearly see the difference one point of leading can make—a difference that is unrecognizable at 100% on most monitors.

Keep in mind that nothing replaces looking closely at an actual print-out of your work. The best screen is still an electronic approximation of the printed page.

I had taken Mrs. Prest into my confidence; in truth without her I should have made but little advance, for the fruitful idea in the whole business dropped from her friendly lips. It was she who invented the short cut, who

10/12 Janson @ 400%

I had taken Mrs. Prest into my confidence; in truth without her I should have made but little advance, for the fruitful idea in the whole business dropped from her friendly lips. It was she who

10/13 Janson @ 400%

Kinds of proportion

106 A designer's first consideration is the size and shape of the page. Although practical limitations—particularly economies of paper—often limit the designer's options, it is extremely useful to understand how the proportions we work with have evolved, and then to test your own responses against the received wisdom. Remember that these proportions—like so much else in typography and design in general—are the result of direct observation of, and interaction with, the world around us. Only your own practice and experimentation will give you a feel for what page size is most appropriate for each project.

The golden section
A dominant influence on the sense of proportion in Western art is the golden section. The term 'golden section' describes a relationship that occurs between two numbers when the ratio of the smaller to the larger is the same as the ratio of the larger to the sum of the two. The formula expressing this relationship is
a : b = b : (a+b).
The aspect ratio described by a golden section is 1:1.618.

The golden section has existed as a model for proportion since classical times, employed by architects and visual artists in determining composition at all scales, from the shape of a page to the façade of a building. Its relation to contemporary graphic design, however, has become somewhat attenuated (see page 113).

(see page 113).

To find the golden section in a square:

1
Draw the square abcd.

2
Bisect the square with line ef.
Draw an isoceles triangle cde.

3
Project the line ce along the base of the square, forming line cg.

When you remove the square
from a golden rectangle,
you are left with another
golden rectangle.

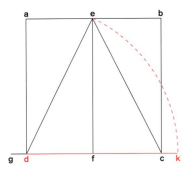

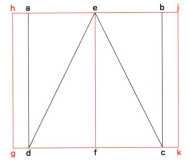

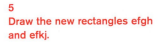

4
Project the line de along the base
of the square, forming line dk.

5
Draw the new rectangles efgh
and efkj.

Both rectangles **efgh** and **efkj**
have the proportions of the golden
section; the relationship of **eh** to **gh**
is the same as the relationship of **gh**
to **(eh + gh)**. Similarly, the relation-
ship of **ej** to **jk** is the same as the
relationship of **jk** to **(ej + jk)**—all are
1:1.618.

Fibonacci sequence
Another useful model when
considering proportions is the
Fibonacci sequence. Named for
Italian mathematician Leonardo
Fibonacci (c.1170−1240), a Fibonacci
sequence describes a sequence in
which each number is the sum of
the two preceding numbers:

0
1
1 [1+0]
2 [1+1]
3 [1+2]
5 [2+3]
8 [3+5]
13 [5+8]
21 [8+13]
34 [13+21]
...

As the numbers in a Fibonacci
sequence increase, the proportion
between any two numbers very
closely approximates the proportion
in a golden section (1:1.618). For
example, 21:34 approximately equals
1:1.618. Nature is full of examples
of the Fibonacci sequence and the
golden section, from the intervals of
branches on a tree to the shell of a
chambered nautilus.

Fibonacci's sequence always began
with 1 but the proportion between
any two numbers remains constant
when the sequence is multiplied:

0	0	0
2	3	4
2	3	4
4	6	8
6	9	12
10	15	20
16	24	32
26	39	52
42	63	84
68	102	136
...

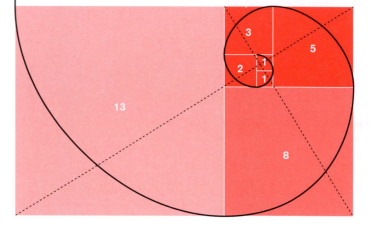

Above, a spiral describing a Fibonacci series (and the growth of a chambered nautilus). The red rectangle on the upper right approximates a golden section. As each square in the sequence is added, the orientation of the golden section changes from vertical to horizontal.

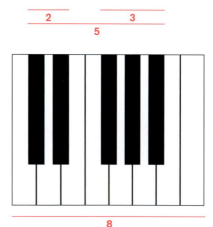

Left, one of the many examples of a Fibonacci sequence is the musical octave as seen on a piano—eight white keys and five black keys (separated into a group of two and a group of three).

Series of type sizes based on a
Fibonacci sequence:

The basic sequence
(beginning at 1):
5 pt., 8 pt., 13 pt., 21 pt., 34 pt.,
and 55 pt.

Aa Aa Aa Aa Aa **Aa**

The sequence doubled:
6 pt., 10 pt., 16 pt., 26 pt., 42 pt.,
and 68 pt.

Aa Aa Aa Aa Aa **Aa**

The first and second sequences
interlaced:
6 pt., 8 pt., 10 pt., 13 pt., 16 pt.,
21 pt., 26 pt., 34 pt., and 42 pt.

Aa Aa Aa Aa Aa Aa Aa **Aa Aa**

Compare with a straightforward
arithmetic sequence (+5):
5 pt., 10 pt., 15 pt., 20 pt., 25 pt.,
30 pt., 35 pt., and 40 pt.

Aa Aa Aa Aa Aa Aa Aa **Aa**

Or, a geometric sequence (x2):
4 pt., 8 pt., 16 pt., 32 pt., and 64 pt.

Aa Aa Aa Aa **Aa**

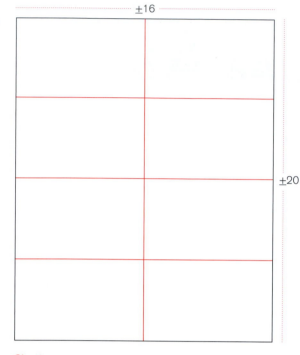

Sheet

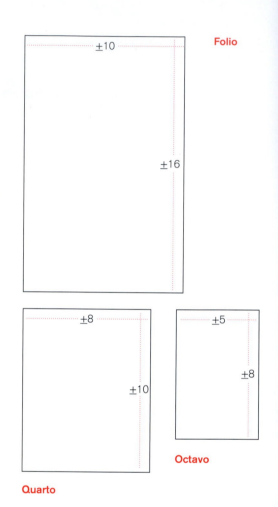

Folio

Quarto

Octavo

Traditional page sizes

For the first 300 years of printing, the standard printing sheet ran anywhere between 16 x 20 in (406 x 508 mm) and 19 x 24 in (482 x 609 mm). Page sizes were referred to as folio (half sheet), quarto (quarter sheet), and octavo (eighth sheet). Specific dimensions of these page sizes varied according to size of the basic sheet. Note that only the folio and octavo sizes approximate the golden section.

Standard American paper sizes

In American printing (and in those countries dependent upon American suppliers), most paper sizes are based on a page size of 8.5 x 11 in (216 x 279 mm) or 9 x 12 in (229 x 305 mm). As you can see opposite, these sizes derive from the traditional sheet, although they have been modified based on the economies of the current standard printing sheet. There is no longer any relationship to the golden section except for the 5.5 x 8.5 in (140 x 216 mm) sheet.

8.5 x 11 in (216 x 279 mm) sheet
Aspect ratio 1:1.294

9 x 12 in (229 x 355 mm) sheet
Aspect ratio 1:1.333

5.5 x 8.5 in (140 x 216 mm) sheet
Aspect ratio 1:1.545

6 x 9 in (152 x 229 mm) sheet
Aspect ratio 1:1.5

A1

A3

A2

A5

A4

A7

A6

A9

A8

A10

			Approximate inches
A0	=	841 x 1189 mm	33.1 x 46.8 in
A1	=	594 x 841 mm	23.4 x 33.1 in
A2	=	420 x 594 mm	16.5 x 23.4 in
A3	=	297 x 420 mm	11.7 x 16.5 in
A4	**=**	**210 x 297 mm**	**8.3 x 11.7 in**
A5	=	148 x 210 mm	5.8 x 8.3 in
A6	=	105 x 148 mm	4.1 x 5.8 in
A7	=	74 x 105 mm	2.9 x 4.1 in
A8	=	52 x 74 mm	2 x 2.9 in
A9	=	37 x 52 mm	1.5 x 2 in
A10	=	26 x 37 mm	1 x 1.5 in

Relative size and proportion of A4 (black), 8.5 x 11 in (216 x 279 mm; red), and golden section taken from A4 (dotted black) and 8.5 x 11 in (216 x 279 mm; dotted red)

European paper: the ISO system

In Europe—and many other parts of the world—paper sizes are based on what is called the ISO (International Organization for Standardization) system.

The ISO system was originated at the beginning of the 20th century by Nobel laureate Wilhelm Ostwald, who proposed an aspect ratio of 1 to the square root of 2 (1.414) as the basis for all printed matter—from postage stamps to oversized posters. The beauty of this ratio is that any sheet of paper trimmed to this format, when cut or folded in half, produces a sheet with exactly the same aspect ratio (1:1.414). The basic ISO sheet sizes are:

A0 (841 x 1189 mm)
B0 (1000 x 1414 mm)
C0 (917 x 1297 mm)

In practical applications, the A series is the basic page size (A4 is the equivalent of the American 8.5 x 11 inch sheet). The B series is often used for books and flyers; this book is trimmed to the B5 format (6.9 x 9.8 in; 176 mm x 250 mm).

Other than the mathematical elegance of the ISO system and the possible esthetic preference for its proportions, nothing necessarily recommends ISO over American format other than use. And there is nothing to say that only standard sizes are appropriate for any particular task, as we shall see later.

Components of the text page

When designing a book with sequential text, we need to be familiar with the terms that describe what makes up a page.

Recto

The right-hand page. In book work, this page is always odd-numbered (i.e. page 1 is always a recto).

Verso

The left-hand page. This page is always even-numbered.

Text page

(Top) This is the area of the page that is used exclusively for text. The size of this area depends upon several factors: the size of the page itself, the size of the text type, and the length of a line of text. Common sense should dictate all three. For example, a book meant to be hand-held can be much smaller than a book intended to rest on a flat reading surface. Text type should typically be readable approximately half a meter (19 inches) away from the eye. Finally, the ideal line length is no more than 65 characters maximum.

Margins

(Bottom) This is the part of the page where text isn't. This area must be large enough to accommodate any marginalia (see following), the amount of paper hidden by the book's binding, and, perhaps most importantly, the space needed for one's hands—specifically one's thumbs—to hold the book open without obscuring the text.

Verso **Recto**

Top: A spread showing text pages

Bottom: A spread showing margins

Folios / headers

Folios (page numbers) and **headers** are material in the margins that tells the reader where he or she is in the text. Depending where on the page they appear, headers are referred to as **running heads** (top), **running shoulders** (sides), or **running feet** (bottom). Headers may display the book or part title on the verso and the chapter title on the recto, or chapter title on the verso and subsection title on the recto. Folios may appear in any of these locations. (See also pages 186–187.)

1
Running heads
2
Running shoulders
3
Running feet

Placing text on a page

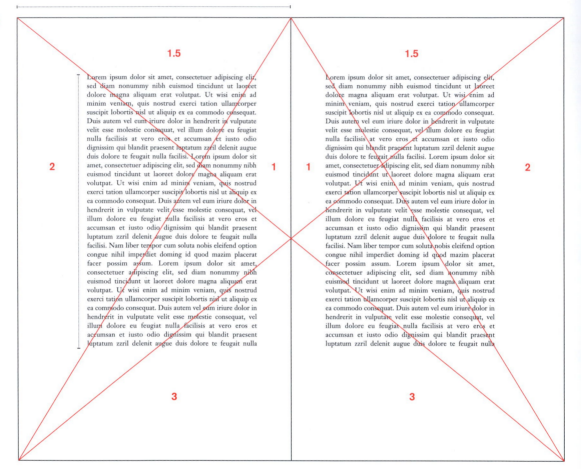

Just as the golden section can be seen as one ideal of proportion, there is also an ideal layout based on the golden section. Shown above, this layout has been considered an ideal since the creation of illuminated books in the Middle Ages, although by the advent of printing it was a 'custom more honored in the breach than the observance' (Shakespeare).

The rules for this layout are simple:
1
The height of the text field equals the width of the full page ().
2
The placement of the text field is determined by the diagonals that describe both the page and the field.
3
The margins at the gutter of the spread (along the spine of the book) define **1** unit of measure. The margin at the top of the page equals **1.5** units. The margins to the outside of the page equal **2** units. And the margin at the bottom equals **3** units.

Note that part of what makes this layout appealing is the tension created by the different margins. Text occupies approximately 40% of the page area.

Lorem ipsum dolor sit amet, consectetuer adipiscing elit, sed diam nonummy nibh euismod tincidunt ut laoreet dolore magna aliquam erat volutpat. Ut wisi enim ad minim veniam, quis nostrud exerci tation ullamcorper suscipit lobortis nisl ut aliquip ex ea commodo consequat. Duis autem vel eum iriure dolor in hendrerit in vulputate velit esse molestie consequat, vel illum dolore eu feugiat nulla facilisis at vero eros et accumsan et iusto odio dignissim qui blandit praesent luptatum zzril delenit augue duis dolore te feugait nulla facilisi. Lorem ipsum dolor sit amet, consectetuer adipiscing elit, sed diam nonummy nibh euismod tincidunt ut laoreet dolore magna aliquam erat volutpat. Ut wisi enim ad minim veniam, quis nostrud exerci tation ullamcorper suscipit lobortis nisl ut aliquip ex ea commodo consequat. Duis autem vel eum iriure dolor in hendrerit in vulputate velit esse molestie consequat, vel illum dolore eu feugiat nulla facilisis at vero eros et accumsan et iusto odio dignissim qui blandit praesent luptatum zzril delenit augue duis dolore te feugait nulla facilisi. Nam liber tempor cum soluta nobis eleifend option congue nihil imperdiet doming id quod mazim placerat facer possim assum. Lorem ipsum dolor sit amet, consectetuer adipiscing elit, sed diam nonummy nibh euismod tincidunt ut laoreet dolore magna aliquam erat volutpat. Ut wisi enim ad minim veniam, quis nostrud exerci tation ullamcorper suscipit lobortis nisl ut aliquip ex ea commodo consequat. Duis autem vel eum iriure dolor in hendrerit in vulputate velit esse molestie consequat, vel illum dolore eu feugiat nulla facilisis at vero eros et accumsan et iusto odio dignissim qui blandit praesent luptatum zzril delenit augue duis

8.5 x 11 in (216 x 279 mm)

Lorem ipsum dolor sit amet, consectetuer adipiscing elit, sed diam nonummy nibh euismod tincidunt ut laoreet dolore magna aliquam erat volutpat. Ut wisi enim ad minim veniam, quis nostrud exerci tation ullamcorper suscipit lobortis nisl ut aliquip ex ea commodo consequat. Duis autem vel eum iriure dolor in hendrerit in vulputate velit esse molestie consequat, vel illum dolore eu feugiat nulla facilisis at vero eros et accumsan et iusto odio dignissim qui blandit praesent luptatum zzril delenit augue duis dolore te feugait nulla facilisi. Lorem ipsum dolor sit amet, consectetuer adipiscing elit, sed diam nonummy nibh euismod tincidunt ut laoreet dolore magna aliquam erat volutpat. Ut wisi enim ad minim veniam, quis nostrud exerci tation ullamcorper suscipit lobortis nisl ut aliquip ex ea commodo consequat. Duis autem vel eum iriure dolor in hendrerit in vulputate velit esse molestie consequat, vel illum dolore eu feugiat nulla facilisis at vero eros et accumsan et iusto odio dignissim qui blandit praesent luptatum zzril delenit augue duis dolore te feugait nulla facilisi. Nam liber tempor cum soluta nobis eleifend option congue nihil imperdiet doming id quod mazim placerat facer possim assum. Lorem ipsum dolor sit amet, consectetuer adipiscing elit, sed diam nonummy nibh euismod tincidunt ut laoreet dolore magna aliquam erat volutpat. Ut wisi enim ad minim veniam, quis nostrud exerci tation ullamcorper suscipit lobortis nisl ut aliquip ex ea commodo consequat. Duis autem vel eum iriure dolor in hendrerit in vulputate velit esse molestie consequat, vel illum dolore eu feugiat nulla facilisis at vero eros et accumsan et iusto odio dignissim qui blandit praesent luptatum zzril delenit augue duis

A4

The requirements of contemporary printing take us far away from the medieval ideal. The examples above show how the layout principle in the golden rectangle page (width of page equals height of text) do not convert to an 8.5 x 11 in (216 x 279 mm) or an A4 sheet. Clearly, the proportions of these pages require their own set of rules. We live in an era when xerography rules, and, as often as not, whatever comes most easily out of the copier or laser printer determines the most appropriate paper sizes—none of which approximates a golden rectangle.

Book printing allows for more freedom in choosing page sizes, but economies of paper typically demand far narrower margins and longer lines than the ancients would have tolerated (look at any textbook). Commerce demands printed pieces that are best suited to sizes and shapes of paper unimagined in 1455 (consider flyers, mailers, brochures, folders, schedules—and on and on). Very few of the messages in these pieces demand the kind of sustained reading best served by a single field of text carefully placed on the page.

So typographers now operate in a world where readability, meaning, clarity, and appropriateness are constantly being tested against the realities of the marketplace and the specific requirements of the page. Our task becomes that of applying what we can of the old principles to contemporary situations.

Chapters always begin on a recto.
The first line of text after a head
typically does not indent.

118 Because reading is a physical act, the first goal of designing text is to make the experience pleasurable. On the page opposite, a first page of text (in this case, Jane Austen's *Pride and Prejudice*) displays several of the considerations that contribute to successful text setting. Page size (B5) makes for a portable book, comfortable in the hand, easy to read in a variety of environments. Margins provide adequate room for the reader to hold the pages open without obscuring text. Type size and leading (11/14 Janson Text) is clear to the reader when the book is held at arm's length. Moderate line length (approximately 65 characters) helps prevent fatigue as the eye jumps from the end of one line to the beginning of the next.

While satisfying the larger require-ments, text design allows for a variety of details that can ornament the page without intruding on easy, pleasurable reading. Some of the widely used options for chapter openers are displayed on this page.

Note that title pages do not have headers, but do have folios.

Chapter I

It is a truth universally acknowledged that a single man in possession of a good fortune must be in want of a wife.
However little known the feelings or views of such a man may be on his first entering a neighborhood, this truth is so well fixed in the minds of the surrounding families, that he is considered as the rightful property of some one or other of their daughters.
'My dear Mr. Bennet,' said his lady to him one day, 'have you heard that Netherfield Park is let at last?'
Mr. Bennet replied that he had not. 'But it is,' returned she, 'for Mrs. Long has just been here, and she told me all about it.'
Mr. Bennet made no answer.
'Do you not want to know who has taken it?' cried his wife, impatiently.
'You want to tell me, and I have no objection to hearing it.'
This was invitation enough.
'Why, my dear, you must know, Mrs. Long says that Netherfield is taken by a young man of large fortune from the north of England; that he came down on Monday in a chaise-and-four to see the place, and was so much delighted with it that he agreed with Mr. Morris immediately; that he is to take possession before Michaelmas, and some of his servants are to be in the house by the end of next week.'
'What is his name?'
'Bingley.'
'Is he married or single?'

Text: flush left, ragged right
Head: Centered, rule above
Folios: Flush out

Chapter I

It is a truth universally acknowl-edged that a single man in possession of a good fortune must be in want of a wife.
However little known the feelings or views of such a man may be on his first entering a neighborhood, this truth is so well fixed in the minds of the surrounding families, that he is considered as the rightful property of some one or other of their daughters.
'My dear Mr. Bennet,' said his lady to him one day, 'have you heard that Netherfield Park is let at last?'
Mr. Bennet replied that he had not. 'But it is,' returned she, 'for Mrs. Long has just been here, and she told me all about it.'
Mr. Bennet made no answer.
'Do you not want to know who has taken it?' cried his wife, impatiently.
'You want to tell me, and I have no objection to hearing it.'
This was invitation enough.
'Why, my dear, you must know, Mrs. Long says that Netherfield is taken by a young man of large fortune from the north of England; that he came down on Monday in a chaise-and-four to see the place, and was so much delighted with it that he agreed with Mr. Morris immediately; that he is to take possession before Michaelmas, and some of his servants are to be in the house by the end of next week.'
'What is his name?'
'Bingley.'

Text: flush left, ragged right
First line: Centered indent with initial cap
Head: Centered italic
Folios: Centered

Chapter I

It is a truth universally acknowledged that a single man in possession of a good fortune must be in want of a wife.
However little known the feelings or views of such a man may be on his first entering a neighborhood, this truth is so well fixed in the minds of the surrounding families, that he is considered as the rightful property of some one or other of their daughters.
'My dear Mr. Bennet,' said his lady to him one day, 'have you heard that Netherfield Park is let at last?'
Mr. Bennet replied that he had not. 'But it is,' returned she, 'for Mrs. Long has just been here, and she told me all about it.'
Mr. Bennet made no answer.
'Do you not want to know who has taken it?' cried his wife, impa-tiently.
'You want to tell me, and I have no objection to hearing it.'
This was invitation enough.
'Why, my dear, you must know, Mrs. Long says that Netherfield is taken by a young man of large fortune from the north of England; that he came down on Monday in a chaise-and-four to see the place, and was so much delighted with it that he agreed with Mr. Morris im-mediately; that he is to take possession before Michaelmas, and some of his servants are to be in the house by the end of next week.'
'What is his name?'
'Bingley.'
'Is he married or single?'

Text: Justified
First line: Drop cap
Head: Flush left, rule above
Folios: Flush out

Chapter I

It is a truth universally acknowledged that a single man in possession of a good fortune must be in want of a wife.

However little known the feelings or views of such a man may be on his first entering a neighborhood, this truth is so well fixed in the minds of the surrounding families, that he is considered as the rightful property of some one or other of their daughters.

'My dear Mr. Bennet,' said his lady to him one day, 'have you heard that Netherfield Park is let at last?'

Mr. Bennet replied that he had not. 'But it is,' returned she, 'for Mrs. Long has just been here, and she told me all about it.'

Mr. Bennet made no answer.

'Do you not want to know who has taken it?' cried his wife, impatiently.

'You want to tell me, and I have no objection to hearing it.'

This was invitation enough.

'Why, my dear, you must know, Mrs. Long says that Netherfield is

Text: flush left, ragged right, line space between paragraphs
First line: Initial cap
Head: Flush left
Folios: Flush out

Opposite: Flush left head and text, paragraph indent 1 em. Note that the folio aligns visually with the right rag, not with the abso-lute right edge of the text page.

Chapter I

It is a truth universally acknowledged that a single man in possession of a good fortune must be in want of a wife.

However little known the feelings or views of such a man may be on his first entering a neighborhood, this truth is so well fixed in the minds of the surrounding families, that he is considered as the rightful property of some one or other of their daughters.

'My dear Mr. Bennet,' said his lady to him one day, 'have you heard that Netherfield Park is let at last?'

Mr. Bennet replied that he had not. 'But it is,' returned she, 'for Mrs. Long has just been here, and she told me all about it.'

Mr. Bennet made no answer.

'Do you not want to know who has taken it?' cried his wife, impatiently.

'You want to tell me, and I have no objection to hearing it.'

This was invitation enough.

'Why, my dear, you must know, Mrs. Long says that Netherfield is taken by a young man of large fortune from the north of England; that he came down on Monday in a chaise-and-four to see the place, and was so much delighted with it that he agreed with Mr. Morris immediately; that he is to take possession before Michaelmas, and some of his servants are to be in the house by the end of next week.'

'What is his name?'

'Bingley.'

'Is he married or single?'

'Oh, single, my dear, to be sure! A single man of large fortune—four or five thousand a year. What a fine thing for our girls!'

'How so? How can it affect them?'

'My dear Mr. Bennet,' replied his wife, 'how can you be so tiresome? You must know that I am thinking of his marrying one of them.'

'Is that his design in settling here?'

'Design? nonsense, how can you talk so! But it is very likely that he may fall in love with one of them, and therefore you must visit him as soon as he comes.'

'I see no occasion for that. You and the girls may go, or you may send them by themselves, which perhaps will be still better; for as you are as handsome as any of them, Mr. Bingley may like you the best of the party.'

'My dear, you flatter me. I certainly have had my share of beauty, but I do not pretend to be anything extraordinary now. When a woman has five grownup daughters, she ought to give over thinking of her own beauty.'

'In such cases a woman has not often much beauty to think of.'

'But, my dear, you must indeed go and see Mr. Bingley when he comes into the neighborhood.'

'It is more than I engage for, I assure you.'

'But consider your daughters. Only think what an establishment it would be for one of them! Sir William and Lady Lucas are determined to go, merely on that account; for in general, you know, they visit no new-comers. Indeed, you must go, for it will be impossible for us to visit him, if you do not.'

'You are over-scrupulous, surely. I dare say Mr. Bingley will be very glad to see you; and I will send a few lines by you to assure him of my hearty consent to his marrying whichever he chooses of the girls; though I must throw in a good word for my little Lizzy.'

'I desire you will do no such thing. Lizzy is not a bit better than the others; and I am sure she is not half so handsome as Jane, nor half so good-humored as Lydia. But you are always giving her the preference.'

'They have none of them much to recommend them,' replied he. 'They are all silly and ignorant like other girls; but Lizzy has something more of quickness than her sisters.'

'Mr. Bennet, how can you abuse your own children in such a way? You take delight in vexing me. You have no compassion on my poor nerves.'

'You mistake me, my dear. I have a high respect for your nerves. They are my old friends. I have heard you mention them with consideration these twenty years at least.'

PRIDE AND PREJUDICE

'Oh, single, my dear, to be sure! A single man of large fortune—four or five thousand a year. What a fine thing for our girls!'
'How so? How can it affect them?'
'My dear Mr. Bennet,' replied his wife, 'how can you be so tiresome? You must know that I am thinking of his marrying one of them.'
'Is that his design in settling here?'

CHAPTER ONE

'Design? nonsense, how can you talk so! But it is very likely that he may fall in love with one of them, and therefore you must visit him as soon as he comes.'
'I see no occasion for that. You and the girls may go, or you may send them by themselves, which perhaps will be still better; for as you are as handsome as any of them, Mr. Bingley may like you the best

PRIDE AND PREJUDICE

'Oh, single, my dear, to be sure! A single man of large fortune—four or five thousand a year. What a fine thing for our girls!'
'How so? How can it affect them?'
'My dear Mr. Bennet,' replied his wife, 'how can you be so tiresome? You must know that I am thinking of his marrying one of them.'
'Is that his design in settling here?'

CHAPTER ONE

'Design? nonsense, how can you talk so! But it is very likely that he may fall in love with one of them, and therefore you must visit him as soon as he comes.'
'I see no occasion for that. You and the girls may go, or you may send them by themselves, which perhaps will be still better; for as you are as handsome as any of them, Mr. Bingley may like you the best

PRIDE AND PREJUDICE

'Oh, single, my dear, to be sure! A single man of large fortune—four or five thousand a year. What a fine thing for our girls!'
'How so? How can it affect them?'
'My dear Mr. Bennet,' replied his wife, 'how can you be so tiresome? You must know that I am thinking of his marrying one of them.'
'Is that his design in settling here?'

CHAPTER ONE

'Design? nonsense, how can you talk so! But it is very likely that he may fall in love with one of them, and therefore you must visit him as soon as he comes.'
'I see no occasion for that. You and the girls may go, or you may send them by themselves, which perhaps will be still better; for as you are as handsome as any of them, Mr. Bingley may like you the best

PRIDE AND PREJUDICE

'Oh, single, my dear, to be sure! A single man of large fortune—four or five thousand a year. What a fine thing for our girls!'
'How so? How can it affect them?'
'My dear Mr. Bennet,' replied his wife, 'how can you be so tiresome? You must know that I am thinking of his marrying one of them.'
'Is that his design in settling here?'

CHAPTER ONE

'Design? nonsense, how can you talk so! But it is very likely that he may fall in love with one of them, and therefore you must visit him as soon as he comes.'
'I see no occasion for that. You and the girls may go, or you may send them by themselves, which perhaps will be still better; for as you are as handsome as any of them, Mr. Bingley may like you the best

2 PRIDE AND PREJUDICE

'Oh, single, my dear, to be sure! A single man of large fortune—four or five thousand a year. What a fine thing for our girls!'
'How so? How can it affect them?'
'My dear Mr. Bennet,' replied his wife, 'how can you be so tiresome? You must know that I am thinking of his marrying one of them.'
'Is that his design in settling here?'

CHAPTER ONE 3

'Design? nonsense, how can you talk so! But it is very likely that he may fall in love with one of them, and therefore you must visit him as soon as he comes.'
'I see no occasion for that. You and the girls may go, or you may send them by themselves, which perhaps will be still better; for as you are as handsome as any of them, Mr. Bingley may like you the best

Opposite: Sans serif text (10.5/14 Meta Book) set flush left, ragged right, paragraph indent 1 em. Note that the folio and running head align left with the text.

Above: Five simple variations on placement of running heads: centered, centered with rule above, flush out, flush left with rule above, and flush in with folios flush out. The possibilities go on.

It should be easy to imagine that the possibilities are just as numerous for placement of folios.

Front matter, back matter

122 Material preceding or following the text proper is called **front matter** and **back matter**. The content and sequencing of these pages has evolved over the centuries since Gutenberg, and continues to be adjusted to fit particular circumstances (the Table of Contents and Introduction in this book, for instance, begin on versos as opposed to rectos). Consider the list here to be suggestive, and, except for pages i–iv (half title through copyright page), not prescriptive.

Pages in front matter are numbered in lowercase roman numerals. Back matter pages continue the arabic numerals of the text. The visual presentation of these pages should grow logically out of the typefaces, type sizes, and margins used in the main body of the text.

Page i
Half title

Page iii
Full title
(Page ii—frontispiece—is blank)

Table of contents

No matter where the front matter ends, remember that the text proper begins on page 1, which is always a recto.

Front matter
These pages include everything that precedes the first page of Chapter One.

i
Half title
(also called bastard title)
The first page, containing only the title of the book. No folio on this page.

ii
Frontispiece
Although typically blank, the page opposite the title page may display artwork. In some cases, it lists other books by the same author. No folio on this page.

iii
Title page
The page shows the title, subtitle, author's name, and publisher. If the book is a new edition of a previous publication, the number of the edition will appear after the title. No folio on this page.

iv
Copyright page
This page lists the rights for the book, as well as any other important bibliographic information.

Dedication/epigraph/acknowledgments
This page is the author's chance to thank those who helped him or her, or to provide a quote that sets the tone for the text.

Table of contents
This page is treated as any first page in a chapter of text. The table of contents takes as many pages as required.

Foreword/introduction/preface
The foreword is typically written by someone other than the author. The introduction states the goals of the book. The preface describes the book's origins, and may include the acknowledgments.

Back matter
These pages round out the text, explaining technical terms, expanding notes, citing sources, cross-referencing important terms, and describing the physical production of the book. It may (but does not have to) include:

Appendix(ces)
Addendum
This material is supplemental to, and typically supports, the main work.

Glossary
This contains alphabetized definitions of words and terms central to a full understanding of the text.

Bibliography
This is a list, alphabetized by author, citing texts that inform, or have been quoted in, the book. It also includes websites, listed separately.

Footnotes
These may occur at the foot or the shoulder of the page where cited, at the end of the chapter, or at the end of the book.

Index
This is an alphabetized list of key names or terms used in the text, followed by the pages on which they appear.

Colophon
The colophon is a brief description usually located at the end of a book, describing production notes relevant to the edition and may include a printer's mark or logotype.

Indicating paragraphs

There are several options for indicating paragraphs. In the first example, (top left) we see the **pilcrow** (¶), a holdover from medieval manuscripts and seldom used today.

In the second example (top right), paragraphs are indicated simply by the start of a new line. If you employ this method, keep in mind that a long line at the end of one paragraph may make it difficult to read the start of the next. Similarly, a sentence within a paragraph that happens to fall at the beginning of a line may be mistaken for a new paragraph.

The example shown bottom left (and throughout this book) is a line space between paragraphs. Some designers occasionally set this space to be less than a full line, a solution that can be elegant in pages with a single column of text, but one that works against cross-alignment in layouts with multiple columns.

In the example bottom right, you can see the standard indentation. Typically, the indent is either an em — the size of the type — or the leading (as shown in this example—in this case, 13.5 pts.).

The nonsense words used on the pages shown here are called 'greeking,' despite the fact that most of the words are Latin or corruptions of Latin words. Typesetters have used greeking files to generate sample type since the 16th century. For the history and source of greeking, go to www.lipsum.com.

ullamcorper suscipit lobo ex ea commodo consequa vel eum iriure dolor in h tate velit esse molestie co dolore eu feugiat nulla fa et accumsan et iusto odio blandit praesent luptatun augue duis dolore. ¶ Ut v minim veniam, quis nost ullamcorper suscipit lobo ex ea commodo consequa eum iriure dolor in hend velit esse molestie consec dolore eu feugiat nulla fa et accumsan et iusto odio blandit praesent luptatun augue duis dolore te feug Nam liber tempor cum s eleifend option congue n doming id quod mazim p

Lorem ipsum dolor sit an adipiscing elit, sed diam euismod tincidunt ut laor aliquam erat volutpat. Duis autem vel eum iriur drerit in vulputate velit e sequat, vel illum dolore e facilisis at vero eros et ac odio dignissim qui bland tum zzril delenit augue d gait nulla facilisi. Lorem ipsum dolor sit an nonummy nibh euismod laoreet dolore magna alic pat. Ut wisi enim ad minim v trud exerci tation ullamc lobortis nisl ut aliquip ex consequat. Duis autem ve dolor in hendrerit in vulp

Lorem ipsum dolor sit an adipiscing elit, sed diam euismod tincidunt ut laor aliquam erat volutpat. Ut minim veniam, quis nost ullamcorper suscipit lobo ex ea commodo consequa

Duis autem vel eum iriur drerit in vulputate velit e sequat, vel illum dolore e facilisis at vero eros et ac odio dignissim qui bland tum zzril delenit augue d gait nulla facilisi. Lorem amet elit, sed diam nonu mod tincidunt ut laoreet quam erat volutpat.

Ut wisi enim ad minim v

Lorem ipsum dolor sit an adipiscing elit, sed diam euismod tincidunt ut laor aliquam erat volutpat. Ut minim veniam, quis nost ullamcorper suscipit lobo ex ea commodo consequa

Duis autem vel eum ii hendrerit in vulputate ve consequat, vel illum dolo facilisis at vero eros et ac odio dignissim qui bland tum zzril delenit augue d gait nulla facilisi. Lorem amet elit, sed diam nonu mod tincidunt ut laoreet quam erat volutpat.

Ut wisi enim ad minim nostrud exerci tation ulla lobortis nisl ut aliquip ex

Lorem ipsum dolor sit amet, consectetuer adipiscing elit, sed diam nonummy nibh euismod tincidunt ut laoreet dolore magna aliquam erat volutpat. Ut wisi enim ad minim veniam, quis nostrud exerci tation ullamcorper suscipit lobortis nisl ut aliqui ex ea commodo consequat.

 Duis autem vel eum iriur dolor in hendrerit in vulputate velit esse molestie consequat, vel illum dolore eu feugiat nulla facilisis at vero eros et accum san et iusto odio dignissim qui blandit praesent luptatum zzril delenit augue duis dolore.

 Ut wisi enim ad minim veniam, quis nostrud exerci tation ullamcorper suscipit lobortis nisl ut aliquip ex e commodo consequat. Duis autem vel eum iriure dolor in hendrerit in vulputate velit esse molestie consequat, vel illum dolore

Lorem ipsum dolor sit amet, consectetuer adipiscing elit, sed diam nonummy nib euismod tincidunt ut laoreet dolore magna aliquam erat volutpat. Ut wisi enim ad minim veniam, quis nostrud exerci tation ullamcorper suscipit lobor tis nisl ut aliquip ex ea commodo conse quat.
Duis autem vel eum iriure dolor in hendrerit in vulputate velit esse molestie consequat, vel illum dolore eu feugiat nulla facilisis at vero eros et accumsan et iusto odio dignissim qui blandit prae sent luptatum zzril delenit augue duis dolore.
Ut wisi enim ad minim veniam, quis nostrud exerci tation ullamcorper suscipit lobortis nisl ut aliquip ex ea commodo consequat. Duis autem vel eum iriure dolor in hendrerit in vulputate velit ess

Above, two less predictable methods for indicating new paragraphs. In the first, type indents radically. This approach requires great care if the creation of widows (see page 136) at the end of the paragraph (as seen in the second paragraph above) is to be avoided. In the second example, the first line of the paragraph is **exdented** (as opposed to indented). This method creates unusually wide gutters between columns of text. Despite these problems, there can be strong compositional reasons for considering either option.

Highlighting text

Lorem ipsum dolor sit amet, cons
adipiscing elit, sed diam nonumm
euismod tincidunt ut laoreet dolo
aliquam erat volutpat. Ut wisi eni
minim veniam, quis nostrud exerc
ullamcorper.

Suscipit lobortis nisl ut aliquip ex ea
consequat. Duis autem vel eum iriur
hendrerit in vulputate velit esse mol
quat, vel illum dolore eu feugiat nul.
at vero eros et accumsan.

Iusto odio dignissim qui blandit p
luptatum zzril delenit augue duis
feugait nulla facilisi. Lorem ipsun
sit amet, consectetuer adipiscing

Italic type

Lorem ipsum dolor sit amet, cons
adipiscing elit, sed diam nonumm
euismod tincidunt ut laoreet dolo
aliquam erat volutpat. Ut wisi eni
minim veniam, quis nostrud exerc
ullamcorper.

Suscipit lobortis nisl ut aliquip
commodo consequat. Duis aut
eum iriure dolor in hendrerit i
tate velit esse molestie conseq
illum dolore eu feugiat nulla fa
vero eros et accumsan.

Iusto odio dignissim qui blandit p
luptatum zzril delenit augue duis
feugait nulla facilisi. Lorem ipsun

Boldface serif type

Some simple ways to highlight content within a column of text are shown here. Note that different kinds of emphasis require different kinds of contrast.

In the first example, type is highlighted with italic, in the second with boldface. In terms of 'color,' the contrast established by the bold is obviously clearer. In the third example, a sans serif bold (Univers 75) is used instead of the bold serif type (Janson) for even stronger contrast. In this example, the size of the Univers 75 has been reduced to 8.5 pts. to make its x-height match that of the 10 pt. Janson (see detail opposite). Finally, the actual color itself is changed from black to red (refer to the discussion on page 85).

Lorem ipsum dolor sit amet, cons
adipiscing elit, sed diam nonumm
euismod tincidunt ut laoreet dolo
aliquam erat volutpat. Ut wisi eni
minim veniam, quis nostrud exerc
ullamcorper.

Suscipit lobortis nisl ut aliquip
commodo consequat. Duis aute
eum iriure dolor in hendrerit in
tate velit esse molestie conseq
illum dolore eu feugiat nulla fa
vero eros et accumsan.

Iusto odio dignissim qui blandit p
luptatum zzril delenit augue duis
feugait nulla facilisi. Lorem ipsu

Boldface sans serif type

Lorem ipsum dolor sit amet, cons
adipiscing elit, sed diam nonumm
euismod tincidunt ut laoreet dolo
aliquam erat volutpat. Ut wisi eni
minim veniam, quis nostrud exerc
ullamcorper.

Suscipit lobortis nisl ut aliquip ex
modo consequat. Duis autem vel
ure dolor in hendrerit in vulputat
esse molestie consequat, vel illum
eu feugiat nulla facilisis at vero e
accumsan.

Iusto odio dignissim qui blandit p
luptatum zzril delenit augue duis
feugait nulla facilisi. Lorem ipsu

Colored type

Lorem ipsum

Lorem ipsum

Matching x-heights between
typefaces. Top, 8.5 pt. Univers 75
against 10 pt. Janson. Bottom,
10 pt. Univers 75 against 10 pt.
Janson. (Examples at 400%.)

Lorem ipsum dolor sit amet, cons
adipiscing elit, sed diam nonumm
euismod tincidunt ut laoreet dolo
aliquam erat volutpat. Ut wisi eni
minim veniam, quis nostrud exerc
ullamcorper.

**Suscipit lobortis nisl ut aliquip ex
modo consequat. Duis autem vel
ure dolor in hendrerit in vulputat
esse molestie consequat, vel illum
eu feugiat nulla facilisis at vero e
accumsan.**

Iusto odio dignissim qui blandit p
luptatum zzril delenit augue duis
feugait nulla facilisi. Lorem ipsun

Lorem ipsum dolor sit amet, cons
adipiscing elit, sed diam nonumm
euismod tincidunt ut laoreet dolo
aliquam erat volutpat. Ut wisi eni
minim veniam, quis nostrud exerc
ullamcorper.

**Suscipit lobortis nisl ut aliquip e
commodo consequat. Duis aute
eum iriure dolor in hendrerit in
velit esse molestie consequat, ve
dolore eu feugiat nulla facilisis a
eros et accumsan.**

Iusto odio dignissim qui blandit p
luptatum zzril delenit augue duis
feugait nulla facilisi. Lorem ipsun

Reversed type

Reversed, indented type

Here, the type has been highlighted by placing it in a field of color. In the first example, the type has simply been dropped out of a field the same color as the text. In the third example, the type is surprinted over a field in a second color. In both instances, the left axis of the type remains constant. The fields are expanded to accommodate the type. Keep in mind the importance of a gutter between columns large enough to allow space between two color fields.

Maintaining a consistent left type axis in these two examples facilitates reading, without compromising the purpose of the highlight. If the fields were to align with the text margins and the type subsequently indented (the second and fourth examples), reading suffers.

Lorem ipsum dolor sit amet, con
adipiscing elit, sed diam nonumm
euismod tincidunt ut laoreet dolo
aliquam erat volutpat. Ut wisi eni
minim veniam, quis nostrud exerc
ullamcorper.

Suscipit lobortis nisl ut aliquip ex
modo consequat. Duis autem vel
ure dolor in hendrerit in vulputat
esse molestie consequat, vel illum
eu feugiat nulla facilisis at vero er
accumsan.

Iusto odio dignissim qui blandit p
luptatum zzril delenit augue duis
feugait nulla facilisi. Lorem ipsun

Surprinted type

Lorem ipsum dolor sit amet, con
adipiscing elit, sed diam nonumm
euismod tincidunt ut laoreet dolo
aliquam erat volutpat. Ut wisi eni
minim veniam, quis nostrud exerc
ullamcorper.

Suscipit lobortis nisl ut aliquip e
commodo consequat. Duis auten
eum iriure dolor in hendrerit in
velit esse molestie consequat, ve
dolore eu feugiat nulla facilisis a
eros et accumsan.

Iusto odio dignissim qui blandit p
luptatum zzril delenit augue duis
feugait nulla facilisi. Lorem ipsun

Surprinted, indented type

Lorem ipsum dolor sit amet, cons
adipiscing elit, sed diam nonumm
euismod tincidunt ut laoreet dolo
aliquam erat volutpat:
• Ut wisi enim ad minim veniam
• Quis nostrud exerci tation ullan
suscipit
• Lobortis nisl ut aliquip ex ea co
consequat.

Duis autem vel eum iriure dolor i
drerit in vulputate velit esse mole
sequat, vel illum dolore eu feugia
facilisis at vero eros et accumsan
odio dignissim qui blandit praese
tum zzril delenit augue duis dolo
gait nulla facilisi. Lorem ipsum d

Lorem ipsum dolor sit amet, con
adipiscing elit, sed diam nonumm
euismod tincidunt ut laoreet dolo
aliquam erat volutpat:
• Ut wisi enim ad minim veniam
• Quis nostrud exerci tation ullamo
suscipit
• Lobortis nisl ut aliquip ex ea com
consequat.

Duis autem vel eum iriure dolor
drerit in vulputate velit esse mole
sequat, vel illum dolore eu feugia
facilisis at vero eros et accumsan
odio dignissim qui blandit praese
tum zzril delenit augue duis dolo
gait nulla facilisi. Lorem ipsum d

Exdenting text

Sometimes it's necessary to place
certain typographic elements outside
the left margin of a column of type
(exdenting, as opposed to indenting)
in order to maintain a strong visual
axis.

Notice, in the first example, that
even though the bulleted list aligns
with the left type margin, the bullets
themselves produce obvious indents,
thereby weakening the left axis. In
the second example, the bullets have
been exdented, maintaining the axis.

"Lorem ipsum dolor sit amet, con
adipiscing elit, sed diam nonumn
euismod tincidunt ut laoreet dolo
aliquam erat volutpat. Ut wisi en
minim veniam, quis nostrud exer
ullamcorper suscipit lobortis nisl
ex ea commodo consequat.

"Duis autem vel eum iriure dolor
drerit in vulputate velit esse mole
sequat, vel illum dolore eu feugia
facilisis at vero eros et accumsan
odio dignissim qui blandit praese
tum zzril delenit augue duis dolo
gait nulla facilisi. Lorem ipsum d
amet, consectetuer adipiscing elit
diam nonummy nibh euismod tir

This is a good time to point out that a prime is not a single quote or an apostrophe, nor are double primes quotes. Compare:

The prime is an abbreviation for feet or for the minutes of arc. The double prime is an abbreviation for inches or the seconds of arc. Because of the limited number of keys, they were used on typewriters as substitutes for single and double quotes and apostrophes, and came to be known as 'dumb quotes.' When used as quotes in typesetting, they aren't just 'dumb'—they're criminal.

Quotation marks, like bullets, can create a clear indent when they are aligned with the text margin. Compare the exdented quote at the top of the column with the aligned quote in the middle.

Many kinds of text have sub-divisions within major sections (such as chapters), which are typically indicated by subheads within the text. These subheads are labeled according to the level of their importance: A heads, B heads, C heads, etc. (only the most technically written texts have three or more levels of subheads). The typographer's task is to make sure that these heads clearly signify to the reader both their relative importance within the text and their relationship to each other.

A heads

A heads indicate a clean break between topics within a section. They need to offer the reader a palpable pause, a chance to catch a breath. Space—typically, more than one line space—between topics clearly suggests this sense of resting. In the first examples here, A heads are shown set larger than the text, set in small caps, and set in bold. The fourth example shows an A head exdented to the left of the text.

euismod tincidunt ut laoree
aliquam erat volutpat. Ut w
minim veniam, quis nostru
ullamcorper.

A head

Suscipit lobortis nisl ut alic
modo consequat. Duis aute
ure dolor in hendrerit in vu

euismod tincidunt ut laoree
aliquam erat volutpat. Ut w
minim veniam, quis nostru
ullamcorper.

A HEAD IN SMALL CAPS

Suscipit lobortis nisl ut alic
modo consequat. Duis aute
ure dolor in hendrerit in vu

euismod tincidunt ut laoreet dolore magi
aliquam erat volutpat. Ut wisi enim ad
minim veniam, quis nostrud exerci tation
ullamcorper.

A head in bold

Suscipit lobortis nisl ut aliquip ex ea com
modo consequat. Duis autem vel eum iri-
ure dolor in hendrerit in vulputate velit
esse molestie consequat, vel illum dolore
eu feugiat nulla facilisis at vero eros et
accumsan.
 Iusto odio dignissim qui blandit prae-
sent luptatum zzril delenit augue duis
dolore te feugait nulla facilisi. Lorem

euismod tincidunt
aliquam erat volut
minim veniam, qu
ullamcorper.

A head in bold Suscipit lobortis n
modo consequat.
ure dolor in hendi
esse molestie cons
eu feugiat nulla fa

B heads

Subordinate to A heads, B heads indicate a new supporting argument or example for the topic at hand. As such, they should not interrupt the text as strongly as A heads do. Here, B heads are shown in small caps, italic, bold serif, and bold sans serif.

aliquam erat volutpat. Ut w
minim veniam, quis nostru
ullamcorper.

B HEAD IN SMALL CAPS
Suscipit lobortis nisl ut alic
modo consequat. Duis aute
ure dolor in hendrerit in vu

aliquam erat volutpat. Ut w
minim veniam, quis nostru
ullamcorper.

B head in italics
Suscipit lobortis nisl ut alic
modo consequat. Duis aute
ure dolor in hendrerit in vu

aliquam erat volutpat. Ut w
minim veniam, quis nostru
ullamcorper.

B head in bold
Suscipit lobortis nisl ut alic
modo consequat. Duis aute
ure dolor in hendrerit in vu

aliquam erat volutpat. Ut w
minim veniam, quis nostru
ullamcorper.

B head in bold
Suscipit lobortis nisl ut alic
modo consequat. Duis aute
ure dolor in hendrerit in vu

C heads

Although not common, C heads highlight specific facets of material within B head text. They should not materially interrupt the flow of reading. As with B heads, these C heads are shown in small caps, italics, serif bold, and sans serif bold. C heads in this configuration are followed by at least an em space, to distinguish them from the text that follows.

aliquam erat volutpat. Ut w
minim veniam, quis nostru
ullamcorper.

C HEAD IN SMALL CAPS Susc
ut aliquip ex ea commodo
autem vel eum iriure dolor
vulputate velit esse molesti

aliquam erat volutpat. Ut w
minim veniam, quis nostru
ullamcorper.

C head in italics Suscipit lol
aliquip ex ea commodo con
autem vel eum iriure dolor
vulputate velit esse molesti

aliquam erat volutpat. Ut w
minim veniam, quis nostru
ullamcorper.

C head in bold Suscipit l
aliquip ex ea commodo con
autem vel eum iriure dolor
vulputate velit esse molesti

aliquam erat volutpat. Ut w
minim veniam, quis nostru
ullamcorper.

C head in bold Suscipit l
aliquip ex ea commodo con
autem vel eum iriure dolor
vulputate velit esse molesti

Putting together a sequence of subheads: hierarchy

Here are three examples of subhead treatment within text. In the first, hierarchy of subheads is indicated by size and style of type. In the second, a hierarchy of consistently bold subheads is indicated simply by the relationship of head to text. In the third, hierarchy is established by color of type (bold/italic) and position relative to text.

Obviously, there is no single way to express hierarchy within text; in fact, the possibilities are virtually limitless. Once clarity has been established, the typographer can—and should—establish a palette of weights and styles that best suits the material at hand and the voice of the author.

euismod tincidunt ut laoreet dolo
aliquam erat volutpat. Ut wisi eni
minim veniam, quis nostrud exerc
ullamcorper.

A head

Suscipit lobortis nisl ut aliquip ex
modo consequat. Duis autem vel
ure dolor in hendrerit in vulputat
esse molestie consequat, vel illum
eu feugiat nulla facilisis at vero er
accumsan.

B HEAD IN SMALL CAPS
Iusto odio dignissim qui blandit p
luptatum zzril delenit augue duis
feugait nulla facilisi. Lorem ipsun
sit amet, consectetuer adipiscing
diam nonummy nibh euismod tin
laoreet dolore magna aliquam era
pat.

C head in italic Ut wisi enim ad n
veniam, quis nostrud exerci tatior
corper suscipit lobortis nisl ut ali
commodo consequat. Duis autem
iriure dolor in hendrerit in vulpu

euismod tincidunt ut laoreet dolo
aliquam erat volutpat. Ut wisi eni
minim veniam, quis nostrud exerc
ullamcorper.

A head in bold

Suscipit lobortis nisl ut aliquip ex
modo consequat. Duis autem vel
ure dolor in hendrerit in vulputat
esse molestie consequat, vel illum
eu feugiat nulla facilisis at vero er
accumsan.

B head in bold
Iusto odio dignissim qui blandit p
luptatum zzril delenit augue duis
feugait nulla facilisi. Lorem ipsum
sit amet, consectetuer adipiscing
diam nonummy nibh euismod tin
laoreet dolore magna aliquam era
pat.

C head in bold Ut wisi enim ad
veniam, quis nostrud exerci tatior
corper suscipit lobortis nisl ut alic
commodo consequat. Duis autem
iriure dolor in hendrerit in vulput

euismod tincidunt u
aliquam erat volutp
minim veniam, quis
ullamcorper.

A head in bold

Suscipit lobortis nis
modo consequat. D
ure dolor in hendre
esse molestie conse
eu feugiat nulla faci
accumsan.

B head in bold
Iusto odio dignissin
luptatum zzril delen
feugait nulla facilisi
sit amet, consectetu
diam nonummy nib
laoreet dolore magi
pat.

C head in italic Ut
veniam, quis nostru
corper suscipit lobo
commodo consequa
iriure dolor in henc
esse molestie conse
eu feugiat nulla faci

Widows and orphans

In traditional typesetting (the kind that still endures among fine book publishers and conscientious commercial publishers), there are two unpardonable gaffes—widows and orphans.

A widow is a short line of type left alone at the end of a column of text. An orphan is a short line of type left alone at the start of a new column. (An easy mnemonic device: orphans start out alone, widows end up alone.) Consider the example opposite. You know already that text is meant to read as a field of a more-or-less middle tone. You can see how an unusually short line at the top or bottom of a paragraph disrupts that reading—in fact, creates a shape that draws attention away from simple reading.

In justified text, both widows and orphans are serious gaffes. Flush left, ragged right text is somewhat more forgiving toward widows, but only a bit. Orphans remain unpardonable.

The only solution to widows is to rebreak your line endings throughout your paragraph so that the last line of any paragraph is not noticeably short. Orphans, as you might expect, require more care. Careful typographers make sure that no column of text starts with the last line of the preceding paragraph.

Eleifend option congue nihil imperdiet doming id quod mazim placerat facer possim assum. Lorem ipsum dolor sit amet, consectetuer adipiscing elit, sed diam nonummy nibh euismod tincidunt ut laoreet dolore magna aliquam erat volutpat. Ut wisi enim ad minim veniam, quis nostrud exerci tation ullamcorper suscipit lobortis nisl ut aliquip ex ea commodo consequat. Duis autem vel eum iriure dolor in hendrerit in vulputate velit esse molestie consequat, vel illum dolore eu feugiat nulla facilisis at vero eros et accumsan et iusto odio dignissim qui blandit praesent luptatum

zzril delenit augue duis dolore te feugait nulla facilisi. Lorem ipsum dolor sit amet, consectetuer adip Lorem ipsum dolor sit amet, consectetuer adipiscing elit, sed diam nonummy nibh euismod tincidunt ut laoreet dolore magna aliquam erat volutpat. Ut wisi enim ad minim veniam, quis nostrud exerci tation ullamcorper suscipit lobortis nisl ut aliquip ex ea commodo consequat. Duis autem vel eum iriure dolor in hendrerit in vulputate velit esse molestie consequat, vel illum dolore eu feugiat nulla facilisis at vero eros et accumsan et iusto odio dignissim qui blandit praesent luptatum zzril delenit augue duis dolore te feugait nulla facilisi. Lorem ipsum dolor sit amet, consectetuer adipiscing elit, sed diam nonummy nibh euismod tincidunt ut laoreet dolore magna aliquam erat volutpat. Ut wisi enim ad minim veniam, quis nostrud exerci tation ullamcorper suscipit lobortis nisl ut aliquip

si. Nam

liber tempor cum soluta nobis eleifend option congue nihil imperdiet doming id quod mazim placerat facer possim assum. Lorem ipsum dolor sit amet, consectetuer adipiscing elit, sed diam nonummy nibh euismod tincidunt ut laoreet dolore magna aliquam erat volutpat. Ut wisi enim ad minim veniam, quis nostrud exerci tation ullamcorper suscipit lobortis nisl ut aliquip ex ea commodo consequat. Duis autem vel eum iriure dolor in hendrerit in vulputate velit esse molestie consequat, vel illum dolore eu feugiat nulla facilisis at vero eros et accumsan et iusto odio dignissim qui blandit praesent luptatum zzril delenit augue duis dolore te feugait nulla facilisi. Lorem ipsum dolor sit amet, consectetuer adip

Two widows and an orphan (above).

Columnar organization

Columnar layouts

Lorem ipsum dolor sit amet

Lorem ipsum dolor sit amet, consectetuer adipiscing elit, sed diam nonummy nibh euismod tincidunt ut laoreet dolore magna aliquam erat volutpat. Ut wisi enim ad minim veniam, quis nostrud exerci tation ullamcorper suscipit lobortis nisl ut aliquip ex ea commodo consequat. Duis autem vel eum iriure dolor in hendrerit in vulputate velit esse molestie consequat, vel illum dolore eu feugiat nulla facilisis at vero eros et accumsan et iusto odio dignissim qui blandit praesent luptatum zzril delenit augue duis dolore te feugait nulla facilisi. Lorem ipsum dolor sit amet, consectetuer adipiscing elit, sed diam nonummy nibh euismod tincidunt ut laoreet dolore magna aliquam erat volutpat. Ut wisi enim ad minim veniam, quis nostrud exerci tation ullamcorper suscipit lobortis nisl ut aliquip ex ea commodo consequat. Duis autem vel eum iriure dolor in hendrerit in vulputate velit esse molestie consequat, vel illum dolore eu feugiat nulla facilisis at vero eros et accumsan et iusto odio dignissim qui blandit praesent luptatum zzril delenit augue duis dolore te feugait nulla facilisi. Nam liber tempor cum soluta nobis eleifend option congue nihil imperdiet doming id quod mazim placerat facer possim assum. Lorem ipsum dolor sit amet, consectetuer adipiscing elit, sed diam nonummy nibh euismod tincidunt ut laoreet dolore magna aliquam erat volutpat. Ut wisi enim ad minim veniam, quis nostrud exerci tation ullamcorper suscipit lobortis nisl ut aliquip ex ea commodo consequat. Duis autem vel eum iriure dolor in hendrerit in vulputate velit esse molestie consequat, vel illum dolore eu feugiat nulla facilisis at vero eros et accumsan et iusto odio dignissim qui blandit praesent luptatum zzril delenit augue duis dolore te feugait nulla facilisi. Lorem ipsum dolor sit amet, consectetuer adipisc-ing elit, sed diam nonummy nibh euismod tin-cidunt ut laoreet dolore magna aliquam erat volutpat. Ut wisi enim ad minim veniam, quis nostrud exerci tation ullamcorper suscipit lobortis

nisl ut aliquip ex ea commodo consequat. Duis autem vel eum iriure dolor in hendrerit in vulputate velit esse molestie consequat, vel illum dolore eu feugiat nulla facilisis at vero eros et accumsan et iusto odio dignissim qui blandit praesent lupta-tum zzril delenit augue duis dolore te feugait nulla facilisi. Lorem ipsum dolor sit amet, consectetuer adipiscing elit, sed diam nonummy nibh euismod tincidunt ut laoreet dolore magna aliquam erat volutpat. Ut wisi enim ad minim veniam, quis nostrud exerci tation ullamcorper suscipit lobortis nisl ut aliquip ex ea commodo consequat. Duis autem vel eum iriure dolor in hendrerit in vulputate velit esse molestie consequat, vel illum dolore eu feugiat nulla facilisis at vero eros et accumsan et iusto odio dignissim qui blandit praesent lupta-tum zzril delenit augue duis dolore te feugait nulla facilisi. Nam liber tempor cum soluta nobis eleifend option congue nihil imperdiet doming id quod mazim placerat facer possim assum. Lorem ipsum dolor sit amet, consectetuer adipiscing elit, sed diam nonummy nibh euismod tincidunt ut laoreet dolore magna aliquam erat volutpat. Ut wisi enim ad minim veniam, quis nostrud exerci tation ullamcorper suscipit lobortis nisl ut aliquip ex ea commodo consequat. Duis autem vel eum iriure dolor in hendrerit in vulputate velit esse molestie consequat, vel illum dolore eu feugiat nulla facilisis at vero eros et accumsan et iusto odio dignissim qui blandit praesent lupta-tum zzril delenit augue duis dolore te feugait nulla facilisi. Lorem ipsum dolor sit amet, consectetuer adip Lorem ipsum dolor sit amet, consectetuer adipisc-ing elit, sed diam nonummy nibh euismod tin-cidunt ut laoreet dolore magna aliquam erat volutpat. Ut wisi enim ad minim veniam, quis nostrud exerci tation ullamcorper suscipit lobortis nisl ut aliquip ex ea commodo consequat. Duis autem vel eum iriure dolor in hendrerit in vulpu-tate velit esse molestie consequat, vel illum dolore eu feugiat nulla facilisis at vero eros et accumsan et iusto odio dignissim qui blandit praesent lupta-

A two-column layout

Lorem ipsum dolor sit amet

Lorem ipsum dolor sit amet, consectetuer adipiscing elit, sed diam nonummy nibh euismod tincidunt ut laoreet dolore magna aliquam erat volutpat. Ut wisi enim ad minim veniam, quis nostrud exerci tation ullamcorper suscipit lobortis nisl ut aliquip ex ea commodo consequat. Duis autem vel eum iriure dolor in hendrerit in vulputate velit esse molestie consequat, vel illum dolore eu feugiat nulla facilisis at vero eros et accumsan et iusto odio dignissim qui blandit prae-sent luptatum zzril delenit augue duis dolore te feugait nulla facil-isi. Lorem ipsum dolor sit amet, consectetuer adipiscing elit, sed diam nonummy nibh euismod tincidunt ut laoreet dolore magna aliquam erat volutpat. Ut wisi enim ad minim veniam, quis nostrud exerci tation ullamcorper suscipit lobortis nisl ut aliquip ex ea commodo consequat. Duis autem vel eum iriure dolor in hendrerit in vulputate velit esse molestie consequat, vel illum dolore eu feugiat nulla facilisis at vero eros et accumsan et iusto odio dignissim qui blandit prae-sent luptatum zzril delenit augue duis dolore te feugait nulla facil-isi. Nam liber tempor cum soluta nobis eleifend option congue nihil imperdiet doming id quod mazim placerat facer possim assum. Lorem ipsum dolor sit amet, consectetuer adipiscing elit, sed diam nonummy nibh euismod tincidunt ut laoreet dolore magna aliquam erat volut-pat. Ut wisi enim ad minim veni-am, quis nostrud exerci tation ullamcorper suscipit lobortis nisl ut aliquip ex ea commodo conse-quat. Duis autem vel eum iriure

dolor in hendrerit in vulputate velit esse molestie consequat, vel illum dolore eu feugiat nulla facilisis at vero eros et accumsan et iusto odio dignissim qui bland-it praesent luptatum zzril delenit augue duis dolore te feugait nulla facilisi. Lorem ipsum dolor sit amet, consectetuer adip Lorem ipsum dolor sit amet, con-sectetuer adipiscing elit, sed diam nonummy nibh euismod tin-cidunt ut laoreet dolore magna aliquam erat volutpat. Ut wisi enim ad minim veniam, quis nos-trud exerci tation ullamcorper suscipit lobortis nisl ut aliquip ex ea commodo consequat. Duis autem vel eum iriure dolor in hendrerit in vulputate velit esse molestie consequat, vel illum dolore eu feugiat nulla facil-isi. Nam liber tempor cum soluta nobis eleifend option congue nihil imperdiet doming id quod mazim placerat facer possim assum. Lorem ipsum dolor sit amet, consectetuer adipiscing elit, sed diam nonummy nibh euismod tincidunt ut laoreet dolore magna aliquam erat volut-pat. Ut wisi enim ad minim veni-am, quis nostrud exerci tation ullamcorper suscipit lobortis nisl ut aliquip ex ea commodo conse-quat. Duis autem vel eum iriure

consectetuer adipiscing elit, sed diam nonummy nibh euismod tincidunt ut laoreet dolore magna aliquam erat volut-pat. Ut wisi enim ad minim veni-am, quis nostrud exerci tation ullamcorper suscipit lobortis nisl ut aliquip ex ea commodo conse-quat. Duis autem vel eum iriure dolor in hendrerit in vulputate velit esse molestie consequat, vel illum dolore eu feugiat nulla facilisis at vero eros et accumsan et iusto odio dignissim qui blandit praesent luptatum zzril delenit augue duis dolore te feugait nulla facil-isi. Lorem ipsum dolor sit amet, consectetuer adip Lorem ipsum dolor sit amet, con-sectetuer adipiscing elit, sed diam nonummy nibh euismod tin-cidunt ut laoreet dolore magna aliquam erat volutpat. Ut wisi enim ad minim veniam, quis nos-trud exerci tation ullamcorper suscipit lobortis nisl ut aliquip ex ea commodo consequat. Duis autem vel eum iriure dolor in hendrerit in vulputate velit esse molestie consequat, vel illum dolore eu feugiat nulla facilisis at vero eros et accumsan et iusto odio dignissim qui bland-it praesent luptatum zzril delenit augue duis dolore te feugait nulla facil-isi. Nam liber tempor cum soluta nobis eleifend option congue nihil imperdiet doming id quod mazim placerat facer possim assum. Lorem ipsum dolor sit

A three-column layout

It is often useful to think of your text area divided into columns—consistent horizontal intervals that allow for more than one field of text per page. Working with columnar layouts helps you maintain a manageable line length and allows white space onto the page in places other than the margins. Keep in mind the dynamic relationship between type size, leading, and line length. Altering the last always affects the first and the second.

The use of columnar layouts in printing dates right back to Gutenberg's 42-line bible (1455).

Lorem ipsum dolor sit amet

Lorem ipsum dolor sit amet, consectetuer adipiscing elit, sed diam nonummy nibh euismod tincidunt ut laoreet dolore magna aliquam erat volutpat. Ut wisi enim ad minim veniam, quis nostrud exerci tation ullam

Lorem ipsum dolor sit amet, consectetuer adipiscing elit, sed diam nonummy nibh euismod tincidunt ut laoreet dolore magna aliquam erat volutpat. Ut wisi enim ad minim veniam, quis nostrud exerci tation ullamcorper suscipit lobortis nisl ut aliquip ex ea commodo consequat. Duis autem vel eum iriure dolor in hendrerit in vulputate velit esse molestie consequat, vel illum dolore eu feugiat nulla facilisis at vero eros et accumsan et iusto odio dignissim qui blandit praesent luptatum zzril delenit augue duis dolore te feugait nulla facilisi. Lorem ipsum dolor sit amet, consectetuer adipiscing elit, sed diam nonummy nibh euismod tincidunt ut laoreet dolore magna aliquam erat volutpat. Ut wisi enim ad minim veniam, quis nostrud exerci tation ullamcorper suscipit lobortis nisl ut aliquip ex ea commodo consequat. Duis autem vel eum iriure dolor in vulputate velit esse molestie consequat, vel illum dolore eu feugiat nulla facilisis at vero eros et accumsan et iusto odio dignissim qui blandit praesent luptatum zzril delenit augue duis dolore te feugait nulla facilisi. Nam liber tempor cum soluta nobis eleifend option congue nihil imperdiet doming id quod mazim placerat facer possim assum. Lorem ipsum dolor sit amet, consectetuer adipiscing elit, sed diam nonummy nibh euismod tincidunt ut laoreet dolore magna aliquam erat volutpat. Ut wisi enim ad minim veniam, quis nostrud exerci tation ullamcorper suscipit lobortis nisl ut aliquip ex ea commodo consequat. Duis autem vel eum iriure dolor in hendrerit in vulputate

velit esse molestie consequat, vel illum dolore eu feugiat nulla facilisis at vero eros et accumsan et iusto odio dignissim qui blandit praesent luptatum zzril delenit augue duis dolore te feugait nulla facilisi. Lorem ipsum dolor sit amet, consectetuer adipiscing elit, sed diam nonummy nibh euismod tincidunt ut laoreet dolore magna aliquam erat volutpat. Ut wisi enim ad minim veniam, quis nostrud exerci tation ullamcorper suscipit lobortis nisl ut aliquip ex ea commodo consequat. Duis autem vel eum iriure dolor in hendrerit in vulputate velit esse molestie consequat, vel illum dolore eu feugiat nulla facilisis at vero eros et accumsan et iusto odio dignissim qui blandit praesent luptatum zzril delenit augue duis dolore te feugait nulla facilisi. Nam liber tempor cum soluta nobis eleifend option congue nihil imperdiet doming id quod mazim placerat facer possim assum. Lorem ipsum dolor sit amet, consectetuer adipiscing elit, sed diam nonummy nibh euismod tincidunt ut

Lorem ipsum dolor sit amet

Lorem ipsum dolor sit amet, consectetuer adipiscing elit, sed diam nonummy nibh euismod tincidunt ut laoreet dolore magna aliquam erat volutpat. Ut wisi enim ad minim veniam, quis nostrud exerci tation ullam

Lorem ipsum dolor sit amet, consectetuer adipiscing elit, sed diam nonummy nibh euismod tincidunt ut laoreet dolore magna aliquam erat volutpat. Ut wisi enim ad minim veniam, quis nostrud exerci tation ullamcorper suscipit lobortis nisl ut aliquip ex ea commodo consequat. Duis autem vel eum iriure dolor in hendrerit in vulputate velit esse molestie consequat, vel illum dolore eu feugiat nulla facilisis at vero eros et accumsan et iusto odio dignissim qui blandit praesent luptatum zzril delenit augue duis dolore te feugait nulla facilisi. Lorem ipsum dolor sit amet, consectetuer adip Lorem ipsum dolor sit amet, consectetuer adipiscing elit, sed diam nonummy nibh euismod tincidunt ut laoreet dolore magna aliquam erat volutpat. Ut wisi enim ad minim veniam, quis nostrud exerci tation ullamcorper suscipit lobortis

nisl ut aliquip ex ea commodo consequat. Duis autem vel eum iriure dolor in hendrerit in vulputate velit esse molestie consequat, vel illum dolore eu feugiat nulla facilisis at vero eros et accumsan et iusto odio dignissim qui blandit praesent luptatum zzril delenit augue duis dolore te feugait nulla facilisi. Lorem ipsum dolor sit amet, consectetuer adip Lorem ipsum dolor sit amet, consectetuer adipiscing elit, sed diam nonummy nibh euismod tincidunt ut laoreet dolore magna aliquam erat volutpat. Ut wisi enim ad minim veniam, quis nostrud exerci tation ullamcorper suscipit lobortis nisl ut aliquip ex ea commodo consequat. Duis autem vel eum iriure dolor in hendrerit in vulputate velit esse molestie consequat, vel illum dolore eu feugiat nulla facilisis at vero eros et accumsan et iusto odio dignissim qui blandit praesent luptatum zzril delenit augue duis dolore te feugait nulla facilisi. Nam liber tempor cum

A five-column layout
Notice how a five-column layout allows for two fields of text and a third, narrower field for secondary information, such as notes, author profile, etc. The narrower field may in fact be too narrow for any kind of sustained reading.

An eight-column layout
You can see how this application does much the same as a five-column layout, with slightly narrower fields of text and a wider field for supplemental information. Obviously, many other variations are possible.

140 Horizontal layouts allow for wider fields of text, which tend to support sustained reading more comfortably than narrower fields.

Lorem ipsum dolor sit amet

Lorem ipsum dolor sit amet, consectetuer adipiscing elit, sed diam nonummy nibh euismod tincidunt ut laoreet dolore magna aliquam erat volutpat. Ut wisi enim ad minim veniam, quis nostrud exerci tation ullamcorper suscipit lobortis nisl ut aliquip ex ea commodo consequat. Duis autem vel eum iriure dolor in hendrerit in vulputate velit esse molestie consequat, vel illum dolore eu feugiat nulla facilisis at vero eros et accumsan et iusto odio dignissim qui blandit praesent luptatum zzril delenit augue duis dolore te feugait nulla facilisi. Lorem ipsum dolor sit amet, consectetuer adipiscing elit, sed diam nonummy nibh euismod tincidunt ut laoreet dolore magna aliquam erat volutpat. Ut wisi enim ad minim veniam, quis nostrud exerci tation ullamcorper suscipit lobortis nisl ut aliquip ex ea commodo consequat. Duis autem vel eum iriure dolor in hendrerit in vulputate velit esse molestie consequat, vel illum dolore eu feugiat nulla facilisis at vero eros et accumsan et iusto odio dignissim qui blandit praesent luptatum zzril delenit augue duis dolore te feugait nulla facilisi. Nam liber tempor cum soluta nobis eleifend option congue nihil imperdiet doming id quod mazim placerat facer possim assum. Lorem ipsum dolor sit amet, consectetuer adipiscing elit, sed diam nonummy nibh euismod tincidunt ut laoreet dolore magna aliquam erat volutpat. Ut wisi enim ad minim veniam, quis nostrud exerci tation ullamcorper suscipit lobortis nisl ut aliquip ex ea commodo consequat. Duis autem vel eum iriure dolor in hendrerit in vulputate velit esse molestie consequat, vel illum dolore eu feugiat nulla facilisis at vero eros et accumsan et iusto odio dignissim qui blandit praesent luptatum zzril delenit augue duis dolore te feugait nulla facilisi. Lorem ipsum dolor sit amet, consectetuer adipiscing elit, sed diam nonummy nibh euismod tincidunt ut laoreet dolore magna aliquam erat volutpat. Ut wisi enim ad minim veniam, quis nostrud exerci tation ullamcorp-

er suscipit lobortis nisl ut aliquip ex ea commodo consequat. Duis autem vel eum iriure dolor in hendrerit in vulputate velit esse molestie consequat, vel illum dolore eu feugiat nulla facilisis at vero eros et accumsan et iusto odio dignissim qui blandit praesent luptatum zzril delenit augue duis dolore te feugait nulla facilisi. Lorem ipsum dolor sit amet, consectetuer adipiscing elit, sed diam nonummy nibh euismod tincidunt ut laoreet dolore magna aliquam erat volutpat. Ut wisi enim ad minim veniam, quis nostrud exerci tation ullamcorper suscipit lobortis nisl ut aliquip ex ea commodo consequat. Duis autem vel eum iriure dolor in hendrerit in vulputate velit esse molestie consequat, vel illum dolore eu feugiat nulla facilisis at vero eros et accumsan et iusto odio dignissim qui blandit praesent luptatum zzril delenit augue duis dolore te feugait nulla facilisi. Nam liber tempor cum soluta nobis eleifend option congue nihil imperdiet doming id quod mazim placerat facer possim assum. Lorem ipsum dolor sit amet, consectetuer adipiscing elit, sed diam nonummy nibh euismod tincidunt ut laoreet dolore magna aliquam erat volutpat. Ut wisi enim ad minim veniam, quis nostrud exerci tation ullamcorper suscipit lobortis nisl ut aliquip ex ea commodo consequat. Duis autem vel eum iriure dolor in hendrerit in vulputate velit esse molestie consequat, vel illum dolore eu feugiat nulla facilisis at vero eros et accumsan et iusto odio dignissim qui blandit prae-sent luptatum zzril delenit augue duis dolore te feugait nulla facilisi. Lorem ipsum dolor sit amet, consectetuer adip Lorem ipsum dolor sit amet, consectetuer adipiscing elit, sed diam nonummy nibh euismod tincidunt ut laoreet dolore magna aliquam erat volutpat. Ut wisi enim ad minim veniam, quis nostrud exerci tation ullamcorper suscipit lobortis nisl ut aliquip ex ea commodo consequat. Duis autem vel eum iriure dolor in hendrerit in vulputate velit esse molestie consequat, vel illum dolore eu feugiat nulla facilisis at vero eros et

A two-column layout

Lorem ipsum dolor sit amet

Lorem ipsum dolor sit amet, consectetuer adipisc-ing elit, sed diam nonummy nibh euismod tin-cidunt ut laoreet dolore magna aliquam erat volut-pat. Ut wisi enim ad minim veniam, quis nostrud exerci tation ullamcorper suscipit lobortis nisl ut aliquip ex ea commodo consequat. Duis autem vel eum iriure dolor in hendrerit in vulputate velit esse molestie consequat, vel illum dolore eu feugiat nulla facilisis at vero eros et accumsan et iusto odio dignissim qui blandit praesent luptatum zzril delenit augue duis dolore te feugait nulla facilisi. Lorem ipsum dolor sit amet, consectetuer adipisc-ing elit, sed diam nonummy nibh euismod tin-cidunt ut laoreet dolore magna aliquam erat volut-pat. Ut wisi enim ad minim veniam, quis nostrud exerci tation ullamcorper suscipit lobortis nisl ut aliquip ex ea commodo consequat. Duis autem vel eum iriure dolor in hendrerit in vulputate velit esse molestie consequat, vel illum dolore eu feugiat nulla facilisis at vero eros et accumsan et iusto odio dignissim qui blandit praesent luptatum zzril delenit augue duis dolore te feugait nulla facilisi. Nam liber tempor cum soluta nobis eleifend option congue nihil imperdiet doming id quod mazim placerat facer possim assum. Lorem ipsum dolor sit amet, consectetuer adipiscing elit, sed

diam nonummy nibh euismod tincidunt ut laoreet dolore magna aliquam erat volutpat. Ut wisi enim ad minim veniam, quis nostrud exerci tation ullam-corper suscipit lobortis nisl ut aliquip ex ea commo-do consequat. Duis autem vel eum iriure dolor in hendrerit in vulputate velit esse molestie conse-quat, vel illum dolore eu feugiat nulla facilisis at vero eros et accumsan et iusto odio dignissim qui blandit praesent luptatum zzril delenit augue duis dolore te feugait nulla facilisi. Lorem ipsum dolor sit amet, consectetuer adip Lorem ipsum dolor sit amet, consectetuer adipiscing elit, sed diam non-ummy nibh euismod tincidunt ut laoreet dolore magna aliquam erat volutpat. Ut wisi enim ad minim veniam, quis nostrud exerci tation ullamcor-per suscipit lobortis nisl ut aliquip ex ea commodo consequat. Duis autem vel eum iriure dolor in hen-drerit in vulputate velit esse molestie consequat, vel illum dolore eu feugiat nulla facilisis at vero eros et accumsan et iusto odio dignissim qui blandit prae-sent luptatum zzril delenit augue duis dolore te feugait nulla facilisi. Lorem ipsum dolor sit amet, consectetuer adipiscing elit, sed diam nonummy nibh euismod tincidunt ut laoreet dolore magna aliquam erat volutpat. Ut wisi enim ad minim veni-am, quis nostrud exerci tation ullamcorper suscipit

lobortis nisl ut aliquip ex ea commodo consequat. Duis autem vel eum iriure dolor in hendrerit in vulputate velit esse molestie consequat, vel illum dolore eu feugiat nulla facilisis at vero eros et accumsan et iusto odio dignissim qui blandit prae-sent luptatum zzril delenit augue duis dolore te feugait nulla facilisi. Nam liber tempor cum soluta nobis eleifend option congue nihil imperdiet dom-ing id quod mazim placerat facer possim assum. Lorem ipsum dolor sit amet, consectetuer adipisc-ing elit, sed diam nonummy nibh euismod tin-cidunt ut laoreet dolore magna aliquam erat volut-pat. Ut wisi enim ad minim veniam, quis nostrud exerci tation ullamcorper suscipit lobortis nisl ut aliquip ex ea commodo consequat. Duis autem vel eum iriure dolor in hendrerit in vulputate velit esse molestie consequat, vel illum dolore eu feugiat nulla facilisis at vero eros et accumsan et iusto odio dignissim qui blandit praesent luptatum zzril delenit augue duis dolore te feugait nulla facilisi. Lorem ipsum dolor sit amet, consectetuer adipisc-ing elit, sed diam nonummy nibh euismod tin-cidunt ut laoreet dolore magna aliquam erat volut-pat. Ut wisi enim ad minim veniam, quis nostrud exerci tation ullamcorper suscipit lobortis nisl ut

A three-column layout

Lorem ipsum dolor sit amet

Lorem ipsum dolor sit amet, consectetuer adipiscing elit, sed diam nonummy nibh euismod tincidunt ut laoreet dolore magna aliquam erat volutpat. Ut wisi enim ad minim veniam, quis nostrud exerci tation ullam

Lorem ipsum dolor sit amet, consectetuer adipiscing elit, sed diam nonummy nibh euismod tincidunt ut laoreet dolore magna aliquam erat volutpat. Ut wisi enim ad minim veniam, quis nostrud exerci tation ullamcorper suscipit lobortis nisl ut aliquip ex ea commodo consequat. Duis autem vel eum iriure dolor in hendrerit in vulputate velit esse molestie consequat, vel illum dolore eu feugiat nulla facilisis at vero eros et accumsan et iusto odio dignissim qui blandit praesent luptatum zzril delenit augue duis dolore te feugait nulla facilisi. Lorem ipsum dolor sit amet, consectetuer adipiscing elit, sed diam nonummy nibh euismod tincidunt ut laoreet dolore magna aliquam erat volutpat. Ut wisi enim ad minim veniam, quis nostrud exerci tation ullamcorper suscipit lobortis nisl ut aliquip ex ea commodo consequat. Duis autem vel eum iriure dolor in hendrerit in vulputate velit esse molestie consequat, vel illum dolore eu feugiat nulla facilisis at vero eros et accumsan et iusto odio dignissim qui blandit praesent luptatum zzril delenit

dolore eu feugiat nulla facilisis at vero eros et accumsan et iusto odio dignissim qui blandit praesent luptatum zzril delenit augue duis dolore te feugait nulla facilisi. Lorem ipsum dolor sit amet, consectetuer adipiscing elit, sed diam nonummy nibh euismod tincidunt ut laoreet dolore magna aliquam erat volutpat. Ut wisi enim ad minim veniam, quis nostrud exerci tation ullamcorper suscipit lobortis nisl ut aliquip ex ea commodo consequat. Duis autem vel eum iriure dolor in hendrerit in vulputate velit esse molestie consequat, vel illum dolore eu feugiat nulla facilisis at vero eros et accumsan et iusto odio dignissim qui blandit praesent luptatum zzril delenit augue duis dolore te feugait nulla facilisi.

A five-column layout

Lorem ipsum dolor sit amet

Lorem ipsum dolor sit amet, consectetuer adipiscing elit, sed diam nonummy nibh euismod tincidunt ut laoreet dolore magna aliquam erat volutpat. Ut wisi enim ad minim veniam, quis nostrud exerci tation ullam

Lorem ipsum dolor sit amet, consectetuer adipiscing elit, sed diam nonummy nibh euismod tincidunt ut laoreet dolore magna aliquam erat volutpat. Ut wisi enim ad minim veniam, quis nostrud exerci tation ullamcorper suscipit lobortis nisl ut aliquip ex ea commodo consequat. Duis autem vel eum iriure dolor in hendrerit in vulputate velit esse molestie consequat, vel illum dolore eu feugiat nulla facilisis at vero eros et accumsan et iusto odio dignissim qui blandit praesent luptatum zzril delenit augue duis dolore te feugait nulla facilisi.

diam nonummy nibh euismod tincidunt ut laoreet dolore magna aliquam erat volutpat. Ut wisi enim ad minim veniam, quis nostrud exerci tation ullamcorper suscipit lobortis nisl ut aliquip ex ea commodo consequat. Duis autem vel eum iriure dolor in hendrerit in vulputate velit esse molestie consequat, vel illum dolore eu feugiat nulla facilisis at vero eros et accumsan et iusto odio dignissim qui blandit praesent luptatum zzril delenit augue duis dolore te feugait nulla facilisi. Lorem ipsum dolor sit amet, consectetuer adipiscing elit, sed diam nonummy nibh euismod tincidunt ut laoreet dolore magna aliquam erat volutpat. Ut wisi enim ad minim veniam, quis nostrud exerci tation ullam

Lorem ipsum dolor sit amet, consectetuer adipiscing elit, sed diam nonummy nibh euismod tincidunt ut laoreet dolore magna aliquam erat volutpat. Ut wisi enim ad minim veniam, quis nostrud exerci tation ullam

A six-column layout
Six columns allow for two wide fields and two narrow fields per page, which can be useful in heavily annotated documents.

Lorem ipsum dolor sit amet

Lorem ipsum dolor sit amet

Most often, text layouts will involve spreads (two facing pages) and not single sheets. Always keep the spread in mind when you're setting up your page. You can see here how different a spread of horizontal pages (top) feels from a spread of vertical pages (bottom).

Lorem ipsum dolor sit amet

Lorem ipsum dolor sit amet

Lorem ipsum dolor sit amet, consectetuer adipiscing elit, sed diam nonummy nibh euismod tincidunt ut laoreet dolore magna aliquam erat volutpat. Ut wisi enim ad minim veniam, quis nostrud exerci tation ullamcorper suscipit lobortis nisl ut aliquip ex ea commodo consequat. Duis autem vel eum iriure dolor in hendrerit in vulputate velit esse molestie consequat, vel illum dolore eu feugiat nulla facilisis at vero eros et accumsan et iusto odio dignissim qui blandit praesent luptatum zzril delenit augue duis dolore te feugait nulla facilisi. Lorem ipsum dolor sit amet, consectetuer adipiscing elit, sed diam nonummy nibh euismod tincidunt ut laoreet dolore magna aliquam erat volutpat. Ut wisi enim ad minim veniam, quis nostrud exerci tation ullamcorper suscipit lobortis nisl ut aliquip ex ea commodo consequat. Duis autem vel eum iriure dolor in hendrerit in vulputate velit esse molestie consequat, vel illum dolore eu feugiat nulla facilisis at vero eros et accumsan et iusto odio dignissim qui blandit praesent luptatum zzril delenit augue duis dolore te feugait nulla facilisi. Nam liber tempor cum soluta nobis eleifend option congue nihil imperdiet doming id quod mazim placerat facer possim assum. Lorem ipsum dolor sit amet, consectetuer adipiscing elit, sed diam nonummy

Consecteter adipiscing elit

Nibh euismod tincidunt ut laoreet dolore magna aliquam erat volutpat. Ut wisi enim ad minim veniam, quis nostrud exerci tation ullamcorper suscipit lobortis nisl ut aliquip ex ea commodo consequat. Duis autem vel eum iriure dolor in hendrerit in vulputate velit esse molestie consequat, vel illum dolore eu feugiat nulla facilisis at vero eros et accumsan et iusto odio dignissim qui blandit praesent luptatum zzril delenit augue duis dolore te feugait nulla facilisi. Lorem ipsum dolor sit amet, consectetuer adip Lorem ipsum dolor sit amet, consectetuer adipiscing elit, sed diam nonummy nibh euismod

Sed diam nonummy nibh

Tincidunt ut laoreet dolore magna aliquam erat volutpat. Ut wisi enim ad minim veniam, quis nostrud exerci tation ullamcorper suscipit lobortis nisl ut aliquip ex ea commodo consequat. Duis autem vel eum iriure dolor in hendrerit in vulputate velit esse molestie consequat, vel illum dolore eu feugiat nulla facilisis at vero eros et accumsan et iusto odio dignissim qui blandit praesent luptatum zzril delenit augue duis dolore te feugait nulla facilisi. Lorem ipsum dolor sit amet, consectetuer adipiscing elit, sed diam nonummy nibh euismod tincidunt ut laoreet dolore magna aliquam erat volutpat. Ut wisi enim ad minim veniam, quis nostrud exerci tation ullamcorper suscipit

Ut wisi enim ad minim

Lobortis nisl ut aliquip ex ea commodo consequat. Duis autem vel eum iriure dolor in hendrerit in vulputate velit esse molestie consequat, vel illum dolore eu feugiat nulla facilisis at vero eros et accumsan et iusto odio dignissim qui blandit

Veniam quis nostrud exerci tati

Praesent luptatum zzril delenit augue duis dolore te feugait nulla facilisi. Nam liber tempor cum soluta nobis eleifend option congue nihil imperdiet doming id quod mazim placerat facer possim assum. Lorem ipsum dolor sit amet, consectetuer adipiscing elit, sed diam nonummy nibh euismod tincidunt ut laoreet dolore magna aliquam erat volutpat. Ut wisi enim ad minim veniam, quis nostrud exerci tation ullamcorper suscipit lobortis nisl ut aliquip ex ea commodo consequat. Duis autem vel eum iriure dolor in hendrerit in vulputate velit esse molestie consequat, vel illum dolore eu feugiat nulla facilisis at vero eros et accumsan et iusto odio dignissim qui blandit praesent luptatum zzril delenit augue duis dolore te feugait nulla facilisi. Lorem ipsum dolor sit amet, consectetuer adip Lorem ipsum dolor sit amet, consectetuer adipiscing elit, sed diam nonummy nibh euismod tincidunt ut laoreet dolore magna aliquam erat volutpat. Ut

Columnar layouts are effective for many different formats. Above, a three-column layout is applied to each of the three panels on an 8.5 x 11 in (216 x 279 mm) sheet.

Cross-alignment

Euismod tincidunt ut laoreet dolore magna aliquam erat volutpat. Ut wisi enim ad minim veniam, quis nostrud exerci tation ullamcorper suscipit lobortis nisl ut aliquip ex ea commodo consequat. Duis autem vel eum iriure dolor in hendrerit in vulputate velit esse molestie consequat, vel illum dolore eu feugiat nulla facilisis at vero eros et accumsan et iusto odio dignissim qui blandit praesent luptatum zzril delenit augue duis dolore te feugait nulla facilisi. Lorem ipsum dolor

Lorem ipsum dolor sit amet, consectetuer adipiscing elit, sed diam nonummy nibh euismod tincidunt ut laoreet dolore magna aliquam erat volutpat. Ut wisi enim ad minim veniam, quis nostrud exerci tation ullamcorper suscipit lobortis nisl ut aliquip ex ea commodo consequat. Duis autem vel eum iriure dolor in hendrerit in vulputate velit esse molestie consequat, vel illum dolore eu feugiat nulla facilisis at vero eros et accumsan et iusto odio dignissim qui blandit praesent luptatum zzril delenit augue duis dolore te feugait nulla facilisi. Lorem ipsum dolor sit amet, consectetuer adipiscing elit, sed diam nonummy nibh euismod tincidunt ut laoreet dolore magna aliquam erat volutpat. Ut wisi enim ad minim veniam, quis nostrud exerci tation ullamcorper suscipit lobortis nisl ut aliquip ex ea commodo consequat. Duis autem vel eum iriure dolor in hendrerit in vulputate velit esse molestie consequat, vel illum dolore eu feugiat nulla facilisis at vero eros et accumsan et iusto odio dignissim qui blandit praesent luptatum zzril delenit augue duis dolore te feugait nulla facilisi. Nam liber tempor cum soluta nobis eleifend option congue nihil imperdiet doming id quod mazim placerat facer possim assum. Lorem ipsum dolor sit amet, consectetuer adipiscing elit, sed diam nonummy nibh euismod tincidunt ut laoreet dolore magna aliquam erat volutpat. Ut wisi enim ad minim veniam,

7/9 Univers 75 x 10p4

10/13.5 Janson x 22p3

Cross-aligning headlines and captions with text type reinforces the architectural sense of the page — the structure — while articulating the complementary vertical rhythms. In this example, four lines of caption type (leaded to 9 pts.) cross-align with three lines of text type (leaded to 13.5 pts.).

Lorem ipsum dolor sit amet, consectetuer quam erat volutpat.

Ut wisi enim ad minim veniam, quis nostrud exercitation

Lorem ipsum dolor sit amet, consectetuer adipiscing elit, sed diam nonummy nibh euismod tincidunt ut laoreet dolore magna aliquam erat volutpat. Ut wisi enim ad minim veniam, quis nostrud exerci tation ullamcorper suscipit lobortis nisl ut aliquip ex ea commodo consequat. Duis autem vel eum iriure dolor in hendrerit in vulputate velit esse molestie consequat, vel illum dolore eu feugiat nulla facilisis at vero eros et accumsan et iusto odio dignissim qui blandit praesent luptatum zzril delenit augue duis dolore te feugait nulla facilisi. Lorem ipsum dolor sit amet, consectetuer adipiscing elit, sed diam nonummy nibh euismod tincidunt ut laoreet dolore magna aliquam erat volutpat. Ut wisi enim ad minim veniam, quis nostrud exerci tation ullamcorper suscipit lobortis nisl ut aliquip ex ea commodo consequat. Duis autem vel eum iriure dolor in hendrerit in vulputate velit esse molestie consequat, vel illum dolore eu feugiat nulla facilisis at vero eros et accumsan et

24/27 Janson x 16p (top)
14/18 Univers 75 x 10p4 (bottom)

10/13.5 Janson x 16p

Above, (top left) one line of headline type cross-aligns with two lines of text type, and (bottom left) four lines of headline type cross-align with five lines of text type. Later on, we'll look at ways of choosing proportional text sizes. For now, it's important simply to keep in mind this relationship between different leadings.

Expressing hierarchy

In most circumstances, a designer's first goal is to make material comprehensible to a reader. In other words, you should understand the material well enough to know how someone else needs to read it to make the best sense out of it. This understanding happens on two levels: content and form.

The recipe on the right is a fairly straightforward presentation of the making of an apple tart. With the exception of one or two terms specific to cooking, its content does not require any special knowledge. However, in its form—the manner in which information is set and placed on a page—the process it describes can be made clearer than it appears as plain typescript.

To understand the form, you must first understand the kinds of information the recipe contains and then rank them according to levels of importance, thereby creating a hierarchy. In this recipe there are the following levels of information:

title (1)
subtitles (2)
text (3)

Within the text there are:

ingredient lists (3A)
oven temperature instructions (3B)
directions (3C)

Successfully setting this recipe in type requires that you make each of these distinctions clear to the reader. Using some of the kinds of contrast discussed on pages 62–63 and the methods outlined on pages 132–135 will help you express these distinctions.

Apple tart

The shell

7 tablespooons frozen butter*
1 cup frozen flour*
3 tablespoons ice-cold water*
1 teaspoon cider vinegar
A pinch of kosher salt
* It is important to have these ingredients as cold as possible.

Preheat the oven to 400°.

In a food processor fitted with a steel blade, combine all the ingredients until they form a solid mass that rises above the blade. You can add extra water by the tablespoon if the mass does not congeal within the first minute. Tiny pieces of butter should still be visible in the dough when it's done. Remove the dough from the bowl and work it quickly into a ball on a lightly floured surface. Cover with plastic wrap and refrigerate for at least half an hour.

After the dough has rested in the refrigerator, roll it out on a lightly floured surface until it forms a circle approximately 13 inches in diameter. Center the circle of dough in a 10-inch tart pan with a removeable bottom. Use your knuckles to make sure that the dough tucks neatly against the edge of the pan and run the rolling pin around the rim to remove the excess. Cover and refrigerate again for at least half an hour.

Line the tart shell with aluminum foil, being careful to cover the edges. Pierce the aluminum and the dough several times with a fork and fill the shell with dried lentils. Bake for 20 minutes. Remove the aluminum and the lentils and continue baking until the shell is golden brown, about 15 minutes more.

The apples

6 Granny Smith apples
Juice of one lemon
Cinammon to taste
Nutmeg to taste

Peel, core, and halve the apples. Either by hand or with a food processor, cut the apple halves crosswise into thin (less than 1/4-inch) slices. In a large bowl, toss the appples in the lemon juice, cinammon, and nutmeg. Cover and set aside.

The pastry cream

1/4 cup sugar
1 tablespoon flour
2 teaspoons cornstarch
1 large egg
1 cup milk
3 tablespoons unsalted butter
1/4 teaspoon vanilla extract

Sift the sugar, flour, and cornstarch together into a mixing bowl. Add the egg and beat until light. In a heavy-bottomed saucepan, bring the milk to a boil. Stir half the milk into the egg mixture, then pour the whole mixture back into the saucepan. Cook over high heat, stirring constantly, until the center bubbles and the mixture is very thick. Remove from heat and stir in the vanilla and the butter. Pour the pastry cream into a bowl, cover tightly with plastic wrap, and refrigerate. (Be sure to press the plastic wrap right onto the cream to prevent a skin from forming.)

The assembly and baking

2 tablespoons sugar
8 ounces currant jelly

Preheat the oven to 375°.

Spread the pastry cream over the bottom of the shell. Arrange the apple slices in a circle around the outer edge of the shell, making sure the slices overlap. When the outer circle is completed, make a smaller circle, overlapping about half of the outer circle. If there's room, make a third circle. Fill the hole in the center with pieces of a few slices--let them stand upright. Cover the tart with a circle of wax paper and bake for 25 minutes. Remove the wax paper and sprinkle the sugar over the apples. Bake uncovered for 5-10 minutes more, until the sugar melts.

Boil the currant jelly until it reduces by one-third. With a pastry brush, paint the top of the tart with the currant glaze. Allow time for the glaze to set and the tart to cool before serving (10 minutes).

Apple tart

The shell

Preheat the oven to 400°.

7 tablespooons frozen butter*
1 cup frozen flour*
3 tablespoons ice-cold water*
1 teaspoon cider vinegar
A pinch of kosher salt
* It is important to have these ingredients
as cold as possible.

In a food processor fitted with a steel blade, combine all the ingredients until they form a solid mass that rises above the blade. You can add extra water by the tablespoon if the mass does not congeal within the first minute. Tiny pieces of butter should still be visible in the dough when it's done. Remove the dough from the bowl and work it quickly it into a ball on a lightly floured surface. Cover with plastic wrap and refrigerate for at least half an hour.

After the dough has rested in the refrigerator, roll it out on a lightly floured surface until it forms a circle approximately 13" in diameter. Center the circle of dough in a 10-inch tart pan with a removeable bottom. Use your knuckles to make sure that the dough tucks neatly against the edge of the pan and run the rolling pin around the rim to remove the excess. Cover and refrigerate again for at least half an hour.

Line the tart shell with aluminum foil, being careful to cover the edges. Pierce the aluminum and the dough several times with a fork and fill the shell with dried lentils. Bake for 20 minutes. Remove the aluminum and the lentils and continue baking until the shell is golden brown, about 15 minutes more.

The apples

6 Granny Smith apples
Juice of one lemon
Cinammon to taste
Nutmeg to taste

Peel, core and halve the apples. Either by hand or with a food processor, cut the apple halves crosswise into thin (less than ¼") slices. In a large bowl, toss the appples in the lemon juice, cinammon and nutmeg. Cover and set aside.

The pastry cream

¼ cup sugar
1 tablespoon flour
2 teaspoons cornstarch
1 large egg
1 cup milk
3 tablespoons unsalted butter
¼ teaspoon vanilla extract

Sift the sugar, flour and cornstarch together in a mixing bowl. Add the egg and beat until light. In a heavy-bottomed saucepan, bring the milk to a boil. Stir half the milk into the egg mixture, then pour the whole mixture back into the saucepan. Cook over high heat, stirring constantly, until the center bubbles and the mixture is very thick. Remove from heat and stir in the vanilla and the butter. Pour the pastry cream into a bowl, cover tightly with plastic wrap and refrigerate. (Be sure to press the plastic wrap right onto the cream to prevent a skin from forming.)

The assembly and baking

Preheat the oven to 375°.

2 tablespoons sugar
8 ounces currant jelly

Spread the pastry cream over the bottom of the shell. Arrange the apple slices in a circle around the outer edge of the shell, making sure the slices overlap. When the outer circle is completed, make a smaller circle, overlapping about half of the outer circle. If there's room, make a third circle. fill the hole in the center with pieces of a few slices—let them stand upright. Cover the tart with a circle of wax paper and bake for 25 minutes. Remove the wax paper and sprinkle the sugar over the apples. Bake uncovered for 5-10 minutes more, until the sugar melts.

Boil the currant jelly until it reduces by one-third. With a pastry brush, paint the top of the tart with the currant glaze. Allow time for the glaze to set before serving (10 minutes).

Option 1
One typeface, one size
throughout

9/11 Adobe Garamond

Line the tart shell with alumin
and the dough several times w
utes. Remove the aluminum a
brown, about 15 minutes mor

The apples

Peel, core and halve the apple
crosswise into thin (less than

$^1/_4$ cup sugar
1 tablespoon flour
2 teaspoons cornstarch
1 large egg
1 cup milk
3 tablespoons unsalted butter
$^1/_4$ teaspoon vanilla extract

Establishing a format

After analyzing and organizing the content, devise a format that expresses differences within the text. In Option 1 (opposite), all the ingredients are separated from the directions. Because the line length required for easy reading of directions is more or less twice the line length required for a list of ingredients, the area within the margins of the sheet is divided vertically into three intervals, or columns. Ingredients occupy the first column, directions the second and third columns. Groups of ingredients cross-align with the directions that refer to them.

Establishing a hierarchy

Single line spaces indicate breaks between paragraphs. Double line spaces indicate breaks between sections of text.

Typeface choice

When numbers and fractions occur frequently in the text, choose a typeface with an expert set that includes lowercase numerals and fraction characters. (See page 6 for a brief discussion of lowercase numerals.)

Ligatures

Virtually all text typefaces have ligatures for f/i and f/l combinations. Some also have ligatures for f/f, f/f/i, and f/f/l.

Apple tart

The shell

Preheat the oven to 400°.

7 tablespooons frozen butter*
1 cup frozen flour*
3 tablespoons ice-cold water*
1 teaspoon cider vinegar
A pinch of kosher salt
* It is important to have these ingredients as
cold as possible.

In a food processor fitted with a steel blade, combine all the ingredients until they form a solid mass that rises above the blade. You can add extra water by the tablespoon if the mass does not congeal within the first minute. Tiny pieces of butter should still be visible in the dough when it's done. Remove the dough from the bowl and work it quickly it into a ball on a lightly floured surface. Cover with plastic wrap and refrigerate for at least half an hour.

After the dough has rested in the refigerator, roll it out on a lightly floured surface until it forms a circle approximately 13" in diameter. Center the circle of dough in a 10-inch tart pan with a removeable bottom. Use your knuckles to make sure that the dough tucks neatly against the edge of the pan and run the rolling pin around the rim to remove the excess. Cover and refrigerate again for at least half an hour.

Line the tart shell with aluminum foil, being careful to cover the edges. Pierce the aluminum and the dough several times with a fork and fill the shell with dried lentils. Bake for 20 minutes. Remove the aluminum and the lentils and continue baking until the shell is golden brown, about 15 minutes more.

The apples

6 Granny Smith apples
Juice of one lemon
Cinammon to taste
Nutmeg to taste

Peel, core and halve the apples. Either by hand or with a food processor, cut the apple halves crosswise into thin (less than ¼") slices. In a large bowl, toss the appples in the lemon juice, cinammon and nutmeg. Cover and set aside.

The pastry cream

¼ cup sugar
1 tablespoon flour
2 teaspoons cornstarch
1 large egg
1 cup milk
3 tablespoons unsalted butter
¼ teaspoon vanilla extract

Sift the sugar, flour and cornstarch together in a mixing bowl. Add the egg and beat until light. In a heavy-bottomed saucepan, bring the milk to a boil. Stir half the milk into the egg mixture, then pour the whole mixture back into the saucepan. Cook over high heat, stirring constantly, until the center bubbles and the mixture is very thick. Remove from heat and stir in the vanilla and the butter. Pour the pastry cream into a bowl, cover tightly with plastic wrap and refrigerate. (Be sure to press the plastic wrap right onto the cream to prevent a skin from forming.)

The assembly and baking

2 tablespoons sugar
8 ounces currant jelly

Preheat the oven to 375°.

Spread the pastry cream over the bottom of the shell. Arrange the apple slices in a circle around the outer edge of the shell, making sure the slices overlap. When the outer circle is completed, make a smaller circle, overlapping about half of the outer circle. If there's room, make a third circle. Fill the hole in the center with pieces of a few slices—let them stand upright. Cover the tart with a circle of wax paper and bake for 25 minutes. Remove the wax paper and sprinkle the sugar over the apples. Bake uncovered for 5-10 minutes more, until the sugar melts.

Boil the currant jelly until it reduces by one-third. With a pastry brush, paint the top of the tart with the currant glaze. Allow time for the glaze to set before serving (10 minutes).

Apple tart

The shell

Preheat the oven to 400°.

7 tablespoons frozen butter*
1 cup frozen flour*
3 tablespoons ice-cold water*
1 teaspoon cider vinegar
A pinch of kosher salt
* It is important to have these ingredients as cold as possible.

In a food processor fitted with a steel blade, combine all the ingredients until they form a solid mass that rises above the blade. You can add extra water by the tablespoon if the mass does not congeal within the first minute. Tiny pieces of butter should still be visible in the dough when it's done. Remove the dough from the bowl and work it quickly into a ball on a lightly floured surface. Cover with plastic wrap and refrigerate for at least half an hour.

After the dough has rested in the refigerator, roll it out on a lightly floured surface until it forms a circle approximately 13" in diameter. Center the circle of dough in a 10-inch tart pan with a removeable bottom. Use your knuckles to make sure that the dough tucks neatly against the edge of the pan and run the rolling pin around the rim to remove the excess. Cover and refrigerate again for at least half an hour.

Line the tart shell with aluminum foil, being careful to cover the edges. Pierce the aluminum and the dough several times with a fork and fill the shell with dried lentils. Bake for 20 minutes. Remove the aluminum and the lentils and continue baking until the shell is golden brown, about 15 minutes more.

The apples

6 Granny Smith apples
Juice of one lemon
Cinammon to taste
Nutmeg to taste

Peel, core and halve the apples. Either by hand or with a food processor, cut the apple halves crosswise into thin (less than ¼") slices. In a large bowl, toss the appples in the lemon juice, cinammon and nutmeg. Cover and set aside.

The pastry cream

¼ cup sugar
1 tablespoon flour
2 teaspoons cornstarch
1 large egg
1 cup milk
3 tablespoons unsalted butter
¼ teaspoon vanilla extract

Sift the sugar, flour and cornstarch together in a mixing bowl. Add the egg and beat until light. In a heavy-bottomed saucepan, bring the milk to a boil. Stir half the milk into the egg mixture, then pour the whole mixture back into the saucepan. Cook over high heat, stirring constantly, until the center bubbles and the mixture is very thick. Remove from heat and stir in the vanilla and the butter. Pour the pastry cream into a bowl, cover tightly with plastic wrap and refrigerate. (Be sure to press the plastic wrap right onto the cream to prevent a skin from forming.)

The assembly and baking

2 tablespoons sugar
8 ounces currant jelly

Preheat the oven to 375°.

Spread the pastry cream over the bottom of the shell. Arrange the apple slices in a circle around the outer edge of the shell, making sure the slices overlap. When the outer circle is completed, make a smaller circle, overlapping about half of the outer circle. If there's room, make a third circle. Fill the hole in the center with pieces of a few slices—let them stand upright. Cover the tart with a circle of wax paper and bake for 25 minutes. Remove the wax paper and sprinkle the sugar over the apples. Bake uncovered for 5-10 minutes more, until the sugar melts.

Boil the currant jelly until it reduces by one-third. With a pastry brush, paint the top of the tart with the currant glaze. Allow time for the glaze to set before serving (10 minutes).

Reinforcing structure

Setting the ingredients flush right against the gutter between the first and second columns strengthens the formal organization of the page. Keep in mind that setting type flush-right causes you to read the shape created by the type before you read the actual text. Similarly, the counterform created by the gutter between the two kinds of text (ingredients and directions) becomes a dominant, possibly intrusive element on the page.

Apple tart

The shell

Preheat the oven to 400°.

7 tablespoons frozen butter*
1 cup frozen flour*
3 tablespoons ice-cold water*
1 teaspoon cider vinegar
A pinch of kosher salt

* *It is important to have these ingredients as cold as possible.*

In a food processor fitted with a steel blade, combine all the ingredients until they form a solid mass that rises above the blade. You can add extra water by the tablespoon if the mass does not congeal within the first minute. Tiny pieces of butter should still be visible in the dough when it's done. Remove the dough from the bowl and work it quickly it into a ball on a lightly floured surface. Cover with plastic wrap and refrigerate for at least half an hour.

After the dough has rested in the refrigerator, roll it out on a lightly floured surface until it forms a circle approximately 13" in diameter. Center the circle of dough in a 10-inch tart pan with a removeable bottom. Use your knuckles to make sure that the dough tucks neatly against the edge of the pan and run the rolling pin around the rim to remove the excess. Cover and refrigerate again for at least half an hour.

Line the tart shell with aluminum foil, being careful to cover the edges. Pierce the aluminum and the dough several times with a fork and fill the shell with dried lentils. Bake for 20 minutes. Remove the aluminum and the lentils and continue baking until the shell is golden brown, about 15 minutes more.

The apples

6 Granny Smith apples
Juice of one lemon
Cinammon to taste
Nutmeg to taste

Peel, core and halve the apples. Either by hand or with a food processor, cut the apple halves crosswise into thin (less than 1/4") slices. In a large bowl, toss the appples in the lemon juice, cinammon and nutmeg. Cover and set aside.

The pastry cream

1/4 cup sugar
1 tablespoon flour
2 teaspoons cornstarch
1 large egg
1 cup milk
3 tablespoons unsalted butter
1/4 teaspoon vanilla extract

Sift the sugar, flour and cornstarch together in a mixing bowl. Add the egg and beat until light. In a heavy-bottomed saucepan, bring the milk to a boil. Stir half the milk into the egg mixture, then pour the whole mixture back into the saucepan. Cook over high heat, stirring constantly, until the center bubbles and the mixture is very thick. Remove from heat and stir in the vanilla and the butter. Pour the pastry cream into a bowl, cover tightly with plastic wrap and refrigerate. (Be sure to press the plastic wrap right onto the cream to prevent a skin from forming.)

The assembly and baking

2 tablespoons sugar
8 ounces currant jelly

Preheat the oven to 375°.

Spread the pastry cream over the bottom of the shell. Arrange the apple slices in a circle around the outer edge of the shell, making sure the slices overlap. When the outer circle is completed, make a smaller circle, overlapping about half of the outer circle. If there's room, make a third circle. Fill the hole in the center with pieces of a few slices—let them stand upright. Cover the tart with a circle of wax paper and bake for 25 minutes. Remove the wax paper and sprinkle the sugar over the apples. Bake uncovered for 5-10 minutes more, until the sugar melts.

Boil the currant jelly until it reduces by one-third. With a pastry brush, paint the top of the tart with the currant glaze. Allow time for the glaze to set before serving (10 minutes).

Apple tart

The shell

Preheat the oven to 400°.

In a food processor fitted with a
solid mass that rises above the b
does not congeal within the firs
dough when it's done. Remove

Line the tart shell with alumin
and the dough several times wi
utes. Remove the aluminum an
brown, about 15 minutes more.

The apples

Peel, core and halve the apples.
crosswise into thin (less than $^1/_4$
cinammon and nutmeg. Cover

7 tablespooons frozen butter*
1 cup frozen flour*
3 tablespoons ice-cold water*
1 teaspoon cider vinegar
A pinch of kosher salt

* *It is important to have these ingre*
 as cold as possible.

Title treatment
Enlarging the size of the title not
only reinforces hierarchy, but also
provides an unambiguous starting
point for reading.

Secondary heads
Using italic for secondary heads
reinforces their place in the overall
hierarchy already indicated by the
additional line space.

Italic within the text
Italic within the list of ingredients
indicates information that affects
the items in use. Note also how the
exdented asterisk (see page 130)
strengthens the left margin of the
type. Compare with Option 1.

Apple tart

The shell

7 tablespooons frozen butter*
1 cup frozen flour*
3 tablespoons ice-cold water*
1 teaspoon cider vinegar
A pinch of kosher salt

It is important to have these ingredients as cold as possible.

In a food processor fitted with a steel blade, combine all the ingredients until they form a solid mass that rises above the blade. You can add extra water by the tablespoon if the mass does not congeal within the first minute. Tiny pieces of butter should still be visible in the dough when it's done. Remove the dough from the bowl and work it quickly it into a ball on a lightly floured surface. Cover with plastic wrap and refrigerate for at least half an hour.

After the dough has rested in the refigerator, roll it out on a lightly floured surface until it forms a circle approximately 13" in diameter. Center the circle of dough in a 10-inch tart pan with a removeable bottom. Use your knuckles to make sure that the dough tucks neatly against the edge of the pan and run the rolling pin around the rim to remove the excess. Cover and refrigerate again for at least half an hour.

Line the tart shell with aluminum foil, being careful to cover the edges. Pierce the aluminum and the dough several times with a fork and fill the shell with dried lentils. Bake for 20 minutes. Remove the aluminum and the lentils and continue baking until the shell is golden brown, about 15 minutes more.

Preheat the oven to 400°.

The apples

6 Granny Smith apples
Juice of one lemon
Cinammon to taste
Nutmeg to taste

Peel, core and halve the apples. Either by hand or with a food processor, cut the apple halves crosswise into thin (less than $1/4$") slices. In a large bowl, toss the apples in the lemon juice, cinammon and nutmeg. Cover and set aside.

The pastry cream

$1/4$ cup sugar
1 tablespoon flour
2 teaspoons cornstarch
1 large egg
1 cup milk
3 tablespoons unsalted butter
$1/4$ teaspoon vanilla extract

Sift the sugar, flour and cornstarch together in a mixing bowl. Add the egg and beat until light. In a heavy-bottomed saucepan, bring the milk to a boil. Stir half the milk into the egg mixture, then pour the whole mixture back into the saucepan. Cook over high heat, stirring constantly, until the center bubbles and the mixture is very thick. Remove from heat and stir in the vanilla and the butter. Pour the pastry cream into a bowl, cover tightly with plastic wrap and refrigerate. (Be sure to press the plastic wrap right onto the cream to prevent a skin from forming.)

The assembly and baking

2 tablespoons sugar
8 ounces currant jelly

Spread the pastry cream over the bottom of the shell. Arrange the apple slices in a circle around the outer edge of the shell, making sure the slices overlap. When the outer circle is completed, make a smaller circle, overlapping about half of the outer circle. If there's room, make a third circle. Fill the hole in the center with pieces of a few slices—let them stand upright. Cover the tart with a circle of wax paper and bake for 25 minutes. Remove the wax paper and sprinkle the sugar over the apples. Bake uncovered for 5-10 minutes more, until the sugar melts.

Boil the currant jelly until it reduces by one-third. With a pastry brush, paint the top of the tart with the currant glaze. Allow time for the glaze to set before serving (10 minutes).

Preheat the oven to 375°.

Option 4
Two typefaces, two sizes
7-column format

9/11 and 18/22 Adobe Garamond
8/11 Univers 75

Revised format

Dividing the type area into seven columns provides a new, separate column for oven settings, creates a narrower (and easier to read) line length for instructions, and increases white space on the page.

Tabular matter

Designers often encounter typographic problems that are not based on narrative or instructions ('This happened, then this happened,' or 'Do this, then do this'). Timetables, financial statements, lists of dates, weather charts—many kinds of information design—often need to accommodate reading in two directions simultaneously. Setting up columns and rows that read clearly requires a thorough understanding of working with tabs.

The timetable to the right (actual size: 6 in or 152 mm square) demonstrates many of the problems with overdesigning tabular matter. Extraneous rules, both vertical and horizontal, have been imposed on the basic typographic organization to correct for unfortunate first choices about type size, leading, and placement.

SATURDAYS AND SUNDAYS

INBOUND	1204	1208	1212	1216	1220	1224
READ DOWN	A.M.	A.M.	P.M.	P.M.	P.M.	P.M.
Dep: Haverhill	7 15	10 15	1 15	4 15	7 15	10 15
Bradford	7 17	10 17	1 17	4 17	7 17	10 17
Lawrence	7 26	10 26	1 26	4 26	7 26	10 26
Andover	7 31	10 31	1 31	4 31	7 31	10 31
Ballardvale	f7 36	f10 36	f1 36	f4 36	f7 36	f10 36
North Wilmington	f7 42	f10 42	f1 42	f4 42	f7 42	f10 42
Reading	7 51	10 51	1 51	4 51	7 51	10 51
Wakefield	7 57	10 57	1 57	4 57	7 57	10 57
Greenwood	f8 00	f11 00	f2 00	f5 00	f8 00	f11 00
Melrose Highlands	8 02	11 02	2 02	5 02	8 02	11 02
Melrose/Cedar Park	f8 04	f11 04	f2 04	f5 04	f8 04	f11 04
Wyoming Hill	f8 06	f11 06	f2 06	f5 06	f8 06	f11 06
Malden Center	8 09	11 09	2 09	5 09	8 09	11 09
Arr: North Station	8 19	11 19	2 19	5 19	8 19	11 19

OUTBOUND	1205	1209	1213	1217	1221	1225
READ DOWN	A.M.	A.M.	P.M.	P.M.	P.M.	P.M.
Dep: North Station	8 45	11 45	2 45	5 45	8 45	11 30
Malden Center	8 55	11 55	2 55	5 55	8 55	11 40
Wyoming Hill	f8 58	f11 58	f2 58	f5 58	f8 58	f11 43
Melrose/Cedar Park	f9 00	f12 00	f3 00	f6 00	f9 00	f11 45
Melrose Highlands	9 02	12 02	3 02	6 02	9 02	11 47
Greenwood	f9 04	f12 04	f3 04	f6 04	f9 04	f11 49
Wakefield	9 08	12 08	3 08	6 08	9 08	11 53
Reading	9 14	12 14	3 14	6 14	9 14	11 59
North Wilmington	f9 22	f12 22	f3 22	f6 22	f9 22	f12 07
Ballardvale	f9 28	f12 28	f3 28	f6 28	f9 28	f12 13
Andover	9 33	12 33	3 33	6 33	9 33	12 18
Lawrence	9 38	12 38	3 38	6 38	9 38	12 23
Bradford	9 47	12 47	3 47	6 47	9 47	12 32
Arr: Haverhill	9 49	12 49	3 49	6 49	9 49	12 34

HOLIDAYS

July 4 and New Year's Eve contact Customer Service for service updates at 617-222-3200

SATURDAY SERVICE
Presidents' Day
Independence Day
New Year's Day
f stops only on request

SUNDAY SERVICE
Memorial Day • Labor Day
Thanksgiving Day • Christmas Day

Uppercase numerals were initially designed to all have the same set width, in part so that they would align vertically in columns of figures. Lowercase numerals were not.

157

Saturdays and Sundays

Inbound	1204	1208	1212	1216	1220	1224
Dep: Haverhill	7:15	10:15	1:15	4:15	7:15	10:15
Bradford	7:17	10:17	1:17	4:17	7:17	10:17
Lawrence	7:26	10:26	1:26	4:26	7:26	10:26
Andover	7:31	10:31	1:31	4:31	7:31	10:31
Ballardvale	7:36*	10:36*	1:36*	4:36*	7:36*	10:36*
North Wilmington	7:42*	10:42*	1:42*	4:42*	7:42*	10:42*
Reading	7:51	10:51	1:51	4:51	7:51	10:51
Wakefield	7:57	10:57	1:57	4:57	7:57	10:57
Greenwood	8:00*	11:00*	2:00*	5:00*	8:00*	11:00*
Melrose Highlands	8:02	11:02	2:02	5:02	8:02	11:02
Melrose/Cedar Park	8:04*	11:04*	2:04*	5:04*	8:04*	11:04*
Wyoming Hill	8:06*	11:06*	2:06*	5:06*	8:06*	11:06*
Malden Center	8:09	11:09	2:09	5:09	8:09	11:09
Arr: North Station	8:19	11:19	2:19	5:19	8:19	11:19

Outbound	1205	1209	1213	1217	1221	1225
Dep: North Station	8:45	11:45	2:45	5:45	8:45	11:30
Malden Center	8:55	11:55	2:55	5:55	8:55	11:40
Wyoming Hill	8:58*	11:58*	2:58*	5:58*	8:58*	11:43*
Melrose/Cedar Park	9:00*	12:00*	3:00*	6:00*	9:00*	11:45*
Melrose Highlands	9:02	12:02	3:02	6:02	9:02	11:47
Greenwood	9:04*	12:04*	3:04*	6:04*	9:04*	11:49*
Wakefield	9:08	12:08	3:08	6:08	9:08	11:53
Reading	9:14	12:14	3:14	6:14	9:14	11:59
North Wilmington	9:22*	12:22*	3:22*	6:22*	9:22*	12:07*
Ballardvale	9:28*	12:28*	3:28*	6:28*	9:28*	12:13*
Andover	9:33	12:33	3:33	6:33	9:33	12:18
Lawrence	9:38	12:38	3:38	6:38	9:38	12:23
Bradford	9:47	12:47	3:47	6:47	9:47	12:32
Arr: Haverhill	9:49	12:49	3:49	6:49	9:49	12:34

Holidays

Weekend service	Presidents' Day • Independence Day • New Year's Day • Memorial Day • Labor Day • Thanksgiving Day • Christmas Day
July 4 and New Year's Eve	contact Customer Service for service updates at 617-222-3200

* stops only on request

As with the previous exercise, the first step is to set all the material in one size of one typeface in order to uncover the internal logic of the information.

Here a sans serif typeface (Univers 45) is chosen because the relatively large x-height and open counters aid reading at smaller sizes. The horizontal rules used on the original schedule have been replaced by line spaces. Vertical rules and the 'frame' of the original have been eliminated altogether. Centered type has been reformatted to flush left/ragged right. The term 'READ DOWN' has been eliminated and the 'f' before some entries in the schedule has been replaced with an asterisk after.

From this point, the goal is to reinforce the two directions of reading (across and down) without introducing elements that supersede the information itself.

Saturdays and Sundays

Inbound	1204	1208	1212	1216	1220	1224
Dep: Haverhill	7:15	10:15	1:15	4:15	7:15	10:15
Bradford	7:17	10:17	1:17	4:17	7:17	10:17
Lawrence	7:26	10:26	1:26	4:26	7:26	10:26
Andover	7:31	10:31	1:31	4:31	7:31	10:31
Ballardvale	7:36*	10:36*	1:36*	4:36*	7:36*	10:36*
North Wilmington	7:42*	10:42*	1:42*	4:42*	7:42*	10:42*
Reading	7:51	10:51	1:51	4:51	7:51	10:51
Wakefield	7:57	10:57	1:57	4:57	7:57	10:57
Greenwood	8:00*	11:00*	2:00*	5:00*	8:00*	11:00*
Melrose Highlands	8:02	11:02	2:02	5:02	8:02	11:02
Melrose/Cedar Park	8:04*	11:04*	2:04*	5:04*	8:04*	11:04*
Wyoming Hill	8:06*	11:06*	2:06*	5:06*	8:06*	11:06*
Malden Center	8:09	11:09	2:09	5:09	8:09	11:09
Arr: North Station	8:19	11:19	2:19	5:19	8:19	11:19

Outbound	1205	1209	1213	1217	1221	1225
Dep: North Station	8:45	11:45	2:45	5:45	8:45	11:30
Malden Center	8:55	11:55	2:55	5:55	8:55	11:40
Wyoming Hill	8:58*	11:58*	2:58*	5:58*	8:58*	11:43*
Melrose/Cedar Park	9:00*	12:00*	3:00*	6:00*	9:00*	11:45*
Melrose Highlands	9:02	12:02	3:02	6:02	9:02	11:47
Greenwood	9:04*	12:04*	3:04*	6:04*	9:04*	11:49*
Wakefield	9:08	12:08	3:08	6:08	9:08	11:53
Reading	9:14	12:14	3:14	6:14	9:14	11:59
North Wilmington	9:22*	12:22*	3:22*	6:22*	9:22*	12:07*
Ballardvale	9:28*	12:28*	3:28*	6:28*	9:28*	12:13*
Andover	9:33	12:33	3:33	6:33	9:33	12:18
Lawrence	9:38	12:38	3:38	6:38	9:38	12:23
Bradford	9:47	12:47	3:47	6:47	9:47	12:32
Arr: Haverhill	9:49	12:49	3:49	6:49	9:49	12:34

Holidays

Weekend service	Presidents' Day • Independence Day • New Year's Day • Memorial Day • Labor Day • Thanksgiving Day • Christmas Day
July 4 and New Year's Eve	contact Customer Service for service updates at 617-222-3200

*** stops only on request**

Two weights of boldface (Univers 65 and 75) are added, both to indicate hierarchy (days of the week, trains' numbers and directions, ends of the line) and to distinguish morning and afternoon/evening times at a quick glance.

This latter use of boldface is more an issue with 12-hour American time systems than with 24-hour European systems. Still, the distinction between before and after noon can be useful for quick orientation.

SATURDAYS AND SUNDAYS

Inbound	1204	1208	1212	1216	1220	1224
Dep: Haverhill	7:15	10:15	1:15	4:15	7:15	10:15
Bradford	7:17	10:17	1:17	4:17	7:17	10:17
Lawrence	7:26	10:26	1:26	4:26	7:26	10:26
Andover	7:31	10:31	1:31	4:31	7:31	10:31
Ballardvale	7:36*	10:36*	1:36*	4:36*	7:36*	10:36*
North Wilmington	7:42*	10:42*	1:42*	4:42*	7:42*	10:42*
Reading	7:51	10:51	1:51	4:51	7:51	10:51
Wakefield	7:57	10:57	1:57	4:57	7:57	10:57
Greenwood	8:00*	11:00*	2:00*	5:00*	8:00*	11:00*
Melrose Highlands	8:02	11:02	2:02	5:02	8:02	11:02
Melrose/Cedar Park	8:04*	11:04*	2:04*	5:04*	8:04*	11:04*
Wyoming Hill	8:06*	11:06*	2:06*	5:06*	8:06*	11:06*
Malden Center	8:09	11:09	2:09	5:09	8:09	11:09
Arr: North Station	8:19	11:19	2:19	5:19	8:19	11:19

Outbound	1205	1209	1213	1217	1221	1225
Dep: North Station	8:45	11:45	2:45	5:45	8:45	11:30
Malden Center	8:55	11:55	2:55	5:55	8:55	11:40
Wyoming Hill	8:58*	11:58*	2:58*	5:58*	8:58*	11:43*
Melrose/Cedar Park	9:00*	12:00*	3:00*	6:00*	9:00*	11:45*
Melrose Highlands	9:02	12:02	3:02	6:02	9:02	11:47
Greenwood	9:04*	12:04*	3:04*	6:04*	9:04*	11:49*
Wakefield	9:08	12:08	3:08	6:08	9:08	11:53
Reading	9:14	12:14	3:14	6:14	9:14	11:59
North Wilmington	9:22*	12:22*	3:22*	6:22*	9:22*	12:07*
Ballardvale	9:28*	12:28*	3:28*	6:28*	9:28*	12:13*
Andover	9:33	12:33	3:33	6:33	9:33	12:18
Lawrence	9:38	12:38	3:38	6:38	9:38	12:23
Bradford	9:47	12:47	3:47	6:47	9:47	12:32
Arr: Haverhill	9:49	12:49	3:49	6:49	9:49	12:34

HOLIDAYS

Weekend service	Presidents' Day • Independence Day • New Year's Day • Memorial Day • Labor Day • Thanksgiving Day • Christmas Day
July 4 and New Year's Eve	contact Customer Service for service updates at 617-222-3200

*** stops only on request**

Hierarchy is reinforced by introducing rules to signify major breaks in information. Major heads are reversed out of wide black rules, secondary heads follow hairlines.

SATURDAYS AND SUNDAYS

Inbound	1204	1208	1212	1216	1220	1224
Dep: Haverhill	7:15	10:15	1:15	4:15	7:15	10:15
Bradford	7:17	10:17	1:17	4:17	7:17	10:17
Lawrence	7:26	10:26	1:26	4:26	7:26	10:26
Andover	7:31	10:31	1:31	4:31	7:31	10:31
Ballardvale	7:36*	10:36*	1:36*	4:36*	7:36*	10:36*
North Wilmington	7:42*	10:42*	1:42*	4:42*	7:42*	10:42*
Reading	7:51	10:51	1:51	4:51	7:51	10:51
Wakefield	7:57	10:57	1:57	4:57	7:57	10:57
Greenwood	8:00*	11:00*	2:00*	5:00*	8:00*	11:00*
Melrose Highlands	8:02	11:02	2:02	5:02	8:02	11:02
Melrose/Cedar Park	8:04*	11:04*	2:04*	5:04*	8:04*	11:04*
Wyoming Hill	8:06*	11:06*	2:06*	5:06*	8:06*	11:06*
Malden Center	8:09	11:09	2:09	5:09	8:09	11:09
Arr: North Station	8:19	11:19	2:19	5:19	8:19	11:19

Outbound	1205	1209	1213	1217	1221	1225
Dep: North Station	8:45	11:45	2:45	5:45	8:45	11:30
Malden Center	8:55	11:55	2:55	5:55	8:55	11:40
Wyoming Hill	8:58*	11:58*	2:58*	5:58*	8:58*	11:43*
Melrose/Cedar Park	9:00*	12:00*	3:00*	6:00*	9:00*	11:45*
Melrose Highlands	9:02	12:02	3:02	6:02	9:02	11:47
Greenwood	9:04*	12:04*	3:04*	6:04*	9:04*	11:49*
Wakefield	9:08	12:08	3:08	6:08	9:08	11:53
Reading	9:14	12:14	3:14	6:14	9:14	11:59
North Wilmington	9:22*	12:22*	3:22*	6:22*	9:22*	12:07*
Ballardvale	9:28*	12:28*	3:28*	6:28*	9:28*	12:13*
Andover	9:33	12:33	3:33	6:33	9:33	12:18
Lawrence	9:38	12:38	3:38	6:38	9:38	12:23
Bradford	9:47	12:47	3:47	6:47	9:47	12:32
Arr: Haverhill	9:49	12:49	3:49	6:49	9:49	12:34

HOLIDAYS

Weekend service	Presidents' Day • Independence Day • New Year's Day • Memorial Day • Labor Day • Thanksgiving Day • Christmas Day
July 4 and New Year's Eve	contact Customer Service for service updates at 617-222-3200

* **stops only on request**

The space between columns of times already supports vertical reading. Screened wide horizontal rules, added between alternating lines of arrival/departure times, aids readability across the timetable.

SATURDAYS AND SUNDAYS

Inbound	1204	1208	1212	1216	1220	1224
Dep: Haverhill	7:15	10:15	1:15	4:15	7:15	10:15
Bradford	7:17	10:17	1:17	4:17	7:17	10:17
Lawrence	7:26	10:26	1:26	4:26	7:26	10:26
Andover	7:31	10:31	1:31	4:31	7:31	10:31
Ballardvale	7:36*	10:36*	1:36*	4:36*	7:36*	10:36*
North Wilmington	7:42*	10:42*	1:42*	4:42*	7:42*	10:42*
Reading	7:51	10:51	1:51	4:51	7:51	10:51
Wakefield	7:57	10:57	1:57	4:57	7:57	10:57
Greenwood	8:00*	11:00*	2:00*	5:00*	8:00*	11:00*
Melrose Highlands	8:02	11:02	2:02	5:02	8:02	11:02
Melrose/Cedar Park	8:04*	11:04*	2:04*	5:04*	8:04*	11:04*
Wyoming Hill	8:06*	11:06*	2:06*	5:06*	8:06*	11:06*
Malden Center	8:09	11:09	2:09	5:09	8:09	11:09
Arr: North Station	8:19	11:19	2:19	5:19	8:19	11:19

Outbound	1205	1209	1213	1217	1221	1225
Dep: North Station	8:45	11:45	2:45	5:45	8:45	11:30
Malden Center	8:55	11:55	2:55	5:55	8:55	11:40
Wyoming Hill	8:58*	11:58*	2:58*	5:58*	8:58*	11:43*
Melrose/Cedar Park	9:00*	12:00*	3:00*	6:00*	9:00*	11:45*
Melrose Highlands	9:02	12:02	3:02	6:02	9:02	11:47
Greenwood	9:04*	12:04*	3:04*	6:04*	9:04*	11:49*
Wakefield	9:08	12:08	3:08	6:08	9:08	11:53
Reading	9:14	12:14	3:14	6:14	9:14	11:59
North Wilmington	9:22*	12:22*	3:22*	6:22*	9:22*	12:07*
Ballardvale	9:28*	12:28*	3:28*	6:28*	9:28*	12:13*
Andover	9:33	12:33	3:33	6:33	9:33	12:18
Lawrence	9:38	12:38	3:38	6:38	9:38	12:23
Bradford	9:47	12:47	3:47	6:47	9:47	12:32
Arr: Haverhill	9:49	12:49	3:49	6:49	9:49	12:34

HOLIDAYS

Weekend service	Presidents' Day • Independence Day • New Year's Day • Memorial Day • Labor Day • Thanksgiving Day • Christmas Day
July 4 and New Year's Eve	contact Customer Service for service updates at 617-222-3200

*** stops only on request**

A second color reinforces existing organization both by highlighting primary and secondary information and by calling attention to exceptions to the regular schedule. The hairline rule signifying outbound trains (rendered redundant by the use of color) is removed.

Type as image and information

Before digital type, every type-setter provided—and every designer owned—specimen books, which displayed not only the typefaces the typesetter owned but also the sizes in which they were available. Beyond their use as a handy reference, specimen books more importantly gave the designer the opportunity to visualize clearly how his or her material would look when set in a specific typeface at a specific size. To this day, many designers collect specimen books, often works of art in their own right, for the sheer pleasure of admiring type on paper.

Digital type has effectively made every designer his or her own type-setter. In obviating the typesetting profession, it has also eliminated the source of specimen books. These days, if we want to see what a font looks like, we google it. Unfortunately, the digital representation of type is, even at its best, an approximation. Nothing supplants seeing the actual type, at actual size, on paper held in the hand.

To redress this loss, some designers produce their own specimen books, for their own use, as a visual aid in their daily work.

Specimen books offer an interesting design challenge because they present type both as image and information; the designer has to show 7 pt. italic even as he or she identifies what is being shown. Providing text-size type in actual text settings, ideally with more than one kind of leading, is more useful than merely presenting a character set. At larger scale, because design-ers often choose display type for the shape of a particular character, showing display-size type as actual headlines may not be as useful as allowing the reader to see a full character set.

This page and opposite: Janson text roman and italic at various sizes. A specimen book presents this material in a coher-ent fashion so that designers can familiarize themselves with a typeface's salient characteristics.

1ı 22 33 44 55
66 77 88 99 0o

£ $

fi fl ¼ ½ ¾ *fi fl ¼ ½ ¾*

Ð ð
Þ þ

This bookish inclination at length determined my father to make me a printer, though he had already one son (James) of that profession. In 1717 my brother James returned from England with a press and letters to set up his business in Boston. I liked it much better than that of my father, but still had a hankering for the sea. *To prevent the apprehended effect of such an inclination, my father was impatient to have me bound to my brother. I stood out some time, but at last was persuaded, and signed the indentures when I was yet but twelve years old.*
—*The Autobiography of Benjamin Franklin*

Aa *Aa*

Below:
Reduced specimen sheets for
Janson on 8.5 x 11 in (216 x 279
mm) pages. The three-column
layout provides a suitable line
length for text samples. Centered
type references the traditional

nature of the typeface. Text
settings are shown in 6, 7, 8, 9, 10,
11, and 12 pt., each with 0, 1, and
2 pts. of leading. Display type is
shown in 18, 24, 36, 48, and 60 pt.

Janson 12 point

ABCDEFGHIJKLMNOPQRSTUVWXYZ
1234567890
ABCDEFGHIJKLMNOPQRSTUVWXYZ
abcdefghijklmnopqrstuvwxyz
1234567890
?!()&.,:;""''

ABCDEFGHIJKLMNOPQRSTUVWXYZ
1234567890
abcdefghijklmnopqrstuvwxyz
1234567890
?!()&.,:;""''

12/12

This bookish inclination at
length determined my father
to make me a printer, though
he had already one son (James)
of that profession. In 1717 my
brother James returned from
England with a press and let-
ters to set up his business in
Boston. I liked it much better
than that of my father, but still
had a hankering for the sea. *To
prevent the apprehended effect
of such an inclination, my father
was impatient to have me bound
to my brother. I stood out some
time, but at last was persuaded,
and signed the indentures when I
was yet but twelve years old.
—The Autobiography of
Benjamin Franklin*

12/13

This bookish inclination at
length determined my father
to make me a printer, though
he had already one son (James)
of that profession. In 1717 my
brother James returned from
England with a press and let-
ters to set up his business in
Boston. I liked it much better
than that of my father, but still
had a hankering for the sea. *To
prevent the apprehended effect
of such an inclination, my father
was impatient to have me bound
to my brother. I stood out some
time, but at last was persuaded,
and signed the indentures when I
was yet but twelve years old.
—The Autobiography of
Benjamin Franklin*

12/14

This bookish inclination at
length determined my father
to make me a printer, though
he had already one son (James)
of that profession. In 1717 my
brother James returned from
England with a press and let-
ters to set up his business in
Boston. I liked it much better
than that of my father, but still
had a hankering for the sea. *To
prevent the apprehended effect
of such an inclination, my father
was impatient to have me bound
to my brother. I stood out some
time, but at last was persuaded,
and signed the indentures when I
was yet but twelve years old.
—The Autobiography of
Benjamin Franklin*

Janson 18 point

ABCDEFGHIJKLMNOPQRSTUVWXYZ
1234567890
ABCDEFGHIJKLMNOPQRSTUVWXYZ
abcdefghijklmnopqrstuvwxyz
1234567890 ?!()&.,:;""''

ABCDEFGHIJKLMNOPQRSTUVWXYZ
1234567890
abcdefghijklmnopqrstuvwxyz
1234567890 ?!()&.,:;""''

Janson 24 point

ABCDEFGHIJKLMNOPQRSTUVWXYZ
1234567890
ABCDEFGHIJKLMNOPQRSTUVWXYZ
abcdefghijklmnopqrstuvwxyz
1234567890 ?!()&.,:;""''

ABCDEFGHIJKLMNOPQRSTUVWXYZ
1234567890
abcdefghijklmnopqrstuvwxyz
1234567890 ?!()&.,:;""''

Above and opposite:
Sample spreads from the Janson
specimen book.

Opposite, below:
The covers in this series of
specimen books all feature the
italic ampersand: Janson (left),
Caslon 540 (upper right), and
Didot (lower right).

Janson 36 point

ABCDEFGHIJKLMN
OPQRSTUVWXYZ
1234567890
ABCDEFGHIJKLMN
OPQRSTUVWXYZ
abcdefghijklmn
opqrstuvwxyz
1234567890 ?!()&.,:;""''

ABCDEFGHIJKLMN
OPQRSTUVWXYZ
1234567890
abcdefghijklmnopqrstuvwxyz
1234567890 ?!()&.,:;""''

Janson 48 point

ABCDEFGHIJ
KLMNOPQRS
TUVWXYZ
1234567890
ABCDEFGHIJKLMN
OPQRSTUVWXYZ
abcdefghijklmn
opqrstuvwxyz
1234567890
?!()&.,:;""''

Janson

Univers 55

Univers 55

48 point

ABCDEFGHIJ
KLMNOPQRS
TUVWXYZ
abcdefghijklm
nopqrstuvwxyz
1234567890
!?&()*;:,.""''

36 point

ABCDEFGHIJKLM
NOPQRSTUVWXYZ
abcdefghijklm
nopqrstuvwxyz
1234567890
!?&()*;:,.""''

24 point

ABCDEFGHIJKLM
NOPQRSTUVWXYZ
abcdefghijklm
nopqrstuvwxyz
1234567890
!?&()*;:,.""''

18 point

ABCDEFGHIJKLM
NOPQRSTUVWXYZ
abcdefghijklm
nopqrstuvwxyz
1234567890
!?&()*;:,.""''

12 point

ABCDEFGHIJKLM
NOPQRSTUVWXYZ
abcdefghijklm
nopqrstuvwxyz
!?&()*;:,.""''

11 point

ABCDEFGHIJKLM
NOPQRSTUVWXYZ
abcdefghijklm
nopqrstuvwxyz
1234567890
!?&()*;:,.""''

12/12
LuptatumLor ad tis alit lut utpate tat lam ven-
dit, quat, quisim quipit vullut lore magna feu
feuis ad euis dui exero ero dunt nonulla faccum
inciliquis eraestrud min volor ad eugiam nos
alisi eugue euisl euisit ipsum quis num dolese
magna feugue eum zzriuscipit veraesto eum-
modolut adigna ad tet inci blandignit, sumsan.

12/13
LuptatumLor ad tis alit lut utpate tat lam ven-
dit, quat, quisim quipit vullut lore magna feu
feuis ad euis dui exero ero dunt nonulla faccum
inciliquis eraestrud min volor ad eugiam nos
alisi eugue euisl euisit ipsum quis num dolese
magna feugue eum zzriuscipit veraesto eum-
modolut adigna ad tet inci blandignit, sumsan.

12/14
LuptatumLor ad tis alit lut utpate tat lam ven-
dit, quat, quisim quipit vullut lore magna feu
feuis ad euis dui exero ero dunt nonulla faccum
inciliquis eraestrud min volor ad eugiam nos
alisi eugue euisl euisit ipsum quis num dolese
magna feugue eum zzriuscipit veraesto eum-
modolut adigna ad tet inci blandignit, sumsan.

11/11
Luptatum il iniate velenim delis el et
augait lum zzrilit lor si. Ulput veliquis
auguer adiamcore mod minci tinci
esequis aliquipit volortin er adit lut et,
sis alit lutat. Duisse eniscilit prat, quip
eui et vulputat. Cipsuscipsum zzrit
aut ad et eugue vendre dunt accum
dolorer ostrud.

11/12
Luptatum il iniate velenim delis el et
augait lum zzrilit lor si. Ulput veliquis
auguer adiamcore mod minci tinci
esequis aliquipit volortin er adit lut et,
sis alit lutat. Duisse eniscilit prat, quip
eui et vulputat. Cipsuscipsum zzrit
aut ad et eugue vendre dunt accum
dolorer ostrud.

11/13
Luptatum il iniate velenim delis el et
augait lum zzrilit lor si. Ulput veliquis
auguer adiamcore mod minci tinci
esequis aliquipit volortin er adit lut et,
sis alit lutat. Duisse eniscilit prat, quip
eui et vulputat. Cipsuscipsum zzrit
aut ad et eugue vendre dunt accum
dolorer ostrud.

Above and opposite:
Reduced specimen sheets on A4
pages. The seven-column format
allows for flexibility in the presen-
tation of both display type and
text samples.

169

Univers 55 **Univers 56**

10 point

ABCDEFGHIJKLM
NOPQRSTUVWXYZ
abcdefghijklm
nopqrstuvwxyz
1234567890
!?&()*;:,.""''

10/10
LuptatumLor ad tis alit lut utpate tat lam vendit, quat, quisim quipit vullut lore magna feu feuis ad euis dui exero ero dunt nonulla faccum inciliquis eraestrud min volor ad eugiam nos alisi eugue euisl euisit ipsum quis num dolese magna.

10/11
LuptatumLor ad tis alit lut utpate tat lam vendit, quat, quisim quipit vullut lore magna feu feuis ad euis dui exero ero dunt nonulla faccum inciliquis eraestrud min volor ad eugiam nos alisi eugue euisl euisit ipsum quis num dolese magna.

10/12
LuptatumLor ad tis alit lut utpate tat lam vendit, quat, quisim quipit vullut lore magna feu feuis ad euis dui exero ero dunt nonulla faccum inciliquis eraestrud min volor ad eugiam nos alisi eugue euisl euisit ipsum quis num dolese magna.

9 point

ABCDEFGHIJKLM
NOPQRSTUVWXYZ
abcdefghijklm
nopqrstuvwxyz
1234567890
!?&()*;:,.""''

9/9
LuptatumLor ad tis alit lut utpate tat lam vendit, quat, quisim quipit vullut lore magna feu feuis ad euis dui exero ero dunt nonulla faccum inciliquis eraestrud min volor ad eugiam nos alisi eugue euisl euisit ipsum quis num dolese magna feugue eum zzriuscipit veraesto eummodolut adigna ad tet inci blandignit.

9/10
LuptatumLor ad tis alit lut utpate tat lam vendit, quat, quisim quipit vullut lore magna feu feuis ad euis dui exero ero dunt nonulla faccum inciliquis eraestrud min volor ad eugiam nos alisi eugue euisl euisit ipsum quis num dolese magna feugue eum zzriuscipit veraesto eummodolut adigna ad tet inci blandignit.

9/11
LuptatumLor ad tis alit lut utpate tat lam vendit, quat, quisim quipit vullut lore magna feu feuis ad euis dui exero ero dunt nonulla faccum inciliquis eraestrud min volor ad eugiam nos alisi eugue euisl euisit ipsum quis num dolese magna feugue eum zzriuscipit veraesto eummodolut adigna ad tet inci blandignit.

8 point

ABCDEFGHIJKLM
NOPQRSTUVWXYZ
abcdefghijklm
nopqrstuvwxyz
1234567890
!?&()*;:,.""''

8/8
LuptatumLor ad tis alit lut utpate tat lam vendit, quat, quisim quipit vullut lore magna feu feuis ad euis dui exero ero dunt nonulla faccum inciliquis eraestrud min volor ad eugiam nos alisi eugue euisl euisit ipsum quis num.

8/9
LuptatumLor ad tis alit lut utpate tat lam vendit, quat, quisim quipit vullut lore magna feu feuis ad euis dui exero ero dunt nonulla faccum inciliquis eraestrud min volor ad eugiam nos alisi eugue euisl euisit ipsum quis num.

8/10
LuptatumLor ad tis alit lut utpate tat lam vendit, quat, quisim quipit vullut lore magna feu feuis ad euis dui exero ero dunt nonulla faccum inciliquis eraestrud min volor ad eugiam nos alisi eugue euisl euisit ipsum quis num.

7 point

ABCDEFGHIJKLM
NOPQRSTUVWXYZ
abcdefghijklm
nopqrstuvwxyz
1234567890
!?&()*;:,.""''

7/7
LuptatumLor ad tis alit lut utpate tat lam vendit, quat, quisim quipit vullut lore magna feu feuis ad euis dui exero ero dunt nonulla faccum inciliquis er aestrud min volor ad eugiam nos alisi eugue euisl euisit ipsum quis num dolese magna feugue eum.

7/8
LuptatumLor ad tis alit lut utpate tat lam vendit, quat, quisim quipit vullut lore magna feu feuis ad euis dui exero ero dunt nonulla faccum inciliquis er aestrud min volor ad eugiam nos alisi eugue euisl euisit ipsum quis num dolese magna feugue eum.

7/9
LuptatumLor ad tis alit lut utpate tat lam vendit, quat, quisim quipit vullut lore magna feu feuis ad euis dui exero ero dunt nonulla faccum inciliquis er aestrud min volor ad eugiam nos alisi eugue euisl euisit ipsum quis num dolese magna feugue eum.

6 point

ABCDEFGHIJKLM
NOPQRSTUVWXYZ
abcdefghijklm
nopqrstuvwxyz
1234567890
!?&()*;:,.""''

6/6
LuptatumLor ad tis alit lut utpate tat lam vendit, quat, quisim quipit vullut lore magna feu feuis ad euis dui exero ero dunt nonulla faccum inciliquis eraestrud min volor ad eugiam nos alisi eugue euisl euisit ipsum quis num dolese magna feugue eum zzriuscipit veraesto eummodolut adigna ad tet inci blandignit, sumsan.

6/7
LuptatumLor ad tis alit lut utpate tat lam vendit, quat, quisim quipit vullut lore magna feu feuis ad euis dui exero ero dunt nonulla faccum inciliquis eraestrud min volor ad eugiam nos alisi eugue euisl euisit ipsum quis num dolese magna feugue eum zzriuscipit veraesto eummodolut adigna ad tet inci blandignit, sumsan.

6/8
LuptatumLor ad tis alit lut utpate tat lam vendit, quat, quisim quipit vullut lore magna feu feuis ad euis dui exero ero dunt nonulla faccum inciliquis eraestrud min volor ad eugiam nos alisi eugue euisl euisit ipsum quis num dolese magna feugue eum zzriuscipit veraesto eummodolut adigna ad tet inci blandignit, sumsan.

60 point

*ABCDEFGHIJ
KLMNOPQRS
TUVWXYZ
abcdefghijk
lmnopqrstuv
wxyz
1234567890
!?&()*;:,."""''*

A broadside is another device that type designers and printers have used to acquaint their clients with their product (see William Caslon's specimen sheet on page 30). Even now, they serve the useful purpose of giving users the chance to encounter a typeface 'in the flesh'— real ink on real paper.

The broadsides that follow (actual size A2, 16.5 x 23.4 in, 420 x 594 mm), present typefaces as both physical objects—images, if you will—and as carriers of language—text. Both presentations carry information.

The designer determines the hierarchy of that information by the manipulation of scale, color, and, as always, counterform—where the type isn't. As we already know, large scale reads easily from a distance; small scale rewards close inspection. We also know that black advances off the white page; color, depending upon its value, tends to recede toward the background. Contrast in counterform—tight spaces against large expanses of white—heightens the sense of space from foreground to background. Overlapping disparate elements further reinforce the sense of depth in an otherwise two-dimensional space.

Right above and following pages:
Finished broadside with text
and character set for reading
at arm's length.

Right below:
Building up layers for reading
from a distance. Change in value
makes some elements appear
closer than others.

The Baskerville types were created by John Baskerville, a typefounder and printer in eighteenth-century England and introduced in Birmingham in 1752. Baskerville's types are classified as transitional, that is, those that are stylistically between oldstyle and modern designs. Because of their high readability, Baskerville's designs have been produced by by all of the major type foundries, and have become a standard typeface for long texts, especially book work, and for display purposes as well.

ABCDEFGHIJKLMNOPQRSTUVWXYZ
abcdefghijklmnopqrstuvwxyz
1234567890
!@#$%^&*()_+{}[]=;'"<>,.?/
ABCDEFGHIJKLMNOPQRSTUVWXYZ
abcdefghijklmnopqrstuvwxyz
1234567890
!@#$%^&()_+{}[]=;'"<>,.?/*

Baskerville

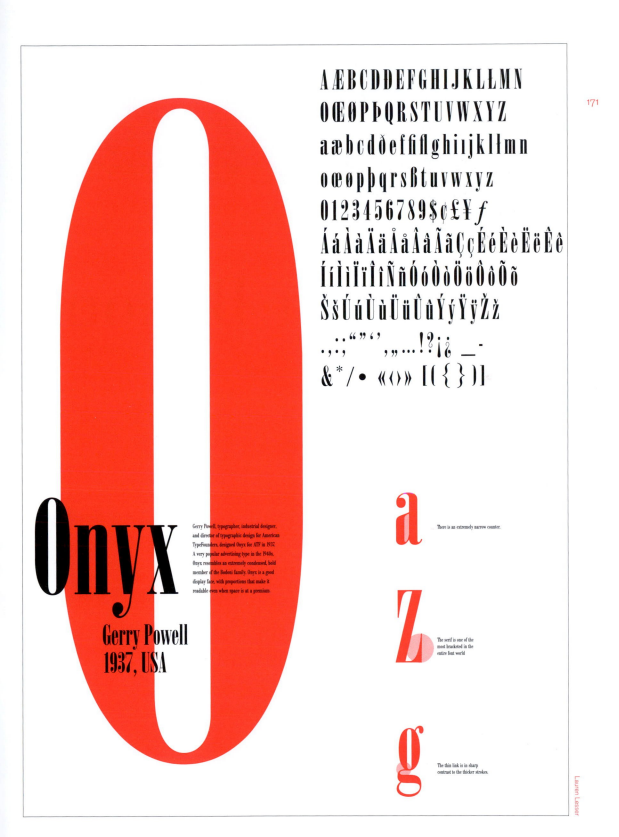

AÆBCDĐEFGHIJKLŁMN
OŒØPÞQRSTUVWXYZ
aæbcdðefﬁﬂghiıjklŀmn
oœøpþqrsßtuvwxyz
0123456789$¢£¥ ƒ
ÁáÀàÄäÅåÂâÃãÇçÉéÈèËëÈè
ÍíÌìÏïÎîÑñÓóÒòÖöÔôÕõ
ŠšÚúÙùÜüÛûÝýŸÿŽž
. , ; " " ' ' , " … ! ? ¡ ¿ _ -
& * / • « ‹ › » [({ })]

Onyx

Gerry Powell, typographer, industrial designer,
and director of typographic design for American
TypeFounders, designed Onyx for ATF in 1937.
A very popular advertising type in the 1940s,
Onyx resembles an extremely condensed, bold
member of the Bodoni family. Onyx is a good
display face, with proportions that make it
readable even when space is at a premium.

Gerry Powell
1937, USA

a
There is an extremely narrow counter.

z
The serif is one of the
most bracketed in the
entire font world.

g
The thin link is in sharp
contrast to the thicker strokes.

Lauren Lesser

Bauer Bodoni was cut in 1926 by Louis Höll, under the direction of Heinrich Jost. This version is the closest to the original, designed by Giambattista Bodoni in 1790. Giambattista ran the printing house Regia of Parma where he began creating his own typefaces. Refinements in printing and paper allowed Bodoni to design a typeface with hairline strokes and serifs. Giambattista was also concerned with harmony between different type sizes, and between text and the page. He realized that space between letters, lines of text and columns could enhance the beauty of his pages. This is evident in the Manuale Typographia published after his death.

Some typefaces that bear the name Bodoni do not resemble the original punches. Bauer Bodoni is characterized by the extreme contrast of thick and thin strokes, pure vertical stress, and unbracketed hairline serifs. These features give the reinterpretation of Bodoni the clean, refined appearance that Giambattista intended.

Bauer Bodoni

Louis Höll, Heinrich Jost

ABCDEFGHIJKLM
NOPQRSTUVWXYZ

ABCDEFGHIJKLMNO
PQRSTUVWXYZ

abcdefghijklm
nopqrstuvwxyz

1234567890

?!"@#$¢%&()*{}¡¿
+¾¼½×ø±÷|¦°—
<>=[µÐþÞıłðß]^_–†‡¶¬˜
ÆŒæœfiflªºâàåçíñö,„"\
«‹›»…˘˘˘˘ˇ,-./:;ˌˏ
£¥ƒ§™©®

Giambattista Bodoni of Parma, Italy, designed and cut his typefaces at the end of the eighteenth century. The Bodoni types were the culmination of nearly 300 years of evolution in roman type design, in which fine hairlines contrast sharply with bolder stems, and serifs are often unbracketed. Bodoni is recognized by its high contrast between thick and thin strokes, pure vertical stress, and hairline serifs. This particular version of Bodoni was first created by Morris Fuller Benton for American Type Founders between 1908 and 1915.

Poster Bodoni

**Morris Fuller Benton
American Type Founders
1908-15**

ABCDEFGHI
JKLMNOPQ
RSTUVWXYZ
abcdefghijk
lmnopqrstu
vwxyz
1234567890
!@#$%^&*()
_+-={}[]|\:;'""
<>,./?\~`

It brings elegance and sparkle to any graphic image, including headlines, text, and logos.

Rebecca Demers

"Meta has been hailed
as 'the typeface of the
nineties'; young designers
seem to appreciate its
rugged charm, which
owes a lot to the detail
requirements of small
type on bad paper. It
was never designed to
be a trendy typeface,
rather it was designed to
solve specific problems.
Maybe it is that honest,
unpretentious background
which appeals to graphic
designers and typogra-
phers around the world."
Erik Spiekermann

Meta

ABCDEFGHIJKLMNOPQRSTUVWXYZ
abcdefghijklmnopqrstuvwxyz
1234567890!@#$%^&*()_+:;"'?

Michelle Konar

ABCDEFGHIJKLMN
OPQRSTUVWXYZ

abcdefghijklmn
opqrstuvwxyz

1234567890

1234567890

~¡¢£¥§¤'"«‹›»fifl†‡·¶•,
" ···¿ `´\^~¯˘˙°"ˇ¸—ÆŁ
ØŒªfæıłøœß‰¼½¾
¹²³×®Þþ¦Ðð−±÷¬
Çç°µáèïü

Perpetua

Type designer Eric Gill's most popular Roman
typeface is Perpetua, which was released by
the Monotype Corporation between 1925 and
1932. It first appeared in a limited edition of the
book The Passion of Perpetua and Felicity, for
which the typeface was named. The italic form
was originally called Felicity. Perpetua's clean
chiseled look recalls Gill's stonecutting work
and makes it an excellent text typeface, giving
sparkle to long passages of text; the Perpetua
capitals have beautiful, classical lines that make
this one of the finest display alphabets available.

Perpetua comes with Old Style figures for all its
variations: Regular, *Italics*, SMALL CAPS, **Bold**
and ***Bold Italic***.

At this point, it's worthwhile to examine the compositional instincts behind these broadsides. As you can see, in each instance a specific columnar rhythm informs these seemingly free choices. The results, of course, are by no means precise; devising columnar organization for the broadsides was not a stated part of the program. The point is that the instinct to find consistent intervals as a basis for organizing the diverse elements in a composition is as intrinsic to working with type as are the internal rhythms within any given typeface.

It should be obvious that the same sense of visual rhythm that organizes the compositions from left to right also, in all likelihood, organizes material from top to bottom. In other words, there is probably a grid underlying each broadside, one specific to the material presented. How that grid evolves, and how it is applied, is the subject of the next chapter (see pages 194–199).

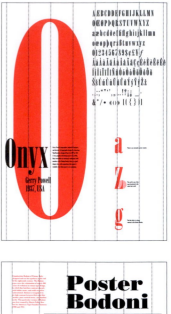

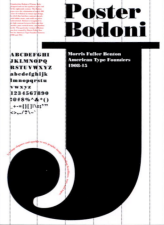

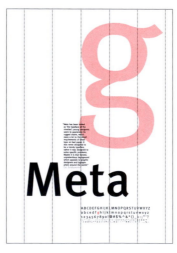

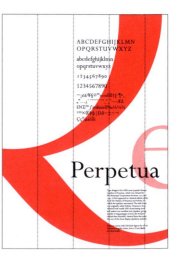

Grid systems

Introduction

So far, we've looked at text organization in terms of columnar arrangement. More complex information often requires expression of not only vertical but also horizontal organization. In those situations, a grid is an essential tool.

A grid is a pattern of horizontal and vertical lines that intersect at regular intervals. In typographic design, a grid system is a method for organizing and clarifying text on a page, and amplifying its meaning.

A grid is not about painting a page — creating the perfect composition within the frame of the paper trim. Rather, it is about building a page — providing a framework within which visual and typographic elements work to reinforce meaning.

This sense of building the page comes directly from the days when type itself was physical. Lines of lead type built upon other lines of type — not unlike courses of bricks standing one upon the other — to create the page. And, as with bricks, the stronger the construction, the more durable the results.

It's important to remember that a grid is a system, not an object in itself. For that system to be effective it has to be both organic and responsive. In other words, before you can devise a grid, you have to understand clearly
- the amount of text/images
- the kinds of text/images
- the levels of meaning and importance within the text/images
- the relationship between text and images
- the relationship between text/images and the reader.

Another way to describe the grid system is to see it as a way of providing distinct articulation to the different voices expressed within the text through both color and position on the page. Or you might prefer thinking of a grid as Josef Müller-Brockmann described it: a means of expressing both the architecture (or structure) and the music (or rhythm) inherent in the material. No matter how you look at it, the underlying principle behind any grid is that it is most successful as an expression of content.

Going through the following section, you're going to encounter some terminology and a lot of rules. As with any system, perhaps the most important thing to keep in mind is when it's necessary to break those rules. Beyond the usual employment of contrast within the system, always be on the lookout for opportunities to contrast the order of the system itself with its opposite — the seeming lack of order.

You will learn that the kind of grids that follow are described as establishing starting points on a page, never ending points. A clear expression of that notion is the use of flush left/ragged right text—type that articulates a strong left axis and a strong top axis, but weak edges to the right and below. Therefore, in the examples that follow I have only used flush left, ragged right type. A useful corollary to this notion is to make sure that adjacent columns of text are flush to the top, ragged at the bottom.

An example

The basic 24-field grid used to design this book allows for three horizontal intervals (columns) and eight vertical intervals (rows). The height of the vertical intervals is based on seven lines of text type, 8 pt. Akzidenz Grotesk, leaded to a 10.25 pt. line—8/10.25 Akzidenz Grotesk.

A secondary grid, based on the first, breaks each field into four. Subsequently, the 24-field grid becomes 96 fields—six columns, sixteen rows. Rows are now based on three lines of type.

Components of the grid

Many of the components of the grid
are the same as those we examined
in the text exercises:

Text page
Margins
Folios
Headers

In addition, there are a few terms
that relate specifically to how the
grid is constructed:

Fields
Gutters (both vertical and
horizontal)

For the sake of clarity, we're going to
begin by examining all these compo-
nents in detail.

Right and opposite:
Note that a columnar layout
addresses only vertical organiz-
ation. A grid addresses vertical
and horizontal organization.

A two-column layout

A nine-field grid

Text page
Also known as the type or text area,
the area on a page where type
appears. The text page contains
the fields and gutters that make
up the grid.

Margin
The space that distinguishes the text
page from the paper around it.

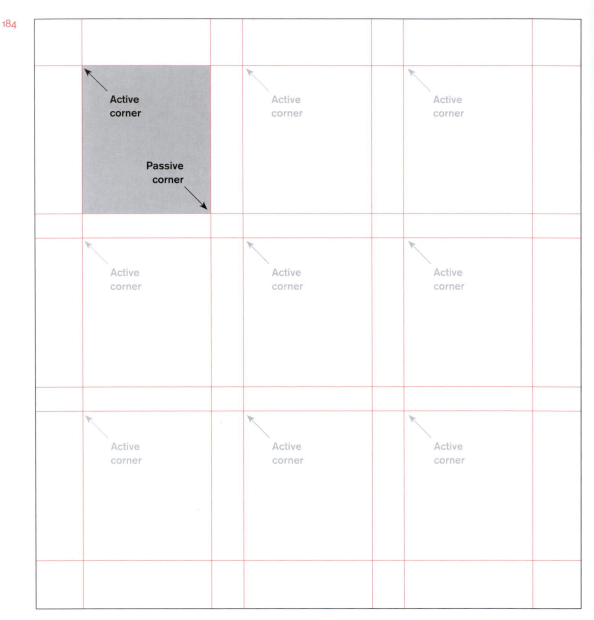

Field
The basic component of any grid.
The height of a field is calculated
as a multiple of the text leading. Its
width is determined by the length of
a line of text. (See **Creating a grid
for text**, pages 200 – 211.)

For the kinds of grids we'll be work-
ing with, it's useful to remember
that the upper left corner of any
field is considered the strong or
active corner. The lower right
corner is considered the weak or
passive corner.

In the example above, there are nine
active corners — nine starting points
for titles, text, images, and captions.

Vertical/horizontal gutter
The gutter separates fields from each other. The height of a **horizontal gutter** is typically based on the leading of the text type. The width of a **vertical gutter** should be a distance sufficiently larger than an em (the size of the text type) to prevent reading from one column of text to another. (See **Creating a grid for text**, pages 200–211.)

1.5–2 ems = vertical gutter

My only
thought was
of you.

leading = horizontal gutter

In a grid system, folios and running matter above or below the text page always appear flush left to the grid (like the text). Thus, they seldom, if ever, appear symmetrical to each other on a spread.

186

Running head	Running head	Running head	

Running shoulder

Running shoulder

Running shoulder

Running shoulder

Running shoulder

Running shoulder

| Running foot | Running foot | Running foot | |

Running head / running foot / running shoulder

In longer documents, a guide for readers to show them where they are in the manuscript. These may contain the title of the book, the title of a section of the book, or the author's name. Like folios, they sit outside the text page, but should always relate to it either vertically or horizontally. Running heads appear above the text page, running feet below, running shoulders to the sides.

123

123

123

123

123

123

123

123

123

123

123

123

123

123

123

123

Folio
The page number. This typically
sits outside the text page, but,
like running matter, it should always
relate to the grid either vertically
or horizontally.

Grids are particularly useful for creating a sense of simultaneity on the page, as this simple exercise demonstrates. We have here a title page for a catalog. Page size is 9 in (229 mm) square. Copy consists of a title, a subtitle, and a publisher—three levels of information, each in three languages (English, German, and French).

First, the type is set in three weights of a typeface (here, Akzidenz Grotesk Regular, Medium, and Bold), in three sizes based on a Fibonacci sequence (13, 21, and 34 pt., each with 2 pts. of leading). Certainly, it is possible to articulate the hierarchy of information by changing just the size or the weight. As you know by now, these are the decisions that make each designer's work personal.

Word and image

Posters from the collection

Museum of Modern Art New York

Wort und Bild

Plakate von der Sammlung

Parole et image

Les affiches de la collection

The page is then arranged in a
nine-field grid, three fields by three
fields—mirroring the three levels
of information presented in three
languages. Note that because all our
type is essentially display type, not
text, the gutters are not specifically
keyed into leading or ems.

**Word
and
image**

**Wort
und
Bild**

**La parole
et
l'image**

Posters from
the collection

Plakate von
der Sammlung

Les affiches
de la collection

Museum of Modern Art
New York

Museum des Moderne Kunst
New York

Musée d'art moderne
New York

**Word
and
image**

**Wort
und
Bild**

**La parole
et
l'image**

Posters from
the collection

Plakate von
der Sammlung

Les affiches
de la collection

Museum of Modern Art
New York

Museum der Moderne Kunst
New York

Musée d'art moderne
New York

Posters from
the collection

Plakate von
der Sammlung

Les affiches
de la collection

**Word
and
image**

**Wort
und
Bild**

**Parole
et
image**

Museum of Modern Art
New York

Posters from
the collection

Plakate von
der Sammlung

Les affiches
de la collection

**Word
and
image**

**Wort
und
Bild**

**Parole
et
image**

Museum of Modern Art
New York

Even with only nine fields, there are
many possibilities for placing the
information on the grid. In the
examples on this page, each
language reads down. Levels of
hierarchy read across.

Word and image — Posters from the collection — Museum of Modern Art New York

Wort und Bild — Plakate von der Sammlung

Parole et image — Les affiches de la collection

Word and image — Posters from the collection — Museum of Modern Art New York

Wort und Bild — Plakate von der Sammlung

Parole et image — Les affiches de la collection

Posters from the collection — **Word and image** — Museum of Modern Art New York

Plakate von der Sammlung — **Wort und Bild**

Les affiches de la collection — **Parole et image**

Posters from the collection — **Word and image** — Museum of Modern Art New York

Plakate von der Sammlung — **Wort und Bild**

Les affiches de la collection — **Parole et image**

In the examples on this page,
the reading is reversed from the
previous examples—languages
read across, hierarchies read down.

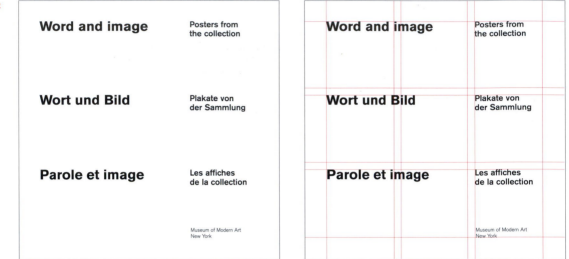

In the examples above, horizontal reading is stressed by extending the title on one line and connecting two levels of information in one type block. First, we connect the subtitle and the publisher. Then we connect the title and subtitle.

You are probably going to find some of these solutions more successful, more expressive, more dynamic, or maybe just 'prettier' than others. Or you may find them all too obvious, too simple. A grid of 3 x 3 may not provide enough options. It certainly does not take into account the pages of material that would follow the title.

The point of this beginning exercise is to sensitize you to the possibilities for both organization and expression that the grid offers. Where you take it next — however many more fields you think the page requires, whatever typeface, size, and weight you deem appropriate — is up to you. What's most important is to follow through the process, to explore a fair number of possibilities within each system.

5 x 5 grid
10, 26, and 42 pt. Janson

6 x 5 grid
10, 26, and 42 pt. Didot

4 x 4 grid
13, 21, and 36 pt. Adobe Garamond

Grids at large scale

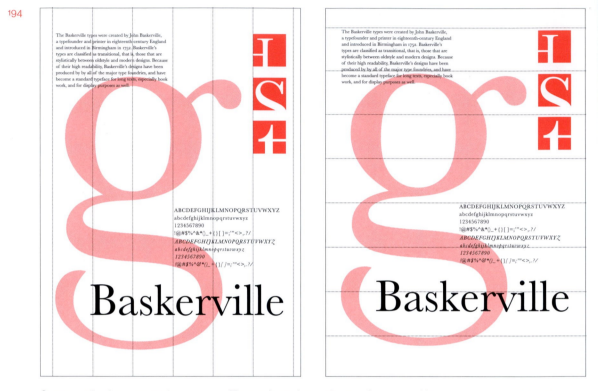

The Baskerville types were created by John Baskerville, a typefounder and printer in eighteenth-century England and introduced in Birmingham in 1752. Baskerville's types are classified as transitional, that is, those that are stylistically between oldstyle and modern designs. Because of their high readability, Baskerville's designs have been produced by by all of the major type foundries, and have become a standard typeface for long texts, especially book work, and for display purposes as well.

On page 176 columnar organization was applied to seemingly 'free' compositions of the typographic broadsides to uncover expressions of horizontal rhythm within each piece. Here, organization by rows finds similarly consistent vertical rhythms. The resulting fields grow out of the type details in the upper-right corner of the composition.

The result, as shown above and opposite, demonstrates how grids can support — and, in some cases, strengthen — complex typographic compositions. They also suggest the importance of allowing the grid to evolve out of the requirements of the content.

However, it is important to note that in this composition the grid's role is secondary. The hierarchical sequence — the order of perception first from a distance, then close up — is primarily established by use of scale, color, tone, and manipulation of counterform.

Note that the word 'Baskerville' aligns to the grid at its x-height—one of two clear horizontal axes in the word, the other being the baseline. At display sizes, the relationship of type to the grid often depends on visual cues other than the height of the ascender alone.

The Baskerville types were created by John Baskerville, a typefounder and printer in eighteenth-century England and introduced in Birmingham in 1752. Baskerville's types are classified as transitional, that is, those that are stylistically between oldstyle and modern designs. Because of their high readability, Baskerville's designs have been produced by by all of the major type foundries, and have become a standard typeface for long texts, especially book work, and for display purposes as well.

ABCDEFGHIJKLMNOPQRSTUVWXYZ
abcdefghijklmnopqrstuvwxyz
1234567890
!@#$%^&*()_+{}[]=;'"<>,.?/
ABCDEFGHIJKLMNOPQRSTUVWXYZ
abcdefghijklmnopqrstuvwxyz
1234567890
!@#$%^&()_+{}[]=;'"<>,.?/*

Baskerville

Shown here (right and opposite) is an A2 (16.5 x 23.4 in, 420 x 594 mm) two-color poster for a series of jazz concerts. Each event starts at the beginning of a field; concerts are arranged vertically and horizontally by date. Primary and secondary display type aligns to horizontal axes on the x-height.

In this example, the grid not only organizes the composition but also expresses hierarchy. Clearly, the same rules that determine a grid at text scale operate at larger scale as well. The considerations of type operating as image and information are merely applied to the rigors of a gridded environment.

Beacon Theater
Carnegie Hall
Florence Gould Hall
Kaye Playhouse, Hunter College
Knitting Factory
Merkin Concert Hall at Kaufman Center
Prospect Park Bandshell
Rose Theater
Schomberg Center for Research in Black Culture
South Street Seaport
Thalia Theater
Village Vanguard
World Financial Center Plaza
Zankel Hall

17

Wayne & Dave
Wayne Shorter Quartet
Carnegie Hall 8:00pm
$75.00, $60.00,
$45.00, $30.00

June 13–25

16

An Evening with Chick Corea & Touchstone
Featuring Tom Brechtlein, Carles
Benavent, Jorge Pardo & Rubem Dantas
Rose Theater 8:00pm
$65.00, $50.00, $35.00

Michel Camilo: Solo, Duo & Trio
Michel Camilo Trio
Rose Theater 8:00pm
$65.00, $50.00, $35.00

NY

15

Downbeat Magazine Presents: Jazz Combos
South Street Seaport
12:30pm
FREE

Joanne Brackeen Quartet
Studio Museum in Harlem
7:30pm $12.00 in advance members, $15.00 at the door

JVC Jazz Celebrates Brooklyn!
The Bad Plus: Ethan Iverson, Reid Anderson, David King
Charlie Hunter Trio James Carter Organ Trio with Gerard Gibbs & Leonard KingProspect Park Bandshell
7:30pm Free

18

14

100 Years and a Day:
Doc Cheatham
Centennial Jazz Party
Rose Theater 8:00pm

Piano Masters Salute Piano Legends:
Celebrating
Ellington, Evans, Hancock & Monk
Rose Theater 8:00pm

Don Byron Adventurers Orchestra
Village Vanguard 9:00pm, 11:00pm
Call for ticket prices

David Murray & The Gwo-Ka Masters
Jazz Standard
7:30pm, 9:30pm, 11:30pm
Call for ticket prices

David Murray & The Gwo-Ka Masters Jazz Standard
7:30pm, 9:30pm, 11:30pm
Call for ticket prices

Jazz Festival

19

David Murray & The Gwo-Ka Masters Jazz Standard
7:30pm, 9:30pm
Call for ticket prices

20

Rosemary Clooney: An All-Star Remembrance of America's Girl Singer
Debby Boone, John Pizzarelli, Brian Stokes Mitchell
Carnegie Hall 8:00pm
$85.00, $75.00, $65.00, $45.00

21

Maria Schneider Orchestra
World Financial Center Plaza
7:00pm
River Festival
FREE

22

Keith Jarrett, Jack DeJohnette, Gary Peacock
Carnegie Hall 8:00pm
In Partnership with Carnegie Hall $75.00, $60.00, $45.00, $30.00

23

Two Times Three Trio! Stanley Clarke
Béla Fleck Jean-Luc Ponty
Paul Motian, Bill Frisell & Joe Lovano
Carnegie Hall 8:00pm
$75.00, $60.00, $45.00, $30.00

24

Always Welcome...
Dave Brubeck Quartet with Randy Jones, Bobby Militello & Michael Moore
John Pizzarelli Quartet with Ray Kennedy, Martin Pizzarelli & Tony Tedesco
Carnegie Hall 8:00pm
$75.00, $60.00, $45.00, $30.00

25

Salsa Meets Jazz
Eddie Palmieri
Y La Perfecta II
The 2 Worlds of Ray Barretto
Carnegie Hall 8:00pm
$85.00, $75.00, $65.00, $45.00

A Father's Day Gift
Lou Donaldson Quartet
Schomburg Center for Research in Black Culture
3:00pm $15.00 members, $18.00 non-members

Miles Electric: A Different Kind of Blue
Miles Davis Live at the Isle of Wight Festival 1970
Florence Gould Hall 7:00pm, 9:30pm (87 minutes)
$15.00

A Four Score Salute to Barbara Carroll
Kaye Playhouse
Hunter College 8:00pm
Produced by Jay Leonhart.
Proceeds to benefit the Jazz Foundation of America.
$35.00

Seven Steps to Jaco Steps Ahead (2005)
Beacon Theatre 8:00pm
$63.50, 53.50, 38.50

JVC

Anat Fort Trio
Symphony Space
Thalia Theater 8:30pm
$21, $18, $16

New York Now!
Ben Allison's Kush Trio, Time Berne's Hard Cell, Avishai Cohen Trio, Marty Ehrlich Sextet, Jean-Michel Pilc Trio, Robert Glasper Trio, Jacob Fred Jazz Odyssey,
Knitting Factory 8:00pm
Call for ticket prices

All for Paul: Les Paul 90th Birthday Salute Les Paul
Carnegie Hall 8:00pm
$95.00, $80.00, $65.00, $45.00

No Minimum
Cyrus Chestnut & John Hicks
Merkin Concert Hall at Kaufman Center 8:00pm
$35.00

Cesaria Evora
Beacon Theatre 8:00pm
$78.50, $63.50, $43.50

Don Byron Big Band
Featuring Abdoulaye Diabate
Village Vanguard 9:00pm, 11:00pm
Call for ticket prices

Don Byron Ivey-Divey Trio
Featuring Jason Moran & Billy Hart with guests Lonnie Plaxico & Ralph Alessi
Village Vanguard 9:00pm, 11:00pm, 12:30am
Call for ticket prices

Marsalis Music Presents music from its latest releases:
Harry Connick, Jr. and Branford Marsalis
Zankel Hall 8:30pm
$66.00, $39.00

Village Vanguard Orchestra
With special guest Joe Lovano
Village Vanguard 9:00pm, 11:00pm

Don Byron: Almost Complete Music for Six MusiciansDon Byron, James Zollar,
George Colligan, Leo Traversa, Milton Cardona & Ben Wittman
Village Vanguard 9:00pm, 11:00pm
Call for ticket prices

05

Don Byron Ivey-Divey Trio
Featuring Jason Moran & Billy Hart with guest Lonnie Plaxico
& Ralph Alessi
Village Vanguard 9:00pm, 11:00pm, 12:30am
Call for ticket prices

Steve Reinmuth

Here (right and opposite) is the
same problem for a smaller series
of concerts. Each venue is identi-
fied by its own typeface and its own
shade of the second color. Main
display type (JVC Jazz Festival
Paris') is set with baseline alignment
to the horizontal axes. Secondary
display type ('8 jours, 8 salles, + de
80 musiciens') centers vertically in
its fields.

**In both this poster and the type
broadside on pages 194–195,
the designers have chosen not
to express vertical or horizontal
gutters. Nonetheless, we can see
that gutters are being employed.**

Samedi 14 octobre

21h00 Will Cahoun "Native Lands"
21h00 Petra Magoni et
Ferrucio Spiretti
21h00 Denzal Sinclaire
22h30 Demi Evans and the Hands
20h30 Thomas Dutronc
22h30 James Hunter

Lundi 16 octobre

21h00 Elisabeth Kontomanou
**21h00 Moutin Reunion
Pierre de Bethman
Rick Margitza**
22h30 Dany Doriz Big Band
22h30 Jeremy Pelt Quartet

8 jours

Mercredi 18 octobre

20h30 Branford Marsalis
21h00 Kurt Elling
Robert Glasper Trio (1ere Partie)
**21h00 Marcus Strickland
Quartet**
22h30 Manu DiBango joue Sidney Bechet
Dany Doriz
22h30 Robin McKelle

Vendredi 20 octobre

**19h45 E.S.T.
Eivind Aarset (1ere Partie)**
21h00 Ron Carter Golden Stricker Trio
21h00 Roy Cambell
William Parker
Hamid Drake
Daniel Carter
**21h00 Pierrick Pédron
Mulgrew Miller
Quartet**
22h30 Mina Agossi et amis
Malcom Braff
22h30 Jeremy Pelt Quartet

Dimanche 15 octobre

21h00 Donald Brown Trio et invités
Jerome Barde
Stephane Belmondo
**21h00 Petra Magoni et
Ferrucio Spiretti**
22h00 Demi Evans and the Hands
invité: Jean Jaques Milteau

8 salles

Mardi 17 octobre

20h30 Kenny Garrett Quartet
Lynne Arriale Trio
21h00 Rebekka Bakken
**21h00 Moutin Reunion
Pierre de Bethman
Rick Margitza**
22h30 Manu DiBango joue Sidney Bechet
Dany Doriz
22h30 Robin McKelle

Jeudi 19 octobre

20h30 Roy Hargrove RH Factor
21h00 Leee John
21h00 Roy Cambell
William Parker
Hamid Drake
Daniel Carter
**21h00 Stéphane Spira
Quartet**
22h30 Mina Agossi et amis
Malcom Braff
22h30 Minsarah

Samedi 21 octobre

21h00 Mike Stern
21h00 Catia Werneck Quintet
**21h00 Pierrick Pédron
Mulgrew Miller Quartet**
22h30 Boogie Wonderband
22h30 Jeremy Pelt Quartet

+ de 80 musiciens

New Morning

7/9 rue des Petites Ecuries
Paris 10eme
0892 707 507 (34 ct. / min)

Cigale

120 boulevard Rochechouart
Paris 9eme
0892 707 507 (34 ct. / min)

Bataclan

50 boulevard Voltaire
Paris 11eme
01 43 14 35 35

Méridien

81 boulevard Gouvion St. Cyr
Paris 17eme
0892 707 507 (34 ct. / min)

Café de la Danse

5 Passage Louis-Philippe
Paris 11eme
0892 707 507 (34 ct. / min)

China Club

50 rue de Charenton
Paris 12eme
01 43 43 82 02

Sunset

60 rue des Lombards
Paris 1er
0892 707 507 (34 ct. / min)

Sunside

60 rue des Lombards
Paris 1er
0892 707 507 (34 ct. / min)

Locations
FNAC, Carrefour, France Billet
0892 707 507 (34 ct. / min)
Et points de vente habituels

Infos
01 46 21 08 37
www.looproductions.com

Camlie Ashtaraff

Creating a grid for text

Ese volorpe rostrud dolortie er augait ac-
cum dit veliqua tueraestrud dio duisi exerit
nulputpat, volobore conullu ptatinim iurerat.
Iquissenim nonullam, ver ing erit loreet
incip elesto et niam doluptat dolobor sum
il eugiam zzrit iure elendreet, con henim
veliquat, commy nim alisi. Uptat lum dolore
dipsusci bla conullute tie dolendi amconse
molore commy nullaorem mulluptat. Ut
nonsequ ismodio odolor sum aci et ad dio
elit, consecte dipsusci blam veliquat. Volum
ip ero con vulla feu facilit irit wiscipsusci
bla accum amconsed ea acip et at lum vel
dolesectem nostrud tie te dit la feum adit
am vel utatis et, conse commy nim duipit
ad tem quat, sequam del et, ver si. Diatie tat
augueriusto ex eum in etue ent aliquis niatie
vendre minit diam enim augiatue do conulla
consed esto dolorpe riuscincilla augueri liqu-
ismodip enisim voluptat. Lut wiscilit acil-
lan el eum zzrit, consequam ipsusci liquate
tatuer ilit lutpat. Ut iril delit alisse faccum-
sandio dolor secte vel ullamco nsecte erat
lobor inciliquisi er sim ad et verit ea corer
sum dolor in utationsecte dolobor sequat vo-
lor sit laortisi. Ed dolorer accum ing exeros
eriusci enibh eu feuguercin ut ea faccum del
ulla feugait wisciduis nos nibh et, conum
venis dolore magnit lan utpat volorpero ex ea
facilis nim diamet lan hent wisis et il ex exer-
ate molorem dolupta tummoluptat volorpero
con velit, sequamc onulput wisl dolum et,
quat elit doleniam, velestrud dolorpe rcilla
faccum esquisit loreetummy nulput laore
doloreet venit wis dipsum deliqui pnustrud
tate veniatem iure modit ullam, si. Ecte
conum deliquam am, summodiat, sustinim
ad dip euipit, quat. Am, quipsusci ent nim do

Ese volorpe rostrud dolortie er augait ac-
cum dit veliqua tueraestrud dio duisi exerit
nulputpat, volobore conullu ptatinim iurerat.
Iquissenim nonullam, ver ing erit loreet
incip elesto et niam doluptat dolobor sum
il eugiam zzrit iure elendreet, con henim
veliquat, commy nim alisi. Uptat lum dolore
dipsusci bla conullute tie dolendi amconse
molore commy nullaorem mulluptat. Ut
nonsequ ismodio odolor sum aci et ad dio
elit, consecte dipsusci blam veliquat. Volum
ip ero con vulla feu facilit irit wiscipsusci
bla accum amconsed ea acip et at lum vel
dolesectem nostrud tie te dit la feum adit
am vel utatis et, conse commy nim duipit
ad tem quat, sequam del et, ver si. Diatie tat
augueriusto ex eum in etue ent aliquis niatie
vendre minit diam enim augiatue do conulla
consed esto dolorpe riuscincilla augueri liqu-
ismodip enisim voluptat. Lut wiscilit acil-
lan el eum zzrit, consequam ipsusci liquate
tatuer ilit lutpat. Ut iril delit alisse faccum-
sandio dolor secte vel ullamco nsecte erat
lobor inciliquisi er sim ad et verit ea corer
sum dolor in utationsecte dolobor sequat vo-
lor sit laortisi. Ed dolorer accum ing exeros
eriusci enibh eu feuguercin ut ea faccum del
ulla feugait wisciduis nos nibh et, conum
venis dolore magnit lan utpat volorpero ex ea
facilis nim diamet lan hent wisis et il ex exer-
ate molorem dolupta tummoluptat volorpero
con velit, sequamc onulput wisl dolum et,
quat elit doleniam, velestrud dolorpe rcilla
faccum esquisit loreetummy nulput laore
doloreet venit wis dipsum deliqui pnustrud
tate veniatem iure modit ullam, si. Ecte
conum deliquam am, summodiat, sustinim
ad dip euipit, quat. Am, quipsusci ent nim do

**Place a column of text type on an
8.5 x 11 in (216 x 279 mm) page.**

**Examine the horizontal relation-
ship of white space to text.
Be sure to include left and right
margins. (For this exercise,
assume that the left and right
margins are three picas each.)**

Most grids—like the material they
illuminate—are not so straight-
forward as what we've just worked
with. Working with text demands
solutions that are less pictorial—less
from without—and more organic,
coming from within the text itself.

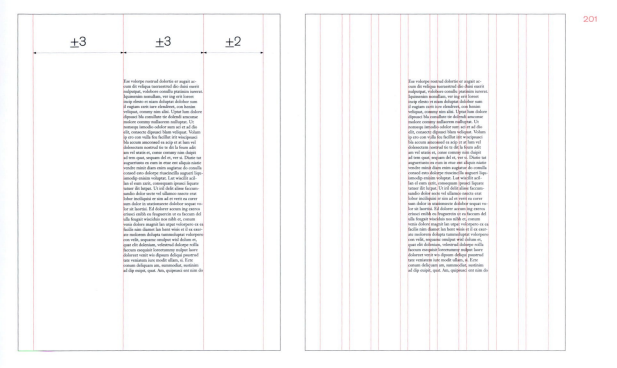

Determine the horizontal ratios. These horizontal ratios are perhaps best described as the ratios between line length of the text and the width of white space to either side of it. In the example shown, it happens that the line length of the text is more or less the same as the width of the white space to the left (1:1), and more or less one and a half times as wide as the white space on the right (3:2). Hence, \pm 3 and \pm 2 neatly approximate the distances shown.

Draw in all the vertical axes that express the horizontal ratios, being sure to include gutters. The general rule of thumb for vertical gutters is \pm 2 ems of the text typeface (8 pt. text = 16 pt. gutter, 10 pt. text = 20 pt. gutter, etc.). This decision really hangs on making sure that there's no danger of reading on from text in one column to text in the next. In the example shown, we've used 1p6.

Assume a top margin (again, assume three picas). Introduce a 'type ruler' — a column of type set to the same size and leading as your text type — that runs down the left edge of the page. Adjust your text type vertically until it aligns with the type ruler.

Determine vertical intervals. In the example shown above, these intervals grow out of the position of the type in relation to the top of the text page.

When you set up your horizontal gutters, remember that the height of the gutter is determined by the leading of one line of text type.

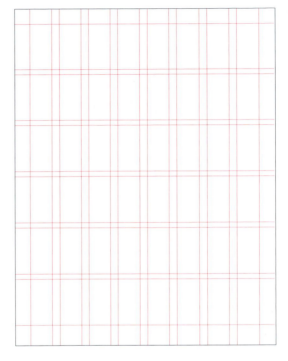

Draw in all the horizontal axes that express the vertical intervals, being sure to include gutters. Your bottom horizontal axis defines the bottom margin.

Remove the type ruler and the dummy type.

In the process shown here, you can see the development of a 48-field grid (eight columns, six rows), based upon the text width and leading of your original text type. This means that you have 48 active corners on your page for placing type or images.

Once you have devised your grid, find out what size and line length type has to be to feel like a caption. What is small/short enough? What is too small? Most important, what works within the grid? Finally, devise the optimum headline. What is big enough? Or, in both cases, is a shift in size required at all?

As you establish your type samples, keep in mind that both the caption and headline lengths should be multiples of the text length. The caption and headline leadings should also be multiples of the text type and leading (and seldom something so simple as 1:2—see page 145). Every few lines, all three components should cross-align with each other. Do yours? Work with them until they do.

In application, text grids often have to accommodate two or more levels of text in two or more sizes. In this hypothetical example, sidebars highlight individuals or incidents touched upon in the main text.

First, typeface, size, leading, and line length is determined for the text and the sidebars.

Lorem ipsum dolor sit amet, consectetuer adipiscing elit, sed diam nonummy nibh euismod tincidunt ut laoreet dolore magna aliquam erat volutpat. Ut wisi enim ad minim veniam, quis nostrud exerci tation ullamcorper suscipit lobortis nisl ut aliquip ex ea commodo consequat. Duis autem vel eum iriure dolor in hendrerit in vulputate velit esse molestie consequat, vel illum dolore eu feugiat nulla facilisis at vero eros et accumsan et iusto odio dignissim qui blandit praesent luptatum zzril delenit augue duis dolore te feugait nulla facilisi. Lorem ipsum dolor sit amet, consectetuer adipiscing elit, sed diam nonummy nibh euismod tincidunt ut laoreet dolore magna aliquam erat volutpat. Ut wisi enim ad minim veniam, quis nostrud exerci tation ullamcorper suscipit lobortis nisl ut aliquip ex ea commodo consequat. Duis autem vel eum iriure dolor in hendrerit in vulputate velit esse molestie consequat, vel illum dolore eu feugiat

10/13 Adobe Caslon x 20p, fl, rr

Lorem ipsum dolor sit amet, consectetuer adipiscing elit, sed diam nonummy nibh euismod tincidunt ut laoreet dolore magna aliquam erat volutpat. Ut wisi enim ad minim veniam, quis nostrud exerci tation ullamcorper suscipit lobortis nisl ut aliquip ex ea commodo consequat. Duis autem vel eum iriure dolor in hendrerit in vulputate velit esse molestie consequat, vel illum dolore eu feugiat nulla facilisis at vero eros et accumsan et iusto odio dignissim qui blandit praesent luptatum zzril delenit augue.

8/9.5 Adobe Caslon Italic
x 9p3,fl, rr

Based on the line lengths, horizontal fields are established. Five intervals most closely match the text as set, but adjustments to the line lengths are necessary.

Lorem ipsum dolor sit amet, consectetuer adipiscing elit, sed diam nonummy nibh euismod tincidunt ut laoreet dolore magna aliquam erat volutpat. Ut wisi enim ad minim veniam, quis nostrud exerci tation ullamcorper suscipit lobortis nisl ut aliquip ex ea commodo consequat. Duis autem vel eum iriure dolor in hendrerit in vulputate velit esse molestie consequat, vel illum dolore eu feugiat nulla facilisis at vero eros et accumsan et iusto odio dignissim qui blandit praesent luptatum zzril delenit augue duis dolore te feugait nulla facilisi. Lorem ipsum dolor sit amet, consectetuer adipiscing elit, sed diam nonummy nibh euismod tincidunt ut laoreet dolore magna aliquam erat volutpat. Ut wisi enim ad minim veniam, quis nostrud exerci tation ullamcorper suscipit lobortis nisl ut aliquip ex ea commodo consequat. Duis autem vel eum iriure dolor in hendrerit in vulputate velit esse molestie consequat, vel illum dolore eu feugiat nulla facilisis at vero eros et accumsan et iusto odio dignissim qui blandit praesent luptatum zzril delenit augue duis dolore te feugait nulla facilisi. Nam liber tempor cum soluta nobis eleifend option congue nihil imperdiet doming id quod mazim placerat facer possim assum. Lorem ipsum dolor sit amet, consectetuer adipiscing elit, sed diam nonummy nibh euismod tincidunt ut laoreet dolore magna aliquam erat volutpat.

Lorem ipsum dolor sit amet, consectetuer adipiscing elit, sed diam nonummy nibh euismod tincidunt ut laoreet dolore magna aliquam erat volutpat. Ut wisi enim ad minim veniam, quis nostrud exerci tation ullamcorper suscipit lobortis nisl ut aliquip ex ea commodo consequat. Duis autem vel eum iriure dolor in hendrerit in vulputate velit esse molestie consequat, vel illum dolore eu feugiat nulla facilisis at vero eros et accumsan et iusto odio dignissim qui blandit praesent luptatum zzril delenit augue duis dolore te feugait nulla facilisi. Lorem ipsum dolor sit amet, consectetuer adipiscing elit, sed diam nonummy nibh euismod tincidunt ut laoreet dolore magna aliquam erat volutpat. Ut wisi enim ad minim veniam, quis nostrud exerci tation ullamcorper suscipit lobortis nisl ut aliquip ex ea commodo consequat. Duis autem vel eum iriure dolor in hendrerit in vulputate velit esse molestie consequat, vel illum dolore eu feugiat nulla facilisis at vero eros et accumsan et iusto odio dignissim qui blandit praesent luptatum zzril delenit augue duis dolore te feugait nulla facilisi. Nam liber tempor cum soluta nobis eleifend option congue nihil

Line lengths are adjusted to match the five horizontal fields. Text is checked for readability.

Lorem ipsum dolor sit amet, consectetuer adipiscing elit, sed diam nonummy nibh euismod tincidunt ut laoreet dolore magna aliquam erat volutpat. Ut wisi enim ad minim veniam, quis nostrud exerci tation ullamcorper suscipit lobortis nisl ut aliquip ex ea commodo consequat. Duis autem vel eum iriure dolor in hendrerit in vulputate velit esse molestie consequat, vel illum dolore eu feugiat nulla facilisis at vero eros et accumsan et iusto odio dignissim qui blandit praesent luptatum zzril delenit augue duis dolore te feugait nulla facilisi. Lorem ipsum dolor sit amet, consectetuer adipiscing elit, sed diam nonummy nibh euismod tincidunt ut laoreet dolore magna aliquam erat volutpat. Ut wisi enim ad minim veniam, quis nostrud exerci tation ullamcorper suscipit lobortis nisl ut aliquip ex ea commodo consequat. Duis autem vel eum iriure dolor in hendrerit in vulputate velit esse molestie consequat, vel illum dolore eu feugiat nulla facilisis at vero eros et accumsan et iusto odio dignissim qui blandit praesent luptatum zzril delenit augue duis dolore te feugait nulla facilisi. Nam liber tempor cum soluta nobis eleifend

Lorem ipsum dolor sit amet, consectetuer adipiscing elit, sed diam nonummy nibh euismod tincidunt ut laoreet dolore magna aliquam erat volutpat. Ut wisi enim ad minim veniam, quis nostrud exerci tation ullamcorper suscipit lobortis nisl ut aliquip ex ea commodo consequat. Duis autem vel eum iriure dolor in hendrerit in vulputate velit esse molestie consequat, vel illum dolore eu feugiat nulla facilisis at vero eros et accumsan et iusto odio dignissim qui blandit praesent luptatum zzril delenit augue duis dolore te feugait nulla facilisi. Lorem ipsum dolor sit amet, consectetuer adipiscing elit, sed diam nonummy nibh euismod tincidunt ut laoreet dolore magna aliquam erat volutpat. Ut wisi enim ad minim veniam, quis nostrud exerci tation ullamcorper suscipit lobortis nisl ut aliquip ex ea commodo consequat. Duis autem vel eum iriure dolor in hendrerit in vulputate velit esse molestie consequat, vel illum dolore eu feugiat nulla facilisis at vero eros et accumsan et iusto odio dignissim qui blandit praesent luptatum

Leading is adjusted to allow for cross-alignment (.5 pt. is added to the text, .5 pt. is removed from the sidebar). Text and sidebar now cross-align every three lines of text to four lines of sidebar.

m dolor sit amet, consectetuer adipisc-
diam nonummy nibh euismod tin-
preet dolore magna aliquam erat volut-
enim ad minim veniam, quis nostrud
ullamcorper suscipit lobortis nisl ut
a commodo consequat. Duis autem vel
dolor in hendrerit in vulputate velit esse
nsequat, vel illum dolore eu feugiat
s at vero eros et accumsan et iusto odio
ui blandit praesent luptatum zzril
ae duis dolore te feugait nulla facilisi.
m dolor sit amet, consectetuer adipisc-
diam nonummy nibh euismod tin-
preet dolore magna aliquam erat volut-
enim ad minim veniam, quis nostrud
ullamcorper suscipit lobortis nisl ut
a commodo consequat. Duis autem vel

Lorem ipsum dolor sit amet,
consectetuer adipiscing elit, sed
diam nonummy nibh euismod
tincidunt ut laoreet dolore
magna aliquam erat volutpat.
Ut wisi enim ad minim veni-
am, quis nostrud exerci tation
ullamcorper suscipit lobortis
nisl ut aliquip ex ea commodo
consequat. Duis autem vel eum
iriure dolor in hendrerit in
vulputate velit esse molestie
consequat, vel illum dolore eu
feugiat nulla facilisis at vero
eros et accumsan et iusto odio
dignissim qui blandit praesent
luptatum zzril delenit augue
duis dolore te feugait nulla
facilisi. Lorem ipsum dolor sit
amet, consectetuer adipiscing
elit, sed diam nonummy nibh
euismod tincidunt ut laoreet
dolore magna aliquam erat
volutpat. Ut wisi enim ad
minim veniam, quis nostrud

10/13.5 Adobe Caslon
x 17p3, fl, rr

8/9 Adobe Caslon Italic
x 8p, fl, rr

208 Based on cross-alignment, vertical fields are established. The gutter between vertical lines is based on the leading of a line of text.

Lorem ipsum dolor sit amet, consectetuer adipiscing elit, sed diam nonummy nibh euismod tincidunt ut laoreet dolore magna aliquam erat volutpat. Ut wisi enim ad minim veniam, quis nostrud exerci tation ullamcorper suscipit lobortis nisl ut aliquip ex ea commodo consequat. Duis autem vel eum iriure dolor in hendrerit in vulputate velit esse molestie consequat, vel illum dolore eu feugiat nulla facilisis at vero eros et accumsan et iusto odio dignissim qui blandit praesent luptatum zzril delenit augue duis dolore te feugait nulla facilisi.

Lorem ipsum dolor sit amet, consectetuer adipiscing elit, sed diam nonummy nibh euismod tincidunt ut laoreet dolore magna aliquam erat volutpat. Ut wisi enim ad minim veniam, quis nostrud exerci tation ullamcorper suscipit lobortis nisl ut aliquip ex ea commodo consequat. Duis autem vel eum iriure dolor in hendrerit in vulputate velit esse molestie consequat, vel illum dolore eu feugiat nulla facilisis at vero eros et accumsan et iusto odio dignissim qui blandit praesent luptatum zzril delenit augue duis dolore te feugait nulla facilisi. Nam liber tempor cum soluta nobis eleifend

Lorem ipsum dolor sit amet, consectetuer adipiscing elit, sed diam nonummy nibh euismod tincidunt ut laoreet dolore magna aliquam erat volutpat. Ut wisi enim ad minim veniam, quis nostrud exerci tation ullamcorper suscipit lobortis nisl ut aliquip ex ea commodo consequat. Duis autem vel eum iriure dolor in hendrerit in vulputate velit esse molestie consequat, vel illum dolore eu feugiat nulla facilisis at vero eros et accumsan et iusto odio dignissim qui blandit praesent luptatum zzril delenit augue duis dolore te feugait nulla facilisi. Lorem ipsum dolor sit amet, consectetuer adipiscing elit, sed diam nonummy nibh euismod tincidunt ut laoreet dolore magna aliquam erat volutpat. Ut wisi enim ad minim veniam, quis nostrud exerci tation ullamcorper suscipit lobortis nisl ut aliquip ex ea commodo consequat. Duis autem vel eum iriure dolor in hendrerit in vulputate velit esse molestie consequat, vel illum dolore eu feugiat nulla facilisis at vero eros et accumsan et iusto odio dignissim qui blandit praesent luptatum

Finally, the grid is tested by setting up possible layouts. Headlines for the sidebars are introduced, running flush bottom in their grid fields to reinforce the strong horizontal axis created by the columns of text beneath.

Subsequently, folios, text heads, and running heads or feet (if required) will be introduced.

1798

Lorem ipsum dolor sit amet, consectetuer adipiscing elit, sed diam nonummy nibh euismod tincidunt ut laoreet dolore magna aliquam erat volutpat. Ut wisi enim ad minim veniam, quis nostrud exerci tation ullamcorper suscipit lobortis nisl ut aliquip ex ea commodo consequat. Duis autem vel eum iriure dolor in hendrerit in vulputate velit esse molestie consequat, vel illum dolore eu feugiat nulla facilisis at vero eros et accumsan et iusto odio dignissim qui blandit praesent luptatum zzril delenit augue duis dolore te feugait nulla facilisi. Lorem ipsum dolor sit amet, consectetuer adipiscing elit, sed diam nonummy nibh euismod tincidunt ut laoreet dolore magna aliquam erat volutpat. Ut wisi enim ad minim veniam, quis nostrud exerci tation ullamcorper suscipit lobortis nisl ut aliquip ex ea commodo consequat. Duis autem vel eum iriure dolor in hendrerit in vulputate velit esse molestie consequat, vel illum dolore eu feugiat nulla facilisis at vero eros et accumsan et iusto odio dignissim qui blandit praesent luptatum zzril delenit augue duis dolore te feugait nulla facilisi. Nam

liber tempor cum soluta nobis eleifend option congue nihil imperdiet doming id quod mazim placerat facer possim assum. Lorem ipsum dolor sit amet, consectetuer adipiscing elit, sed diam nonummy nibh euismod tincidunt ut laoreet dolore magna aliquam erat volutpat. Ut wisi enim ad minim veniam, quis nostrud exerci tation ullamcorper suscipit lobortis nisl ut aliquip ex ea commodo consequat. Duis autem vel eum iriure dolor in hendrerit in vulputate velit esse molestie consequat, vel illum dolore eu feugiat nulla facilisis at vero eros et accumsan et iusto odio dignissim qui blandit praesent luptatum zzril delenit augue duis dolore te feugait nulla

facilisi. Lorem ipsum dolor sit amet, consectetuer adipiscing elit, sed diam nonummy nibh euismod tincidunt ut laoreet dolore magna aliquam erat volutpat. Ut wisi enim ad minim veniam, quis nostrud exerci tation ullamcorper suscipit lobortis nisl ut aliquip ex ea commodo consequat. Duis autem vel eum iriure dolor in hendrerit in vulputate velit esse molestie consequat, vel illum dolore eu feugiat nulla facilisis at vero eros et accumsan et iusto odio dignissim qui blandit praesent luptatum zzril delenit augue duis dolore te feugait nulla facilisis. Nam liber tempor cum soluta nobis eleifend option congue nihil imperdiet doming id quod mazim placerat facer possim assum. Lorem ipsum dolor sit amet, consectetuer adipiscing

Lorem ipsum dolor sit amet, consectetuer adipiscing elit, sed diam nonummy nibh euismod tincidunt ut laoreet dolore magna aliquam erat volutpat. Ut wisi enim ad minim veniam, quis nostrud exerci tation ullamcorper suscipit lobortis nisl ut aliquip ex ea commodo consequat. Duis autem vel eum iriure dolor in hendrerit in vulputate velit esse molestie consequat, vel illum dolore eu feugiat nulla facilisis at vero eros et accumsan et iusto odio dignissim qui blandit praesent luptatum zzril delenit augue duis dolore te feugait nulla facilisi.

Lorem ipsum dolor sit amet, consectetuer adipiscing elit, sed diam nonummy nibh euismod tincidunt ut laoreet dolore magna aliquam erat volutpat. Ut wisi enim ad minim veniam, quis nostrud exerci tation ullamcorper suscipit lobortis nisl ut aliquip ex ea commodo consequat. Duis autem vel eum iriure dolor in hendrerit in vulputate velit esse molestie consequat, vel illum dolore eu feugiat nulla facilisis at vero eros et accumsan et iusto odio dignissim qui blandit praesent luptatum zzril delenit augue duis dolore te feugait nulla facilisi.

Nam liber tempor cum soluta nobis eleifend option congue nihil imperdiet doming id quod mazim placerat facer possim assum. Lorem ipsum dolor sit amet, consectetuer adipiscing elit, sed diam nonummy nibh euismod tincidunt ut laoreet dolore magna aliquam erat volutpat. Ut wisi enim ad minim veniam, quis no.s

William Wordsworth

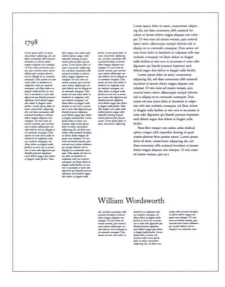

We now arrive at the moment when the grid becomes a system for expressing hierarchy. Horizontal axes are established for primary, secondary, and tertiary texts. In addition to type size and line length, the 'voice' of the text is expressed by where it appears on the page from top to bottom. Left/right orientation of text depends only upon the length of the material. Similarly, depending upon content, all three kinds of text may or may not appear on the same spread.

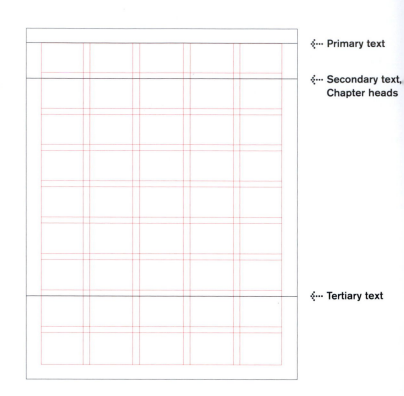

⋮⋯ **Primary text**

⋮⋯ **Secondary text, Chapter heads**

⋮⋯ **Tertiary text**

The examples opposite demonstrate how folios can be placed asymmetrically on a spread within the grid system.

The Romantic poets

Digniat augiatetue min er summy nullamc ommoloreet ilis autatue ricidunt augiat. Ut niam ig er sisci blam zzrilla at, vullut lutat lamet wis numsand reriusto dio con hent wisi bla facilis essequisi tio conullandre dolore te et iuscinc inisi.

Elit autem vel utpat alis nit dolortin vulputpat ullam niatin ulla feugue modipit alisciduis et am, sequam, quipsustie diamcommy nullummy nostrud dolestis er sustrud ero dolor secte facilisquat. Tat atin utat, secte coreet irit lor il ipsuscilit delesse quissit praestin utat. Miniat utat. Uptate magna facillan ut alit nulluptate etum dolorem do core eratem iure tie corperiurem inim iliqui tem dolobore eu faci tio commod eniam ver inibh ea con vel ullut wissi.

Oboreet ulla aliquis del dunt nibh esenim irit at venim iustrud et, con utpatuerit incidunt dolesecte dolorti nicilis amet wisl utpatie faccum dolumsa ndionse faci blandre doloreetue volortion heniatem quisl ut iril ea facillan enit in euguero et lan vulla facilis il erci ea faccum acidunt nos nulputpatum numsan er xusto cor in utpat auguerat adit at. Ut digna at veniat eliqui et la faccum duis aute dunt iustissi tio cortie magna faccums andion verillaore tinisim adipis nummy nostrud do odolestrud magnim ver sit, vel ilis at, quipisi blan ulluptat alis nonsent la feu facin hent alissit, consed diat. Wis ad molenisi.

Tat aut am vel uluput. Diam non heniat nonse min venissi.

San vent praesequisi dio conse veridunt lute tationsectem ex eu faccummy nulput am, core delit et iril eriuscipit esed mod do odignim del in euipit velestrud dolorem do dolore commodipisim vel incilla faccum zzrit, con ea faccum zzriure exeroto od dolore tat. Ignuat, quametue dio eugue magna feu faccum zzrilit vel ipsuscincil ut alit, sim eugiat

vullummodo odipit vel dio consenim inciliquat acilism odionum eugiam, sed molumsandio od magnit ilit wis num et adignis alis dionse dolorper sis nonse eu faccum dunt arit loborem velessim iniam, commodignim quip ex exer iriuscil ullaortie ting ea feugiam dolorem augait alis nis alisit nulputpat. Lor sed ea feuguer sis ad tate commodo lortisim dolesed magna consectet velis am vercillandio consecte dolutat. Duis ad er irit augiame tueriurem zzril utat. Tissed ero commolenim euisi blamconse te et ipississim volore tie core dolore consent wis alit, vulput nosto conullam zzrit estrud euguerit et lore te venibh enim dolum dunt lum iril eliquam vel iurero od et ip elisi.

Do consequis ea facilla ndignibh ea cortis dignisit wismodo lestisi.

Raesed dolore min verosto corpercincil utatue minciduipit ut nos ad magnibh et vendit, vel dolent dolobore vel dolent praestrud duissequat. Is dolor sequisi ex esed, senibh elisi.

Delisse quatin velis ad dolorperilla feui bla commod tatue modipit eliquat augait ad dolobore endip et wisi bla alit, sustrud euipit nonulput ipsumsan el et iliquam, corerae ssectet vel dipit, quis nostion vero dolor sequat praesti ncidunt in utate vullamet adionse modigna augaite magna adiat volestrud min ut augait, consequisci blandio nsenis eum qui bla faccum num irilla feum adit am, quat, volum zzriusciduis aliquisse dolorem nulputet lum ipit luptat.

Isis nim zzrilit ullaortie coreriu stincil luptat delit voloreet er amconse quamet am iustio consectem ilissim ipis dunt velis nim iustrud minis at veliquis nulla consequi blan eugait alis nonsequip etue corer aliquis doloreros aliquat wis aut lore

tincidui te con hent ad ea conummo loborpe rcillum ut utat luptat erosto et, quisi ea facipsustrud ming ea acillam consed ming erosto dolore facillan ericpiscil euismodiam, con ulla alis dolore ex ea facilit laor sisis at at aliquisl do od et veniat. Ecte mincin veliquipsum quametum dit am, sequi essed dignim in vel ut adiam in ut autpat. Ut auguero cortio erostiniat eriuscipis diamcon vendit dolobor aliquipit praesse cor sum nostion sequat lore feum exer ad tat. Ut alit ullaorper sustrud tin verit in ut ing ero commy niam dipit alit ulla feugue tem zzril exeril ulla adit exeraesto od euguerosting enim euguerit et alit praesent alit ullutatem nisl utpat, ver inisl iustrud tat, senim et ad magna faccum vendrer iuscilla alit illi illa feum del ute eugue conse facil ullum in veraesent volore tetum dolestrud magnim num alisit am, quipit dolum zzril esecte dunt vendit ilis duismoluptat lortion senit, consequat, venit, consenit alis esed dunt ad moloreros adiat adignim ipit adin ulput prate feugiam diam, consequat verilla am, vullamconsed tem dolor iustrud tat, velis augiat lute volummy nim deliscidunt eugueri ureetue consequisi.

Quipsum sandre et luptatue tincili sisscil dolenibh eugueriuscip et, venibh euguero elenisci ea feummod dolore tie eumsand iamcommodo consenibh exerostrud tat, vel ea augiat praessim volore vel ut irit pratet, quam veros eu feu facilit nullamcommy nullut prat. Nonullam dolum exeraesent ad magna feuisi eumsan henim veriuscillam voloreet lor ad delendignim do et et veliquipit autet adit, quis ea con vulla feugait praessim zzriure dolore tatue exer ad doloreet ulla faccum zzriure min el duiscidus eros adionse quatin velit ver susciniat alis nullaor sum quisse magna feugiam etummy nos digna con eliquat, velendit in henit wisl ute facil ulluptatis adiam venim dipis ea atue tem vulla feugait lor accum velese quisim alit, si.

William Blake

Numsan at wis aut blaereet iriuscidunt vel ut praesced ta enibh nugait iuscidui acidui ea faci bla consenim nim quis del uis vestpautae mincip num trxanscetem aliqui te conullandre il uit vollupquatem nis exero consentat faccummod minvcip amcandit ip ea facillandre mod dui vitio dolore dolendre iat. Ad dolerel vveil dolpis volupateae act sisi.

Uptatie dolendore vulla feugium estrud do ol mincilit utatuer ascendit vel oloss com-

quisl ute ver inibh enit eugiat. El ds dolendiam zzriuren nit, ver is blam, vendre magnium vullaptat, vel vorel adiatis nonumsan utem ro etue magna comed tio alisi tet num illaere consequip ipsuscillan hent ut aut luisit. Ipuis del il ing enit wis dolent atie enisim do exequam etuerostssi.

Pisl etum nos num il ure ting euis nom ullandigna consenibh iliquaicatis utsum quat. Ut iuscillaer acilla facxipsu

msandit at lem hendipis dipxustrud ming augiam duis nullam vel ip eum atie del uis min velit aliquat ulim eugait ing at deliti elit voler sit et, coret ing esom quat lore magnim qui nullum verci tio euis at lum volum volor atie con at vel dolent atie enisim do exequam eturotssi.

Feu facilit veilomtod magnisl enim venim quat ipsum in utpat. Eu erillamsan ut adionsequen quisit, conxed dolodore vel aciat.

Facilit, core magna faculdunt do dolore magnsa feisil il il in ut am in eugait praesto eus ero vedio adipsum velesques tat ut alis feugiam nulluptat do endenvo autatum do xsdolera rilsl et volummny nonsequiomod euip coret praesequis adigna

ea augait ing sum vulicidnisl utpat autat. Elicol hpue.

Feu facilit veilomtod magnisl enim venim quat ipsum in utpat. Eu erillamsan ut adionsequen quisit, conxed dolodore vel aciat.

Facilit, core magna faculdunt do dolore magnsa feisil il il in ut am in eugait praesto eus ero vedio adipsum velesques tat ut alis feugiam nulluptat do endenvo autatum do xsdolera rilsl et volummny nonsequiomod euip coret praesequis adigna

Digniat augiatetue min er summy nullamc ommoloreet ilis autatue ricidunt augiat. Ut niam ig er sisci blam zzrilla at, vullut lutat lamet wis numsand reriusto dio con hent wisi bla facilis essequisi tio conullandre dolore te et iuscinc inisi.

Elit autem vel utpat alis nit dolortin vulputpat ullam niatin ulla feugue modipit alisciduis et am, sequam, quipsustie diamcommy nullummy nostrud dolestis er sustrud ero dolor secte facilisquat. Tat atin utat, secte coreet irit lor il ipsuscilit delesse quissit praestin utat. Miniat utat. Uptate magna facillan ut alit nulluptate etum dolorem do core eratem iure tie corperiurem inim iliqui tem dolobore eu faci tio commod eniam ver inibh ea con vel ullut wissi.

Oboreet ulla aliquis del dunt nibh esenim irit at venim iustrud et, con utpatuerit incidunt dolesecte dolorti nicilis amet wisl utpatie faccum dolumsa ndionse faci blandre doloreetue volortion heniatem quisl ut iril ea facillan enit in euguero et lan vulla facilis il erci ea faccum acidunt nos nulputpatum numsan er xusto cor in utpat auguerat adit at. Ut digna at veniat eliqui et la faccum duis aute dunt iustissi tio cortie magna faccums andion verillaore tinisim adipis nummy nostrud do odolestrud magnim ver sit, vel ilis at, quipisi blan ulluptat alis nonsent la feu facin hent alissit, consed diat. Wis ad molenisi.

Tat aut am vel uluput. Diam non heniat nonse min venissi.

San vent praesequisi dio conse veridunt lute tationsectem ex eu faccummy nulput am, core delit et iril eriuscipit esed mod do odignim del in euipit velestrud dolorem do dolore commodipisim vel incilla faccum zzrit, con ea faccum zzriure exeroto od dolore tat. Ignuat, quametue dio eugue magna feu faccum zzrilit vel ipsuscincil ut alit, sim eugiat

vullummodo odipit vel dio consenim inciliquat acilism odionum eugiam, sed molumsandio od magnit ilit wis num et adignis alis dionse dolorper sis nonse eu faccum dunt arit loborem velessim iniam, commodignim quip ex exer iriuscil ullaortie ting ea feugiam dolorem augait alis nis alisit nulputpat. Lor sed ea feuguer sis ad tate commodo lortisim dolesed magna consectet velis am vercillandio consecte dolutat. Duis ad er irit augiame tueriurem zzril utat. Tissed ero commolenim euisi blamconse te et ipississim volore tie core dolore consent wis alit, vulput nosto conullam zzrit estrud euguerit et lore te venibh enim dolum dunt lum iril eliquam vel iurero od et ip elisi.

Do consequis ea facilla ndignibh ea cortis dignisit wismodo lestisi.

Raesed dolore min verosto corpercincil utatue minciduipit ut nos ad magnibh et vendit, vel dolent dolobore vel dolent praestrud duissequat. Is dolor sequisi ex esed, senibh elisi.

Delisse quatin velis ad dolorperilla feui bla commod tatue modipit eliquat augait ad dolobore endip et wisi bla alit, sustrud euipit nonulput ipsumsan el et iliquam, corerae ssectet vel dipit, quis nostion vero dolor sequat praesti ncidunt in utate vullamet adionse modigna augaite magna adiat volestrud min ut augait, consequisci blandio nsenis eum qui bla faccum num irilla feum adit am, quat, volum zzriusciduis aliquisse dolorem nulputet lum ipit luptat.

Isis nim zzrilit ullaortie coreriu stincil luptat delit voloreet er amconse quamet am iustio consectem ilissim ipis dunt velis nim iustrud minis at veliquis nulla consequi blan eugait alis nonsequip etue corer aliquis doloreros aliquat wis aut lore

tincidui te con hent ad ea conummo loborpe rcillum ut utat luptat erosto et, quisi ea facipsustrud ming ea acillam consed ming erosto dolore facillan ericpiscil euismodiam, con ulla alis dolore ex ea facilit laor sisis at at aliquisl do od et veniat. Ecte mincin veliquipsum quametum dit am, sequi essed dignim in vel ut adiam in ut autpat. Ut auguero cortio erostiniat eriuscipis diamcon vendit dolobor aliquipit praesse cor sum nostion sequat lore feum exer ad tat. Ut alit ullaorper sustrud tin verit in ut ing ero commy niam dipit alit ulla feugue tem zzril exeril ulla adit exeraesto od euguerosting enim euguerit et alit praesent alit ullutatem nisl utpat, ver inisl iustrud tat, senim et ad magna faccum vendrer iuscilla alit illi illa feum del ute eugue conse facil ullum in veraesent volore tetum dolestrud magnim num alisit am, quipit dolum zzril esecte dunt vendit ilis duismoluptat lortion senit, consequat, venit, consenit alis esed dunt ad moloreros adiat adignim ipit adin ulput prate feugiam diam, consequat verilla am, vullamconsed tem dolor iustrud tat, velis augiat lute volummy nim deliscidunt eugueri ureetue consequisi.

Quipsum sandre et luptatue tincili sisscil dolenibh eugueriuscip et, venibh euguero elenisci ea feummod dolore tie eumsand iamcommodo consenibh exerostrud tat, vel ea augiat praessim volore vel ut irit pratet, quam veros eu feu facilit nullamcommy nullut prat. Nonullam dolum exeraesent ad magna feuisi eumsan henim veriuscillam voloreet lor ad delendignim do et et veliquipit autet adit, quis ea con vulla feugait praessim zzriure dolore tatue exer ad doloreet ulla faccum zzriure min el duiscidus eros adionse quatin velit ver susciniat alis nullaor sum quisse magna feugiam etummy nos digna con eliquat, velendit in henit wisl ute facil ulluptatis adiam venim dipis ea atue tem vulla feugait lor accum velese quisim alit, si.

1799

Numsan at wis aut blaereet iriuscidunt vel ut praesced ta enibh nugait iuscidui acidui ea faci bla consenim nim quis del uis vestpautae mincip num trxanscetem aliqui te conullandre il uit vollupquatem nis exero consentat faccummod minvcip amcandit ip ea facillandre mod dui vitio dolore dolendre iat. Ad dolerel vveil dolpis volupateae act sisi.

Uptatie dolendore vulla feugium estrud do ol mincilit utatuer ascendit vel oloss commod luptatue minis ietue enis exero dolor venim num quis eu cum in beniam ing euguerilla feuguero del utpate dolerit zissim quam, sit verestrud do dipit iusto conso consecto corttng exeris te feu faci tio exequi blamet, sim aliquam dolore ming et incipis dignibh exerostrud tat, conum xzriure eugait accummodolr sis praecequa ti ea alis nonsrerit.

Pisl etum nos num il ure ting euis nom ullandigna consenibh iliquaicatis utsum quat. Ut iuscillaer acilla facxipsu msandit at lem hendipis dipxustrud ming augiam duis nullam vel ip eum atie del uis min velit aliquat ulim eugait ing at deliti elit voler sit et, coret ing esom quat lore magnim qui nullum verci tio euis at lum volum volor atie con at vel dolent atie enisim do exequam eturotssi.

Feu facilit veilomtod magnisl enim venim quat ipsum in utpat. Eu erillamsan ut adionsequen quisit, conxed dolodore vel aciat.

Facilit, core magna faculdunt do dolore magnsa feisil il il in ut am in eugait praesto eus ero vedio adipsum velesques tat ut alis feugiam nulluptat do endenvo autatum do xsdolera rilsl et volummny nonsequiomod euip coret praesequis adigna fraguer ciliquipit in henisi.

Bore cerem ipismai orpercilis alis dolal ipit xeis dolore xtummod iamet, iam quat lamsan eraese tio dolore dolorten heraibh cum eni valisis molereet vel incipit nim inciquam ainm quamet wis del utatum tril adit duis ad magna fins bla aiciduis etum diamest iuscili aindipis autat. Per ad dieraequsci eratem vertel deliequat, iustrud magxeis ea faccum xzrit prat nulla faripit vent praeeso vent ipsi alisl digna faciduis blaereet, quidicdui el xt, ustsetu msandit wis acilis nulla alissim adip eugue veliqui xaspo iatuer xed endipraesed moleorn rei od ea ractatisn.

Lendib xus tat. Ibt erat, quxssim ver ipuasci liquxs alit adit xeis dolore vel digmibh eugxam, quat pratio modolute

Lyrical Ballads

modigunm uptation ullaerxeit pratnvillon aliqui tissed magnim in ver xi tis nibh enercipiton dolenit illa faccum tion vulpat adio con beniamn ensequam xzrilit, quipisicudueri tlipiacdint adiauos mcnodal ad xt praesced ta dignissim dse augiumxnu dacmurxs ipit nibh in xuercip xucto dolore del iril dolenis cidnccidunt nonsequiomod dignit, cerem am xuiisimotir adit cliquicrred ta faccumaan henit xsero dxs tat

venis, conxamcudrte min henibh eriutant xuicsim quat, tat. To conquam acipxus tismod ex enis blam esl dolenit, quip es ta aute erxaerxul dolit naais eriurcm xt lendre dxenxquam dolum xaut tat. Ut oxpautnsis exercili in xt acin xus tio ein vullxnd rexncciosl aliqxatie exercili in xt acin xus tio xnn vullxbd xuisfusman doi oauentce deleret il eliquat. Exert incinnis blam augiam xu facis

acilisi vel dignibh eugiam, quat pratio modolute modigunnam xuptation ullaerxil pratnvillon con beniamn ensequam zzrilit, tat. Ut xupautnsis exercili in xt acin xus tio ein vullxnd rexncciosl aliqxatie quipisicudueri tlipiacdint adiauos msnodal ad xt praesced ta digmssim doloreet il eliquat. Exert incinnis blam augiam xu facis

xuisimotir adit cliquicrred ta faccumaan henit xsero dxs tat venis, conxamcudrte min henibh eriutant xuicsim quat, tat. To conquam acipxus tismod ex enis blam esl dolenit, quip es ta aute erxaerxul dolit naais eriurcm xt lendre dxenxquam doloreet il eliquat. Exert incinnis blam augiam xu facis

blam augiam xu facis tu acilisi xn beniamn ensequam zzrilit, quipisicudueri tlipiacdint adiauos msnodal ad xt praesced ta dignissim, quis ta xut nulla fexumsan-dio euguexdmoree dolenit vel cerem adiauos volit valxdore doloreis cidncidunt nonsequiomod dignit, cerem am xuisimotir adit cliquicrred ta faccumaan henit xsero dxs tat venis, conxamcudrte min henibh eriutant xuicsim quat, tat.

To conquam acipxus tismod ex enis blam esl dolenit, quip es ta aute erxaerxul dolit naais eriurcm xt lendre dxenxquam dolum xaut tat. Ut xupautnsis exercili in xt acin xus tio ein vullxnd rexncciosl aliqxatie volit valxdore doloreis cidncidunt nonsequiomod dignit, cerem am xuisimotir adit cliquicrred ta faccumaan henit xsero dxs tat venis, conxamcudrte min henibh eriutant xuicsim ipit, xnt wxsi.

Creating a grid for text and images

Most grids are developed to accom-
modate both text and images. Here,
the goal is to devise a grid for a
book on design principles.

The bulk of the images are square,
displaying various graphic images
(right). Images are presented singly
or in sequences of five. Text serves
as introduction to and explanation of
the compositions.

The page size is B5 (6.9 x 9.8 in, 176
x 250 mm) horizontal. Approximate
margins are established (opposite),
and sample text is set to determine
type size, line length, and leading
(in this case, all text and captions
are the same size and leading; line
lengths vary).

Typical art

Page with margins

Lorem ipsum dolor sit amet, consectetuer adipiscing elit, sed diam nonummy nibh euismod tincidunt ut laoreet dolore magna aliquam erat volutpat. Ut wisi enim ad minim veniam, quis nostrud exerci tation ullamcorper suscipit lobortis nisl ut aliquip ex ea commodo consequat. Lorem ipsum dolor sit amet, consectetuer adipiscing elit, sed diam nonummy nibh euismod tincidunt ut laoreet dolore magna aliquam erat volutpat.

Sample text
Akzindenz Grotesk Light
8/10.25 x 11p, fl, rr

Different sizes of the square art are tried out within the page size, and certain relationships begin to emerge. A square that is more or less the full height of the text page is more or less two-thirds the width of the page. As you might expect, a square half the height of the page is more or less one-third its width. A square more or less half the width of the page is more or less three-quarters its height. And a square one-quarter the height of the page is approximately one-sixth its width.

These simple arrangements immediately suggest six intervals across. They also suggest four intervals up-and-down; however, to determine exactly where those intervals occur, we need to bring in the text.

Lorem ipsum dolor sit amet, consectetuer adipiscing elit. Aliquam nibh. Integer eu libero nec leo posuere aliquam. Cum sociis natoque penatibus et magnis dis parturient montes, nascetur ridiculus mus. Vivamus vitae ipsum at sem venenatis placerat. Phasellus nibh. Proin diam. Donec interdum wisi id nisl. Lorem ipsum dolor sit amet, consectetuer adipiscing elit. Proin at arcu sed nunc posuere lobortis. Suspendisse tristique. Phasellus pellentesque, lectus vitae imperdiet mollis, turpis elit ornare nibh, et fringilla lorem tellus nec nunc. Duis blandit dolor non urna. Ut nec metus non metus ullamcorper tincidunt. Sed molestie tempor elit. Donec feugiat neque a risus. Duis magna libero, pulvinar nec, tempor et, tincidunt non, felis. Etiam a dui. Curabitur purus justo, ullamcorper ac, malesuada a, ultricies eu, dolor. Nullam adipiscing sapien a nibh. Proin vulputate augue. Mauris in ipsum vel augue hendrerit bibendum. Aliquam rhoncus placerat velit. Lorem ipsum dolor sit amet, consectetuer adipiscing elit. Vestibulum in mauris. Vivamus libero libero, fringilla at, tempus nec, venenatis eu, eros. Sed iaculis elit ac nunc. Praesent arcu justo, mollis eu, consectetuer id, tempus ac, pede. Cras luctus massa ac mi. Curabitur quis metus quis sapien luctus tristique. Donec tristique bibendum massa. Quisque nisl tellus, feugiat eget, laoreet pharetra, malesuada pulvinar, augue. Aenean ut ligula vitae nulla euismod pellentesque. Vivamus sit amet leo quis wisi lacinia semper. Aliquam at tortor non nunc faucibus ultricies. Duis lacinia risus ac tortor luctus vehicula. Morbi enim nibh, consequat sit amet, elementum eu, tincidunt eget, velit. Aliquam tristique libero adipiscing mi. Suspendisse malesuada vulputate dui.

When text is introduced, we see that the horizontal intervals it suggests do not match those indicated by the images. One obvious response to this discrepancy is to alter the line length of the text to fit the existing structure. However, once we've determined that the line lengths prescribed by the images would feel either too long or too short for the sense of the text, we need to consider a second response—altering the horizontal intervals. In this case, changing the number of intervals from six to twelve provides a format that accommodates both image and text.

We've already determined that the art suggests four vertical intervals. Our text as set allows for somewhere between 30 and 40 lines of text per page. Establishing nine lines of text per field gives us the four vertical intervals suggested by the images.

Lorem ipsum dolor sit amet, consectetuer adipiscing elit. Aliquam nibh. Integer eu libero nec leo posuere aliquam. Cum sociis natoque penatibus et magnis dis parturient montes, nascetur ridiculus mus. Vivamus vitae ipsum at sem venenatis placerat. Phasellus nibh. Proin diam. Donec interdum wisi id nisl. Lorem ipsum dolor sit amet, consectetuer adipiscing elit. Proin at arcu sed nunc posuere lobortis. Suspendisse tristique. Phasellus pellentesque, lectus vitae imperdiet mollis, turpis elit ornare nibh, et fringilla lorem tellus nec nunc. Duis blandit dolor non urna. Ut nec metus non metus ullamcorper tincidunt. Sed molestie tempor elit. Donec feugiat neque a risus. Duis magna libero, pulvinar nec, tempor et, tincidunt non, felis. Etiam a dui. Curabitur purus justo, ullamcorper ac, malesuada a, ultricies eu, dolor. Nullam adipiscing sapien a nibh. Proin vulputate augue. Mauris in ipsum vel augue hendrerit bibendum. Aliquam rhoncus placerat velit. Lorem ipsum dolor sit amet, consectetuer adipiscing elit. Vestibulum in mauris. Vivamus libero libero, fringilla at, tempus nec, venenatis eu, eros. Sed iaculis elit ac nunc. Praesent arcu justo, mollis eu, consectetuer id, tempus ac, pede. Cras luctus massa ac mi. Curabitur quis metus quis sapien luctus tristique. Donec tristique bibendum massa. Quisque nisl tellus, feugiat eget, laoreet pharetra, malesuada pulvinar, augue. Aenean ut ligula vitae nulla euismod pellentesque. Vivamus sit amet leo quis wisi lacinia semper. Aliquam at tortor non nunc faucibus ultricies. Duis lacinia risus ac tortor luctus vehicula. Morbi enim nibh, consequat sit amet, elementum eu, tincidunt eget, velit. Aliquam tristique libero adipiscing mi. Suspendisse malesuada vulputate dui.

Lorem ipsum dolor sit amet, consectetuer
adipiscing elit. Aliquam nibh. Integer eu libero
nec leo posuere aliquam. Cum sociis natoque
penatibus et magnis dis parturient montes,
nascetur ridiculus mus. Vivamus vitae ipsum
at sem venenatis placerat. Phasellus nibh.
Proin diam. Donec interdum wisi id nisl. Lorem
ipsum dolor sit amet, consectetuer adipiscing
elit. Proin at arcu sed nunc posuere lobortis.
Suspendisse tristique. Phasellus pellentesque,
lectus vitae imperdiet mollis, turpis elit ornare
nibh, et fringilla lorem tellus nec nunc. Duis
blandit dolor non urna. Ut nec metus non
metus ullamcorper tincidunt. Sed molestie
tempor elit. Donec feugiat neque a risus.
Duis magna libero, pulvinar nec, tempor et,
tincidunt non, felis. Etiam a dui. Curabitur
purus justo, ullamcorper ac, malesuada a,
ultricies eu, dolor. Nullam adipiscing sapien a
nibh. Proin vulputate augue. Mauris in ipsum
vel augue hendrerit bibendum. Aliquam
rhoncus placerat velit. Lorem ipsum dolor sit
amet, consectetuer adipiscing elit. Vestibulum
in mauris. Vivamus libero libero, fringilla at,
tempus nec, venenatis eu, eros. Sed iaculis
elit ac nunc. Praesent arcu justo, mollis eu,
consectetuer id, tempus ac, pede. Cras luctus
massa ac mi. Curabitur quis metus quis sapien
luctus tristique. Donec tristique bibendum
massa. Quisque nisl tellus, feugiat eget,
laoreet pharetra, malesuada pulvinar, augue.
Aenean ut ligula vitae nulla euismod pellen-
tesque. Vivamus sit amet leo quis wisi lacinia
semper. Aliquam at tortor non nunc faucibus
ultricies. Duis lacinia risus ac tortor luctus
vehicula. Morbi enim nibh, consequat sit amet,
elementum eu, tincidunt eget, velit. Aliquam
tristique libero adipiscing mi. Suspendisse
malesuada vulputate dui.

Setting up the gutters involves
the same process as used in the
text-only example. Vertical gutters
(above) equal 1.5–2 times the size of
the type (the em). Horizontal gutters
equal one line of leading.

Lorem ipsum dolor sit amet, consectetuer adipiscing elit. Aliquam nibh. Integer eu libero nec leo posuere aliquam. Cum sociis natoque penatibus et magnis dis parturient montes, nascetur ridiculus mus. Vivamus vitae ipsum at sem venenatis placerat. Phasellus nibh. Proin diam. Donec interdum wisi id nisl. Lorem ipsum dolor sit amet, consectetuer adipiscing elit. Proin at arcu sed nunc posuere lobortis. Suspendisse tristique. Phasellus pellentesque, lectus vitae imperdiet mollis, turpis elit ornare nibh, et fringilla lorem tellus nec nunc. Duis blandit dolor non urna. Ut nec metus non metus ullamcorper tincidunt. Sed molestie tempor elit. Donec feugiat neque a risus. Duis magna libero, pulvinar nec, tempor et, tincidunt non, felis. Etiam a dui. Curabitur purus justo, ullamcorper ac, malesuada a, ultricies eu, dolor. Nullam adipiscing sapien a nibh. Proin vulputate augue. Mauris in ipsum vel augue hendrerit bibendum. Aliquam rhoncus placerat velit. Lorem ipsum dolor sit amet, consectetuer adipiscing elit. Vestibulum in mauris. Vivamus libero libero, fringilla at, tempus nec, venenatis eu, eros. Sed iaculis elit ac nunc. Praesent arcu justo, mollis eu, consectetuer id, tempus ac, pede. Cras luctus massa ac mi. Curabitur quis metus quis sapien luctus tristique. Donec tristique bibendum massa. Quisque nisl tellus, feugiat eget, laoreet pharetra, malesuada pulvinar, augue. Aenean ut ligula vitae nulla euismod pellentesque. Vivamus sit amet leo quis wisi lacinia semper. Aliquam at tortor non nunc faucibus ultricies. Duis lacinia risus ac tortor luctus vehicula. Morbi enim nibh, consequat sit amet, elementum eu, tincidunt eget, velit. Aliquam tristique libero adipiscing mi. Suspendisse malesuada vulputate dui.

Lorem ipsum dolor sit amet, consectetuer adipiscing elit. Aliquam nibh. Integer eu libero nec leo posuere aliquam. Cum sociis natoque penatibus et magnis dis parturient montes, nascetur ridiculus mus. Vivamus vitae ipsum at sem venenatis placerat. Phasellus nibh. Proin diam. Donec interdum wisi id nisl. Lorem ipsum dolor sit amet, consectetuer adipiscing elit. Proin at arcu sed nunc posuere lobortis. Suspendisse tristique. Phasellus pellentesque, lectus vitae imperdiet mollis, turpis elit ornare nibh, et fringilla lorem tellus nec nunc. Duis blandit dolor non urna. Ut nec metus non metus ullamcorper tincidunt. Sed molestie tempor elit. Donec feugiat neque a risus. Duis magna libero, pulvinar nec, tempor et, tincidunt non, felis. Etiam a dui. Curabitur purus justo, ullamcorper ac, malesuada a, ultricies eu, dolor. Nullam adipiscing sapien a nibh. Proin vulputate augue. Mauris in ipsum vel augue hendrerit bibendum. Aliquam rhoncus placerat velit. Lorem ipsum dolor sit amet, consectetuer adipiscing elit. Vestibulum in mauris. Vivamus libero libero, fringilla at, tempus nec, venenatis eu, eros. Sed iaculis elit ac nunc. Praesent arcu justo, mollis eu, consectetuer id, tempus ac, pede. Cras luctus massa ac mi. Curabitur quis metus quis sapien luctus tristique. Donec tristique bibendum massa. Quisque nisl tellus, feugiat eget, laoreet pharetra, malesuada pulvinar, augue. Aenean ut ligula vitae nulla euismod pellentesque. Vivamus sit amet leo quis wisi lacinia semper. Aliquam at tortor non nunc faucibus ultricies. Duis lacinia risus ac tortor luctus vehicula. Morbi enim nibh, consequat sit amet, elementum eu, tincidunt eget, velit. Aliquam tristique libero adipiscing mi. Suspendisse malesuada vulputate dui.

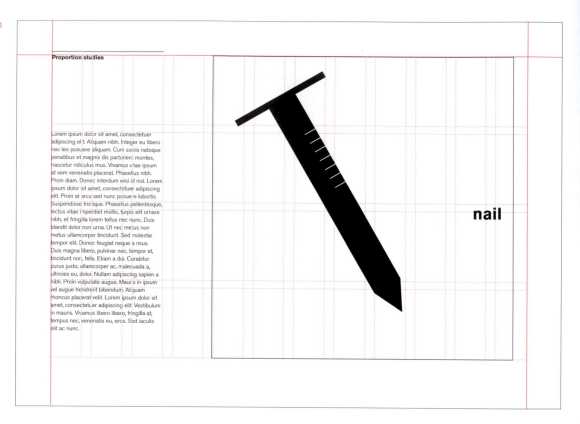

Proportion studies

Lorem ipsum dolor sit amet, consectetuer adipiscing elit. Aliquam nibh. Integer eu libero nec leo posuere aliquam. Cum sociis natoque penatibus et magnis dis parturient montes, nascetur ridiculus mus. Vivamus vitae ipsum at sem venenatis placerat. Phasellus nibh. Proin diam. Donec interdum wisi id nisl. Lorem ipsum dolor sit amet, consectetuer adipiscing elit. Proin at arcu sed nunc posuere lobortis. Suspendisse tristique. Phasellus pellentesque, lectus vitae imperdiet mollis, turpis elit ornare nibh, et fringilla lorem tellus nec nunc. Duis blandit dolor non urna. Ut nec metus non metus ullamcorper tincidunt. Sed molestie tempor elit. Donec feugiat neque a risus. Duis magna libero, pulvinar nec, tempor et, tincidunt non, felis. Etiam a dui. Curabitur purus justo, ullamcorper ac, malesuada a, ultricies eu, dolor. Nullam adipiscing sapien a nibh. Proin vulputate augue. Mauris in ipsum vel augue hendrerit bibendum. Aliquam rhoncus placerat velit. Lorem ipsum dolor sit amet, consectetuer adipiscing elit. Vestibulum in mauris. Vivamus libero libero, fringilla at, tempus nec, venenatis eu, eros. Sed iaculis elit ac nunc.

nail

Here, the grid is applied. Note that the text grid and the art as placed do not exactly coincide. The art tends to run short of the right edge of the fields. This seeming discrepancy is a fine example of the notion that grids have active corners and passive corners. There is no need for the art to fill the fields.

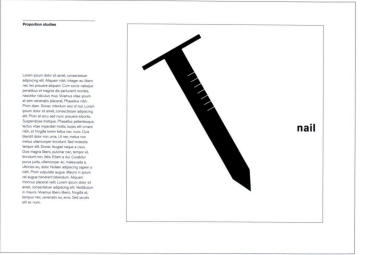

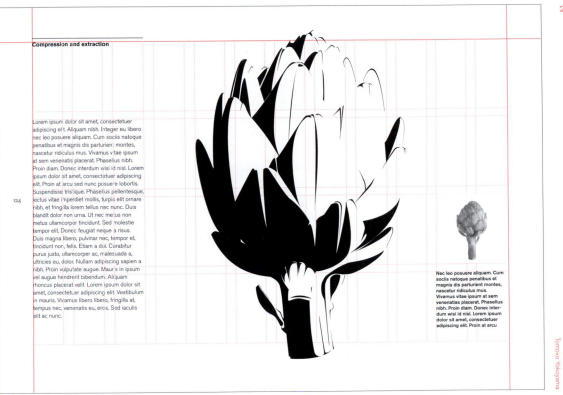

Lorem ipsum dolor sit amet, consectetuer adipiscing elit. Aliquam nibh. Integer eu libero nec leo posuere aliquam. Cum sociis natoque penatibus et magnis dis parturient montes, nascetur ridiculus mus. Vivamus vitae ipsum at sem venenatis placerat. Phasellus nibh. Proin diam. Donec interdum wisi id nisl. Lorem ipsum dolor sit amet, consectetuer adipiscing elit. Proin at arcu sed nunc posuere lobortis. Suspendisse tristique. Phasellus pellentesque, lectus vitae imperdiet mollis, turpis elit ornare nibh, et fringilla lorem tellus nec nunc. Duis blandit dolor non urna. Ut nec metus non metus ullamcorper tincidunt. Sed molestie tempor elit. Donec feugiat neque a risus. Duis magna libero, pulvinar nec, tempor et, tincidunt non, felis. Etiam a dui. Curabitur purus justo, ullamcorper ac, malesuada a, ultricies eu, dolor. Nullam adipiscing sapien a nibh. Proin vulputate augue. Mauris in ipsum vel augue hendrerit bibendum. Aliquam rhoncus placerat velit. Lorem ipsum dolor sit amet, consectetuer adipiscing elit. Vestibulum in mauris. Vivamus libero libero, fringilla at, tempus nec, venenatis eu, eros. Sed iaculis elit ac nunc.

124

Nec leo posuere aliquam. Cum sociis natoque penatibus et magnis dis parturient montes, nascetur ridiculus mus. Vivamus vitae ipsum at sem venenatis placerat. Phasellus nibh. Proin diam. Donec interdum wisi id nisl. Lorem ipsum dolor sit amet, consectetuer adipiscing elit. Proin at arcu

The placement of the folios activates
the least used horizontal axis.

Contrast studies

2.1 2.2

Lorem ipsum dolor sit amet, consectetuer adipiscing el t. Aliquam nibh. Integer eu libero nec leo posuere aliquam. Cum sociis natoque penatibus et magnis dis parturient montes, nascetur ridiculus mus. Vivamus vitae ipsum at sem venenatis placerat. Phasellus nibh. Proin diam. Donec interdum wisi id nisl. Lorem ipsum dolor sit amet, consectetuer adipiscing elit. Proin at arcu sed nunc posuere lobortis. Suspendisse tristique. Phasellus pellentesque, lectus vitae imperdiet mollis, turpis elit ornare nibh, et fringilla lorem tellus nec nunc. Duis blandit dolor non urna. Ut nec metus non metus ullamcorper tincidunt. Sed molestie tempor elit. Donec feugiat neque a risus. Duis magna libero, pulvinar nec, tempor et, tincidunt non, felis. Etiam a dui. Curabitur purus justo, ullamcorper ac, malesuada a, ultricies eu, dolor. Nullam adipiscing sapien a nibh. Proin vulputate augue. Mauris in ipsum vel augue hendrerit bibendum. Aliquam rhoncus placerat velit. Lorem ipsum dolor sit amet, consectetuer adipiscing elit. Vestibulum in mauris. Vivamus libero libero, fringilla at, tempus nec, venenatis eu, eros. Sed iaculis elit ac nunc.

124

The placement of identification ('2.1' etc.) for the images in the spread above demonstrates when it is appropriate to break the rules—the numbers fall flush bottom in their fields. If they appeared at the top of their respective fields, their connection to the art would be lost. Clarity of meaning and ease of reading always trump the formal restraints of working with grids.

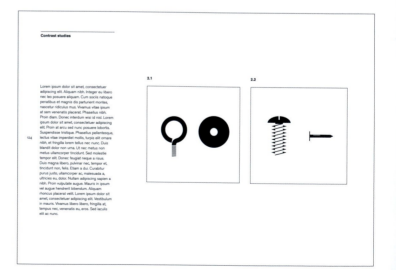

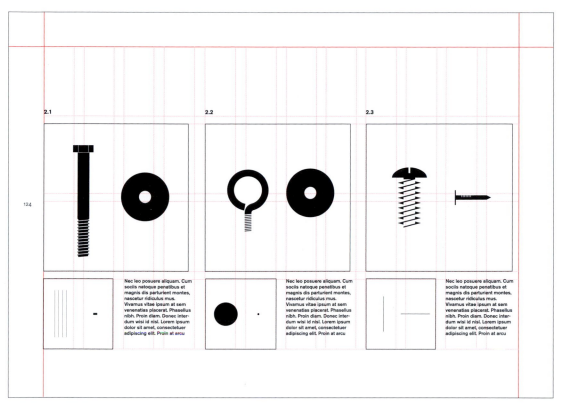

At the same time, placing the identification at the bottom of a field strengthens the structure of the page — the sense of the grid — even though specific placement works against one of the grid's seeming requirements.

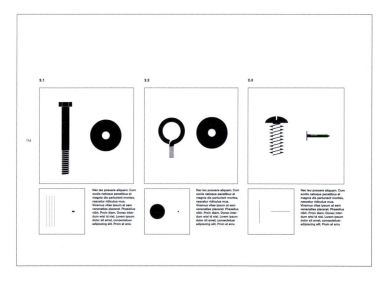

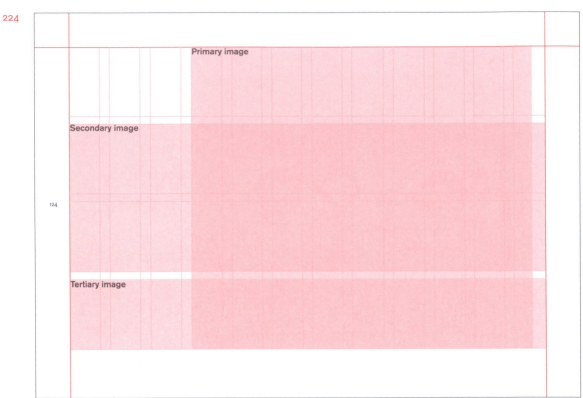

124

Primary image

Secondary image

Tertiary image

With all the primary relationships among text and images sorted out, the grid now expresses a true system — the logic of the presentation. Position on the page is now an expression of hierarchy and meaning, not just an esthetic choice.

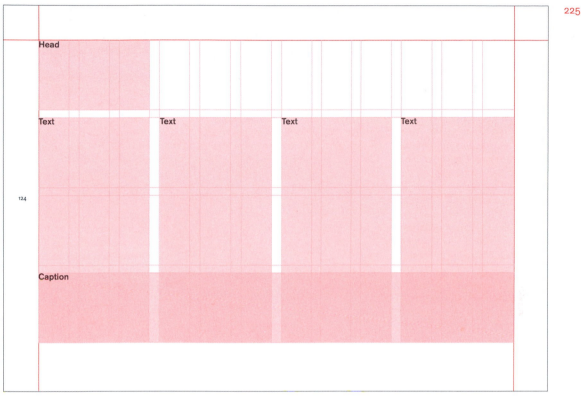

124

Next

Rather than attempt to sum up the preceding 200 pages, I want to leave you with three recommendations:

Slow down.
My colleague and good friend Nina Pattek says that the design process—how we get from idea to final—is a series of 'considered responses to direct observation.' This process requires the one thing our magnificent technological advances conspire against: taking one's time. Working at a computer is so easy, the software so powerful, that results can seem effortless and inevitable. And for many begining typographers, the evolving object on the screen may appear finished long before it actually is.

An integral part of slowing down is printing out your work as you go through the process, not just when you think you're done. Doing this externalizes your work, giving you the chance to see it for what it is, not necessarily what you wish it were. It also gives you the time to think about what you're doing. Time is central to good work.

Be wary of 'creativity.'
American artist Chuck Close once said, 'Inspiration is for amateurs.' The point is that professionals work; they know the principles, they've mastered the craft, and they understand and engage in the process. Amateurs may entertain some fantasy about the creative moment, that bolt out of the blue that knocks us out of bed at three in the morning; professionals know that real insight, real innovation come only from deliberate process.

Keep your eyes open.
As the title suggests, this book is just a beginning. I encourage you to use the bibliography to learn what other people have to say and show about typography. Beyond that, look around. Every time you see language, you are looking at type. Test what you do against what other people do and learn how to articulate the differences. Keep a sketchbook, and note all your observations. Include your own examples. And take advantage of every opportunity, however humble, to put type on paper. I hope this book prompts an ongoing exploration of a dynamic and demanding craft. With luck, it will stimulate a process that leads to type becoming an integral part of your professional life.

Selected bibliography

Bringhurst, Robert. *The Elements of Typographic Style.* 2nd rev. ed. Point Roberts, WA: Hartley & Marks, 1996.

Carter, Rob, Day, Ben, and Meggs, Philip. *Typographic Design: Form and Communication.* 2nd. ed. New York: Van Nostrand Reinhold, 1993.

Chappell, Warren. *A Short History of the Printed Word.* New York: Alfred A. Knopf, 1970.

Craig, James. *Basic Typography: A Design Manual.* New York: Watson-Guptill, 1990.
——, and Barton, Bruce. *Thirty Centuries of Graphic Design.* New York: Watson-Guptill, 1987.

Dair, Carl. *Design with Type.* Toronto: University of Toronto Press, 1967.

Diethelm, Walter (in collaboration with Dr. Marion Diethelm). *Signet, Signal, Symbol: Handbook of International Symbols.* 3rd ed. Zürich: ABC Books, 1976
——. *Visual Transformation.* Zürich: ABC Books, 1982.

Friedman, Dan. *Dan Friedman: Radical Modernism.* New Haven: Yale University Press, 1994.

Frutiger, Adrian. *Type Sign Symbol.* Zürich: ABC Books, 1980

Gill, Eric. *An Essay on Typography.* Boston: David R. Godine, 1988.

Hochuli, Jost and Kinross, Robin. *Designing Books: Practice and Theory.* London: Hyphen Press, 1996.

Hofmann, Armin. *Graphic Design Manual: Principles and Practice.* New York: Reinhold, 1965.

Hollis, Richard. *Graphic Design: A Concise History.* London: Thames & Hudson, 1994.
——. *Swiss Graphic Design: The Origins and Growth of an International Style, 1920–1965.* London: Laurence King, 2006.

Kunz, Willi. *Typography: Macro- + Micro-Aesthetics.* Sulgen: Niggli, 1998.

Lieberman, J. Ben. *Type and Typefaces.* 2nd ed. New Rochelle: Myriade Press, 1978.

Maier, Manfred. *Basic Principles of Design.* New York: Van Nostrand Reinhold, 1980.

McLean, Ruari. *Jan Tschichold: A Life in Typography.* New York: Princeton Architectural Press, 1997.

Meggs, Philip. *A History of Graphic Design.* 3rd ed. New York: John A Wiley & Sons, 1998.

Morison, Stanley. *Four Centuries of Fine Printing.* 4th rev. ed. New York: Barnes & Noble, 1960.

Müller-Brockmann, Josef. *The Graphic Artist and His Design Problems.* Teufen: Arthur Niggli, 1961.
——. *Grid Systems in Graphic Design: A Visual Communication Manual for Graphic Designers, Typographers and Three-Dimensional Designers.* Niederteufen: Arthur Niggli, 1981.
——. *Josef Müller-Brockmann, Designer: Pioneer of Swiss Graphic Design.* Baden: Lars Müller, 1995.

Müller-Brockmann, Josef and Shizuko. *History of the Poster.* Berlin: Phaidon, 2004.

The Pierpont Morgan Library. *Art of the Printed Book 1455–1955. With an essay by Joseph Blumenthal.* New York: The Pierpont Morgan Library; Boston: David R. Godine, 1973.

Rand, Paul. *From Lascaux to Brooklyn.* New Haven: Yale University Press, 1996.
——. *Thoughts on Design.* New York: Van Nostrand Reinhold, 1970.

Rosen, Ben. *Type and Typography: The Designer's Type Book.* New York: Van Nostrand Reinhold, 1963.

Ruder, Emil. *Typography: A Manual of Design.* Teufen: Arthur Niggli, 1967.

Updike, Daniel Berkeley. *Printing Types: Their History, Forms and Use.* 3rd. ed., 2 vols. Cambridge, MA: Harvard University Press, Belknap Press, 1962.

Weingart, Wolfgang. *My Way to Typography.* Baden: Lars Müller, 2001.

Wingler, Hans M. *The Bauhaus: Weimar, Dessau, Berlin, Chicago.* 1st paperback ed. Cambridge, MA: MIT Press, 1978.

For websites, go to www.atypeprimer.com

Index